ART OF
THE VINEYARD

TO MY FATHER...HIS GREAT SPIRIT
IS THE BEACON OF MY LIFE.

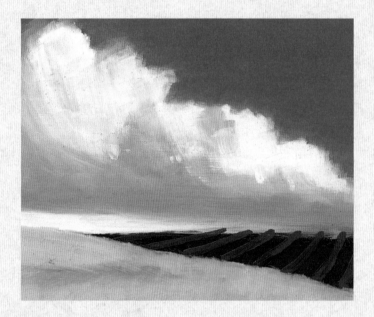

"Those who labor in the earth are the chosen people…"
—THOMAS JEFFERSON

*"Take a little farm and attend to it, put heart and mind in it completely,
and live close to the healing earth… I loved Paso Robles."*
—IGNACE JAN PADEREWSKI

ART OF
THE VINEYARD

GARY CONWAY

JOURNEY EDITIONS

BOSTON • TOKYO

First published in 1995 by

JOURNEY EDITIONS

153 Milk Street

Boston, Massachusetts, 02109

©1995 Gary Conway

Library of Congress Cataloging-in-Publication Data

Conway, Gary,
 Art of the Vineyard / Gary Conway.
 p. cm.
 ISBN 1–885203–10–1
 1. Conway, Gary, 1 2. Vintners—California—Biography.
 3. Wine and wine making—California—Paso Robles Region. I. Title.
TP547.C65C66 1995
641.2'2'092—dc20
[B] 95-7532
 CIP

Edited by Allan McDonell
Designed by Cynthia Patterson

ACKNOWLEDGMENTS

This book evolved out of a chance scattering of wild seeds. Jim McMullan happened at the germination. He and Dick Gautier tirelessly produced a book, *Actors as Artists*. One of my paintings, *The Farmer*, was included. Prophetic, it was.

Then Jim's publisher entered the scene: Peter Ackroyd. Peter has made encouragement and inspiration an art form. He thought there might be a book of paintings somewhere in the studio of my life. Peter and his wife, Roberta Scimone, came one day to take a look. Amongst the clutter there were vineyards and landscapes and a germ of a story…and with Peter's cultivating and my digging into my past…they grew and grew.

Even before I came upon the land, this was a journey with many supporting hands joining on the way. From the nurturing of my beloved mother and father and family, who first declared me an artist, to my cherished wife and children, who went along with it all and brought their boundless loyalty and love.

And then, when the horizon appeared, Allan McDonell took up his shears and pruned in just the right places. Cynthia Patterson shared her artist's vision and studio to design the landscape. Amy Inouye plucked the stray weeds. Kathryn Sky-Peck and the Journey Editions staff provided the fertile ground that was ever enriching…

And it was a bountiful harvest.

CONTENTS

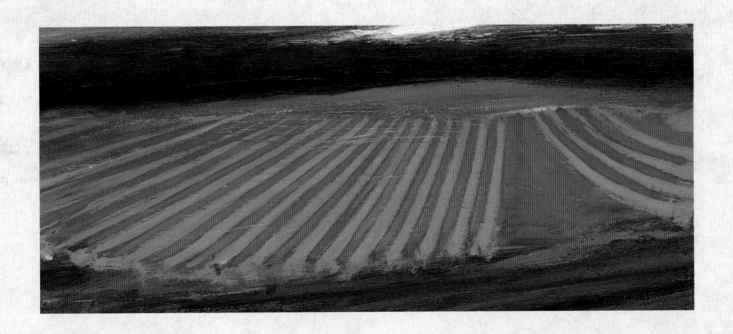

ONE

THE FARMER
WITHIN US

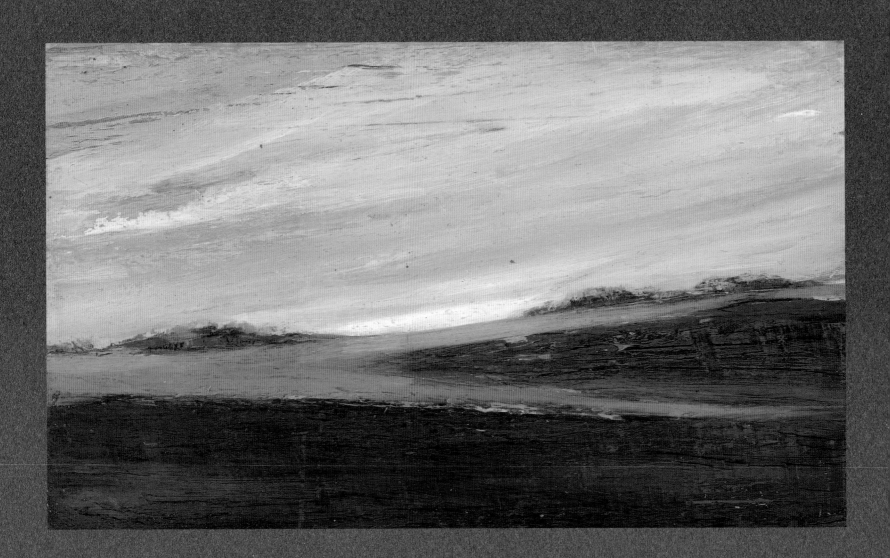

*W*hen *I first saw* the land, I was soaring high above it. I thought we had left behind the farms and ranches. Expanses of dense oak forests passed far below us. But suddenly a valley clearing was shining in the late day sun.

I had never seen anything so perfect. Under a down of spring-green barley, shimmering pastures and gentle hills undulated toward the embracing Santa Lucia Mountains.

"This is it…this is the ranch." Archie veered his two-seated helicopter toward the farmhouse, the only dwelling as far as the eye could see.

"God, is it beautiful!" I got most of those words out as Archie banked his chopper sharply.

"Look at the deer!"

More than a hundred of these creatures bounded gracefully through the waving barley. The helicopter had stirred their twilight grazing, and they took to their own flight.

The whirling rotors kept pace with the leaping deer. As the woodland's corps de ballet streamed over the drift fences, Archie dropped for a closer view.

Without warning, a terrible shuddering rattled the helicopter. The craft seemed on the verge of breaking apart. Archie desperately tried to keep control, frantically working to save our lives.

Terrifying seconds split off into infinity. My young life, or at least the last few incongruous months of it, flashed by.

I was starring in *Burke's Law,* a television series that was one of producer Aaron Spelling's first. The show featured a Rolls-Royce cop and his high-IQ sidekick, marshaling a parade of renowned guest stars.

QUIET LAND *Oil* 5" x 8" 1992

I would go to work every day and encounter my childhood movie fantasies. On a Monday I was shaking hands with Basil Rathbone. As a kid, I had seen every Sherlock Holmes movie.

Basil Rathbone was Sherlock Holmes. Of this I had no doubt. And here we were, shooting the breeze.

By Friday I had played make-believe with one matinee dreamperson after another, from Mary Astor to ZaSu Pitts, and I ended the week asking Gloria Swanson all about *Sunset Boulevard*.

No wonder when a fellow actor asked my wife, Marian, and me to go for a weekend to his brother's ranch some place up the coast called Paso Robles, I refused, not completely masking my incredulity. Give up my bygone idols and their incredible stories of Hollywood past? But Don McGovern kept inviting us to the boonies, and we even had to bring our own food.

I was born in the center of Boston, raised mostly in midtown Los Angeles. City life was the essence and totality of my existence. My big, sprawling family lived and died in cities. I could see a day or two on a yacht at Catalina, or water-skiing on Lake Arrowhead, but some Central Coast potato patch was no vision of a getaway weekend.

Somehow Don gathered up enough actor friends to bolster the outing with laughter and stories of Hollywood present. Our group of ten caravaned up 101 to a 320-acre spread east of Paso Robles, not far from where James Dean was killed in his Porsche. I was to get my first glimpse of country life through grown-up eyes, and the big west country at that.

We chased runaway horses in waist-high barley most of the first night. We cannonballed into a spring-filled reservoir in the clean heat of the following day. We picked up groceries in an oak-floored market with jars of beef jerky on the pine-wood counter.

There was only one thing on my mind during Sunday night's endless trip back to L.A. I had found a home.

Marian slept leaning against me as I drove. My eyes were crazed in the rear view mirror. My internal conversation was exhausting. Startling Marian awake, I finally blurted out, "Dammit…we're going to buy a place up there!"

I tracked down Don the next day in Paton Price's acting class. Paton taught in the converted garage of his Studio City home, having been ostracized from the studios as too radical.

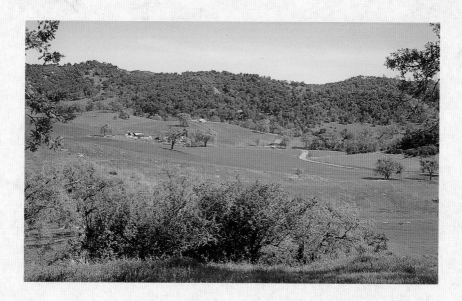

The Old Ramage Place

Don, Jean Seberg, and Dean Reed were there, searching into their deepest beings, unmasking themselves, finding their truth. I was looking for a real estate agent.

During a break, Don put me on to the best real estate agent in Paso Robles, then looked at me quizzically. I knew what he was thinking: is this the same guy I had to drag by the hair to my brother's ranch?

Archie Hansen was the real estate agent of choice in Paso Robles. If real estate and land development could be an art, Archie would be a master. Stalwartly attractive, Archie only seemed right in scruffy cowboy boots and beat-up denims, on the lookout for Indian arrowheads while pointing out property lines on the ranch he was showing.

His own home, ensconced atop a hill on a 2,000-acre spread he had subdivided called Hidden Valley, was a monument to fine country taste. Archie had the definitive collection of books about rock walls. He didn't just put up a rambling stone wall, he fashioned it into a running sculpture.

Archie knew I was hooked. He could talk for hours about the subtleties of barbed wire fencing, and I was enthralled. He never asked me about my television series and all the stars I worked with. Only 200 miles down the coast, that world was a different universe.

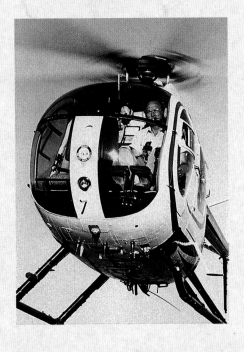

The only stars that interested Archie were the dazzling jewel display that came out every night in the vast Paso Robles sky.

While our wives chatted in the kitchen, Archie and I lounged in big leather chairs in his study. We sipped well-aged bourbon, overlooking Archie's valley, oak forest framed, carpeted in safflower. Here and there the dull sheen of a little lake or an occasional barn highlighted this wide-screen Western scene.

Archie scooped up my glass. He insisted upon showing me the Ramage place before sundown. "You'll love it!" We could jump in Archie's helicopter and be there in less than ten minutes.

What a way to go! This was the kind of country where you flew over to see your next-door neighbor and landed on his airstrip. Lots were measured not in square feet, but in acres and sections.

We had lifted out of Archie's helipad and swooped toward the verdant west side of Paso Robles. And we arrived at the Ramage place...

Via a crash landing!

The copter fell like a great screeching bird, spiraling in flight, as if shot out of the sky by unseen hunters. The crippled bird struck the earth, muffling us instantly in broken wings.

The helicopter was a gruesome pile of metal, but we climbed out with limbs intact. If you must crash, Archie is the pilot you want.

Stunned, Archie poked through the debris, circling a puddle of spilled fuel and shaking his head at a tangle of twisted wires. He studied the rotors, which were hanging like limp pretzels. His helicopter was headed for the junkyard.

But my mind fixed on other things in this transcendental moment. Like some conquistador, high atop one of the hills, I surveyed the Ramage ranch. In the stillness after the crash, there seemed to be no living thing for a hundred miles. The last glow of daylight haloed the distant mountain range with satiny magentas and purples. Those hues defined

the painting that I had stepped, or rather smashed, into—Nature's Divine Landscape. I was ready to make an offer!

Afterward, it seemed appropriate to have plunged like a comet from some distant space into this new land. And I learned one life lesson. Never buzz deer near power lines.

I plundered my bank account for the down payment, and thirty days later Marian and I spent our first night in the time-worn farmhouse. I was eager. Old Ben Ramage hadn't even moved out yet.

Ben stayed up with me that night. I wanted to know every detail about the farm, the house, his life.

Ben Ramage had lived on this farm for eighty years. I'd no idea. Could I ask the man to leave this late in his life?

Oh, I knew he was moving in with his son to some regular neighborhood with packed rows of houses. But this had been his home, his every window overlooking the quiet land. He'd put his life's work into the place. It had been his dairy farm. He'd been born here. He'd brought his wife to this farm. She'd died in this house.

For the first thirty years of their marriage, they drove a horse and buggy into town to attend church or go to market. Ben and his wife could doze the fifteen miles to Paso Robles. The horse would find the way.

It was a cold night. Dropping more logs into the fire, Ben stoked me with the lore of the farm. Stories about the bears and the mountain lions that had roamed these hills. Stories about the bighorn sheep and the Russian boar that escaped from Hearst Castle, not too far away. Stories about the dairy business and the Holstein cattle and how his wife had the most envied garden in all of Adelaida.

After the last oak log crumbled into embers, I went to bed in the second bedroom. Wide awake, I was dreaming. I made a silent promise to old Ben. This farm would thrive once again.

That Ben had to give up all this at the end of his years ate at me. It seemed wrong.

In the morning I was haunted by the pain of Ben's loss. I brought up the subject to Marian. Perhaps there was a way that Ben could stay on…a caretaker of sorts. Marian cut me off—he was very old—Ben, himself, needed to be taken care of…at his son's place.

I helped Ben pack a little. His son arrived, and Ben was ready to leave.

As he and his son motored out of the long driveway, I waved. But Ben didn't look back.

BEN'S LAST DAY *Oil* 11" x 14" 1994

I stepped inside and opened his bedroom closet. It was jammed with women's clothes. Clothes that belonged in faded photographs, never touched after Ben's wife died.

Marian and I took stock of what we had purchased. The ranch was 320 acres and had over a mile of frontage on Chimney Rock Road. Most of the ranch had been cleared for farming, with about 250 acres in barley. The crop would be harvested by Ben Jr. He would keep the profits.

In our property negotiations, Ben Jr. offered to put in next year's crop on the typical one-third/two-thirds arrangement. One-third of the gross sales going to the landowner. I needed to think through what I wanted to do in the way of farming before I committed to a contract. Being a gentleman barley farmer wasn't exactly what I had in mind.

Marian wanted to get a feel for the house. Ben had left a lifetime's accumulation of household items behind, besides his wife's clothes. An ancient, but still working, Singer sewing machine fascinated Marian.

The most interesting objects in the house were Indian bowls and arrowheads that had been discovered on the ranch. At the time of the Franciscan missions, as many as 100,000 Native Americans were living in the region.

I put my old army boots on, and I was ready to be the lord of all I surveyed. It was still early morning, and I didn't know where to strike out first—320 acres is a lot of ground to cover.

I headed for the barn. A barn is a secular church for me with its simple geometric symmetry. No space is more inspiring for an artist. A perfect studio! This is the place to paint the masterpiece. A barn proves that man, held to basics, will build a pure and noble building.

This had been a dairy barn. The center section was raised, as was typical in the area. Burly, hand-hewn beams supported remnants of a hay loft, with doors that pushed out through the gable. Old concrete on one side of the floor was once used for stalls and milking apparatus. In the middle of the concrete slab was a bottling pit. Horseshoes, parts of saw blades and strange machinery, and all kinds of wonderful bygone tools and farming implements were hanging or leaning against the walls.

Nothing had retained any practical use, but they were certainly objets trouvés. But the barn's major artistic statement was its outside siding, especially the north-facing wall.

Here was a mural beyond the technique of abstract expressionism. A hundred years of layered paint and stratified lichen had produced a palette of verdigris and other illusive

hues that no mortal artist could mix from paint tubes. Each board was a study of scumbling patina. Who needs museums and galleries when man and nature collaborate in such unconscious art work?

Close to the barn stood a crumbling milk house, with foot-thick adobe block walls, constructed years ago for dairy storage. I assessed what it would take to reconstruct the charming little building.

A water tower and leaky tank loomed over the adobe. It had served its purpose through time, but it was leaning precariously, and only a minor engineering miracle would straighten it.

Nearby tottered a chicken house and an implement shed. I was getting the idea that this ranch needed a major overhaul. Old Ben had let things go to seed in the past few years. Hard decisions had to be made: renovate or start from scratch in these outbuildings? The blush of the new bride was wearing off; the place was worn to the bones.

Enough of dilapidated buildings. I had bought land! I set out to explore the magnificent 320 acres all about me.

A road led to the main farming fields behind the house. Its wheel ruts followed a stream. Below the house, the stream turned into a boggy mess, and in my mind I planned a dam to create a small lake. My brain exploded with landscape schemes, creating my version of the Gardens of Versailles—or at least Stourhead in Wiltshire, England.

I ran along the stream to higher ground. The day was clean and sparkling. I sucked in the wonderful smell of rich, damp earth and wild grasses. The sky blazed blue.

I veered into the barley field, picking up speed. In my magic kingdom, I ran boundlessly through the high barley like the deer I had seen when I first set eyes on the land.

The fields were soft from plowing. The soil lay deep and dark, like the potting soil sold in little bags at the nurseries. No wonder everything grew with such vigor on this land.

I came face to trunk with a mammoth oak tree standing guard over the pasture. I stopped abruptly, excited to meet this ancient partner to share my life on the ranch.

What an heroic tree! Centered in the barley field, this towering work of nature reigned majestically. I felt a reverence standing next to this venerable specimen. The patience of this oak! Its mighty size—at least five feet in diameter—declared that it had commanded this spot for four hundred years!

I assessed this proud oak as if it were a great statue, every branch and twig part of an ode to the perfect balance of texture and composition.

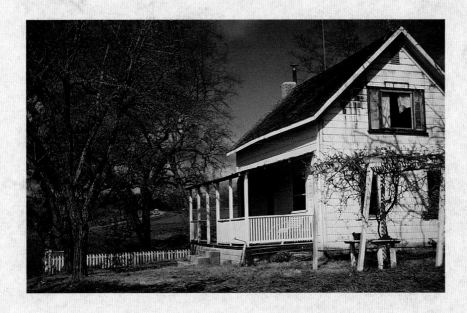

The Farm House

Up ahead, the barley field ended; the rise got steeper. A small forest of oaks crowded the hill at the ranch's center. There were white oaks and silver oaks and scrub oaks and some fallen oaks, crashed to earth from a time before I was born.

Climbing this hill, I was Lewis, or even Clark, discovering the West itself. I reached the top of the hill and gave up my grandiose landscape plans for the farmstead. This peak is where my home, orchards, and gardens would be!

I was slowing down. I could hardly move my feet. Six inches of tenacious adobe caked the soles of my boots. It was a trick removing the mud, but I gained a working knowledge of soil varieties on the ranch.

During the next hour I designed my hilltop home. While constructing my studio-to-be, abandoning for the moment my barn atelier, I realized that I had left Marian alone for a long time. She was probably wondering whether I had fallen into a rabbit hole like Alice in Wonderland. She felt that we were in a place not meant for city folks, and that hidden dangers lurked everywhere.

As I made my way down the hill toward the farmhouse, I marveled at the heaven's light that suffused the area. Everything was softly radiant.

THE OAK *Oil* 11" x 14" 1994

I remembered Van Gogh's first trip to Arles and his intoxication with the crisp clean light of the region. As a very young art student I'd been enchanted with Van Gogh and his love affair with the luminosity of the French countryside. At this moment, I knew what he had experienced.

My own art work at the time was admittedly ambiguous. I had yet to be single-minded in style. This Vincent saw his world in inflaming color and stayed true to it. I was, I suppose, a reticent hybrid. I enjoyed painting portraits, as I had since early youth, but I could plunge into a land of non-formative shapes and hues. I also fell prey to other conflicting modes: paintings of half-abstracted figures emerging from pale washes, or more lurid groupings with hints of expressionism and a dash of social realism.

I was aglow with the "white radiance of eternity" when down-to-earth Marian met me at the kitchen door. While I'd been redesigning my fiefdom, Marian had inventoried what was needed to resuscitate the house. Not only was the list long—about five notebook pages—but number one was that the house had no foundation.

Now that "floored" me. Marian led me to a cellar that I hadn't realized existed. The cellar admitted just enough light to reveal that the floor joists were set directly on the ground. Impossible. But Marian had done her detective work. The house apparently was constructed solely from redwood, and the entire structure rested on a rock outcropping— a natural foundation. And with redwood, well, there was no danger of rot or termites.

Marian and I had built a house in Los Angeles a few years previously. I recalculated all the time and money we'd spent on complicated engineering for the foundation and the special considerations for earthquake protection. This old farmhouse hadn't dealt with any of it and stood proudly in plumb for over a hundred years. The homesteading pioneers could teach us an architectural trick or two.

Marian was nonetheless discouraged. She liked the old house, but it would take a lot more work and money to renovate than to start anew. Her despondency reached further than the house. She had been out to the barn. Marian hadn't fallen for the stratified lichen; she saw a building on its last legs.

The barn was in the jaws of death. It needed a complete cure. I didn't mention the glorious studio I saw within those drooping walls.

We hit our low point. It had all been logic of the heart since I crash-landed. (Maybe I'd landed on my head.)

Cold reality seized my shoulders and shook me. I had a job back in Los Angeles.

An actor's job at that...primping in makeup one morning, hustled out the back door the next. I had a baby daughter. Was this weekend schlep the beginning of endless fixup work for a hopelessly under-qualified handyman and woman? Would this dream hideaway be a constant dollar drain?

The down payment had been a stretch. We had a bear of a mortgage to feed, and now we faced untold expenses "in order to bring the place back to life." Marian interrupted herself..."in order to rescue the barn and house from sure collapse in the next windstorm."

The trip home that weekend was an emotional seesaw. One moment I was furiously rebuilding the barn with my ideal north light studio in the loft. The next moment I was hoping that it wasn't too late to get my money back. But I pulled into the driveway of our Hollywood Hills home convinced it could all work—if I got serious about farming and planned something that made more financial sense than barley.

I checked countless books about farming, ranching, horticulture, and hydroponics. On the *Burke's Law* set my script occupied one side pocket of my chair and in the other, the latest pamphlet from the U.S. Soil Conservation Service about pasture grass varieties and feed lot management. I studied almond orchards, cattle breeding, and catfish farming. I learned about exotic money making crops like kiwis and macadamia nuts and even Christmas trees.

On our next trip to the ranch, Marian and I brought our daughter, Kathleen, with us. Little Kathleen skipped into a field of grain as high as her head, without a backyard fence or busy street to stop or threaten her. Everywhere our Kathleen turned was a new and enchanted adventure. That night, exhausted from her full day running free, our daughter fell fast asleep halfway through her favorite bedtime story, *Lookout for Pirates*.

Marian and I walked outside to gather logs for the fireplace. The sky's star spectacle stunned us. There were millions, my God, billions of shining diamonds.

I was in the matrix of the universe...a part of its enormous presence. During my entire city dweller's life, I had been denied this nightly transhuman splendor.

"What was that?!"

Marian brought me back to this little planet. It was a shooting star...probably a trillion miles away. Then another.

We slipped our arms around each other, infinitely happy, in awe with all that was eternal...the heavens...this land.

It was very cold as we crawled into bed. Kathleen curled between us. It wasn't quite a three-dog night, but it was certainly a one-little-girl night.

Marian was asleep before I turned off my bedside lamp. The room disappeared. I had my first confrontation with utter darkness…the black-on-black of a country night far from any town.

I played games with the darkness. I shut my eyes, then opened them. Not a bit of difference.

A light passed across the ceiling, startling me. It raced down the wall. I sprang up in bed. Was this an intruder? I heard a distant car. From the window, I saw headlights searching the darkness on Chimney Rock Road.

I was probably an incurable city bumpkin. For six hundred thousand years, maybe a million years, primitive man spent every night with unyielding darkness. I was simply experiencing this natural event for the first time.

I drifted off, thinking about the legions of my ancient forebears who lived and died in field and farm and cave and cabin.

The last log in the fire turned to ashes. Then, immaculate silence. Or so I thought. In the distance I heard something like cannon fire. Where the hell would that come from? Camp Roberts wasn't very far away. Nighttime artillery practice? It was so steady. Boom…boom…boom. I finally went to sleep.

Marian was shaking me. "What the hell is that?!"

I struggled awake. For the moment I thought I was back in the Hollywood Hills and late for my set call.

Something was fluttering about the ceiling. The moon was out, and its pale light was enough to illuminate a flying object swooping toward the bed.

"A bat!"

Marian scrambled under the covers. Family defense was the male's role. I started out of bed, the bat dive bombed me. I ducked. The creature buzzed my head. I grabbed a pillow and swung wildly.

The little invader vanished, God knows where to. Marian suggested I find out. I felt that could wait for the following day.

We went back to sleep, covers protecting our heads. I could still hear the timpani beat of distant cannons.

In the morning, Marian headed straight to town for electric blankets. Enough of the wood fireplace, unless I was willing to stay up all night and stoke it.

I asked Marian if, by any chance, she had heard cannons. My South Carolinian wife was positive the Civil War was over. The only strange night noises she was aware of came from Dracula's little helper. She suspected the old place was infested. I dropped the subject. I was just beginning my initiation into country life.

The initial trips back up to the ranch were solid work weekends. I developed a talent for firing up my friends about the good times to be had at my new ranch. I usually trapped a couple of pals, and I worked them half to death before they figured out the con.

On the third or fourth excursion to the ranch, I made a discovery. That damn Civil War cannon I had been hearing was not booming from Camp Roberts. It was, in fact, my heartbeat! In the absolute stillness, I had eavesdropped into the percussion section of my inner body.

In the beginning, my limited objective was to stem the tide of decay on the property. But rather than get rid of anything or tear anything down, each weekend I carted more antiques up to the ranch: a chandelier made from the wheel of an old Cord automobile, a woodburning stove from an even older steam engine train.

The farm was fifteen miles west of town, just enough distance that planning ahead became essential. This was not a place where an overlooked box of roofing nails could be picked up at the corner hardware store.

Paso Robles was the small town I had missed growing up in, with a western tilt. A tree shaded park graced the town center, with a mini-Palladian Carnegie library. Turn-of-the-century architecture prevailed, and unlocked cars parked slanting to the curb.

The barber shop had a barber pole with spiral stripes of red and white. The hardware store had creaky floors and hours' worth of entertaining good stuff. The pie shop needed no sign boasting "homemade" because everything was.

Places were called dime stores and haberdasheries. Every shopping need was met, with no malls and no whatever-marts.

Wilson's was the place to "eat" in town; "dining" had yet to be invented. Like everything in Paso Robles, there were no citified frills, such as interior design. Wilson's was all salmon-colored plastic booths, tables, and counters. Next to the dining room was Wilson's bowling alley—the final touch to the Wilson ambiance. An unwritten town ordinance decreed that no plate should reveal itself under the whopper-sized T-bones and fries.

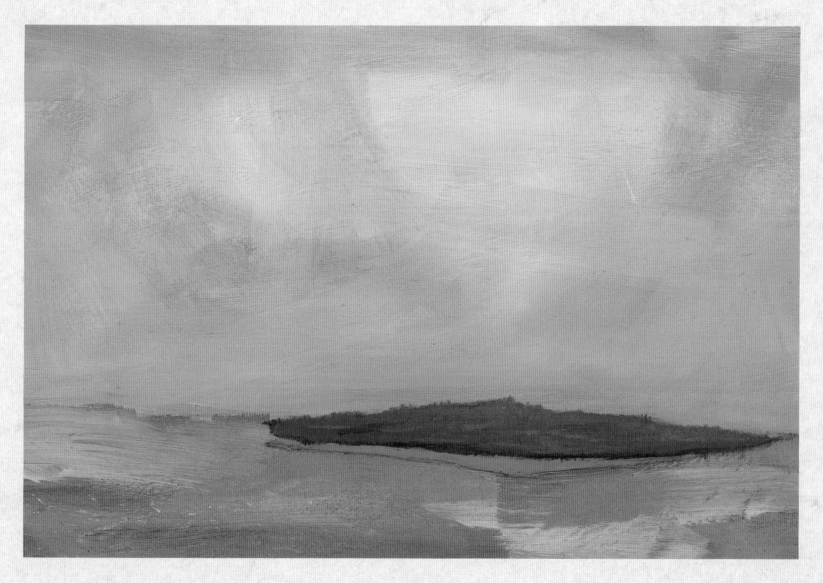

HEAVEN'S LIGHT *Oil* 5" x 7" 1994

Compared to my birthplace, Boston, where tradition is an industry, Paso Robles, like much of California, lacked in historical richness. Or so I thought.

From the early Indians to the mission-building Franciscans, the region's past cast its spell. When Spanish explorer, Juan Cabrillo, first sighted the natural wonder that was California in 1542, he was impressed with the friendly native population (a trait that lasts to this day). Cabrillo observed that the Chumash and Salinan Indians of the Central Coast wore animal skins and knotted their hair in braids. Disappointingly, the braids were tied with bone and wood, and not silver and gold.

Cabrillo had been dispatched from Spain to find the legendary Northwest Passage, fabled to connect the Pacific and Atlantic Oceans. He was also looking for fresh loot, prompted by the discovery of the great Aztec treasures in "New Spain." What he found was an impenetrable coastline with virtually no sheltered anchorages and a long storm season. Worse yet, the local Indians were hunters and gatherers, not temple builders with palaces of gold, silver, and jade. This was two hundred years before the Golden State's great Gold Rush.

Toward the end of the 16th century, interest in this new land picked up, and Spanish explorers plied the waters off the Central Coast and made excursions inland. They were unable to find a manageable harbor, and the closest thing to a temple filled with gold was a big painted rock. Interest in the Central Coast and indeed California waned for almost 170 years.

In the middle 1700s, Spain expelled the powerful religious order known as the Jesuits. Subsequently, the Jesuits established a chain of missions in Baja California. The "Black Robes," as the Jesuits were called, were replaced with the "Gray Friars," or Franciscans. Father Junipero Serra, and other Franciscan priests, along with the soldier-explorer, Gaspar de Portola, were sent to Alta California to further their missionary work.

They blazed a trail that became El Camino Real, a route connecting the string of missions between San Diego and San Francisco. I still blaze this trail when driving to the ranch from Los Angeles.

In 1771, Junipero Serra established the first Franciscan mission near the site of present day San Diego. In 1797, the Mission of San Miguel Archangel was constructed on the banks of the Salinas River, just north of what is now Paso Robles. San Miguel was a typical day's hike from the mission in San Luis Obispo, and another day to the mission further north at San Antonio.

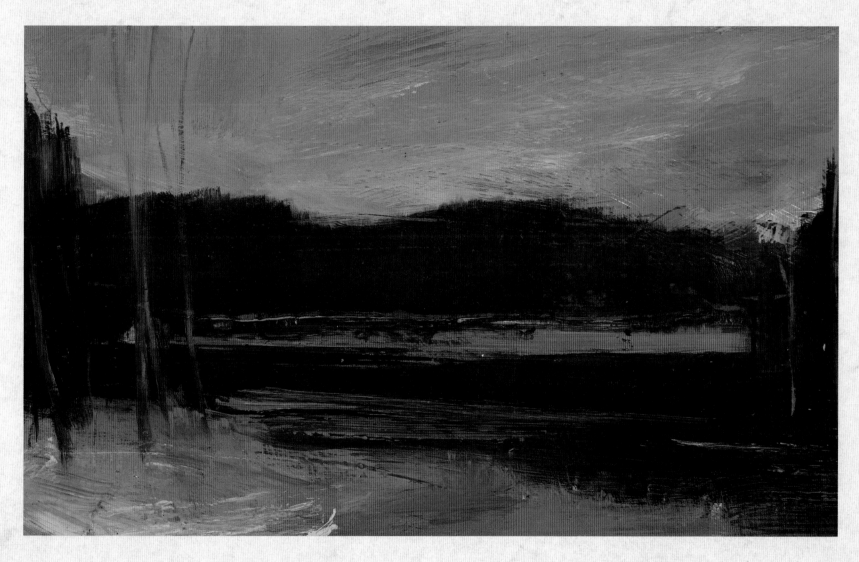

EVENING GLOW *Oil* 9" x 15" 1992

The friars converted many Indians to Christianity and some to early graves. The native Californians had been isolated from mainstream humanity since the Pleistocene Epoch. Immunity to disease, even civilization itself, had not been developed.

But the Indians flourished around Mission San Miguel. The Mission was one of the most populated of the chain of twenty-one, and at its height, San Miguel ministered to six thousand Indians.

With its dependent ranchos of San Marcos and Paso de los Robles, the Mission maintained 91,000 head of cattle, 4,100 horses and mules, 347 oxen, and 47,000 sheep. The size and quality of San Miguel's herds were the envy of all the other missions.

Indian folklore weaves a spell with stories of the early natives who dwelt in the wondrous Santa Lucia Mountains that encompass the ranch. Rumors persist about a lost silver mine that the departing Spanish missionaries swore the Indians to keep secret.

Paso Robles itself was originally called Paso Robles Hot Springs and was distinguished in the early 1900s by a grand hotel designed by Stanford White, and a spa famous worldwide for its hot mineral springs, natural mud baths, bottomless sand springs, and white sulphur springs.

Ignace Paderewski, one of the greatest pianists of all time and Premier of Poland, came to Paso Robles Hot Springs and cured himself of debilitating neuritis that kept him from concertizing. He later bought a ranch in Paso Robles, planted a vineyard and produced an award-winning wine, San Ignacio Zinfandel.

When the hotel burned to the ground in 1940, an era died with it. I found some history books printed in the last century, great reading around the fireplace in a house built in that century.

In a chronicle of the county published in 1883 by Thompson & West, I read from a chapter on El Paso de los Robles—The Pass of the Oaks.

"Among health resorts, Paso Robles Hot Springs stands without a rival, so far as the healing qualities of its waters are concerned. The springs are situated in the beautiful valley of the Salinas River about sixteen miles from the Pacific. This valley is protected from the cold winds and fogs of the ocean by the Santa Lucia range of mountains, and for miles above and below the springs is a natural park, formed by long stretches of level plains, broken at intervals by low hills, and all studded with graceful white and live oak trees, with occasional groups of native shrubs, the whole forming one of the most picturesque landscapes that the eye of man ever rested upon.

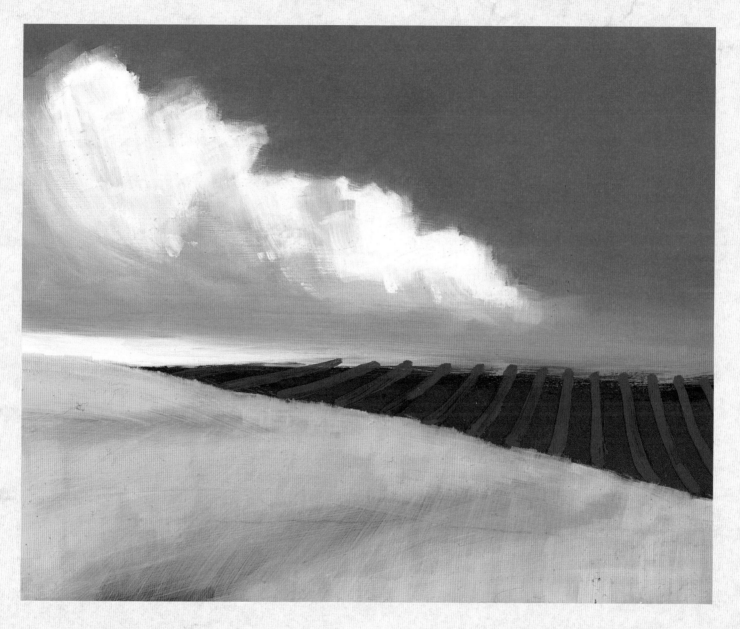

SUMMER *Oil* 11" x 14" 1992

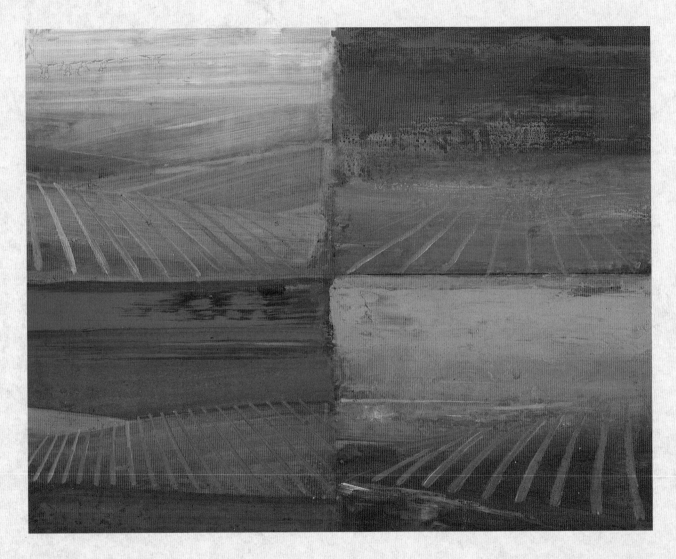

VINEYARD QUARTET *Oil* 10" x 12" 1992

"In the midst of this scene of natural beauty, the waters burst forth from the earth, duly prepared in nature's great laboratories to minister to the diseases of man.

"The springs were observed by the early missionaries, and their curative properties recognized by the Indians and Spaniards from time immemorial. Instances of cures are innumerable.

"Even the grizzly bears, the former monarchs of the region, sought in the warm and invigorating waters the pleasures of the bath. There was formerly a large cottonwood tree growing on the bank of the spring, with a limb extending over the water. A huge grizzly, in the habit of making nocturnal visits to the spring, would plunge into the pool, and, with his forepaws grasping the limb, swing himself up and down in the water, evidently enjoying his bath, his swing, and the pleasant sensations of his dips in warm water, with unspeakable delight."

The book listed many notable physicians who testified to the curative powers of the springs, in healing with nature's medicine, everything from rheumatism to liver and kidney disorders, and even drug cures for the common problem at that time of opium and morphine addiction.

This was before doctors fell under the sway of pharmaceutical conglomerates and their new "wonder" drugs. These drug corporations resented "natural" competition, especially since the abundance of nature's medicine in Paso Robles was pretty much free for the taking. All at once Paso Robles Hot Springs was gone with the wind and a fire. The great old hotel burned down, the magical springs were capped and buried, and sulfa and antibiotic prescriptions became the status quo.

Marian didn't quite buy my web of drug company conspiracies, but she loved the part about the bathing bear.

We became intrigued with the story of Paderewski's initial sojourn into the area that we now called home. We found a copy of Paderewski's autobiography and shared the delight with his discovery of Paso Robles and the baths that allowed his hands of genius to perform anew on the piano keys.

We were also fascinated with his interest in grapes and winemaking. As we delved into his love affair with the vine, seeds were planted in our own hearts and minds. Here, at the turn of the century, the artist-vineyardist-winemaker had worked just a stone's throw from our ranch.

Driving back and forth to town, we tried to pinpoint the Paderewski vineyard. While we were becoming intrigued by the great pianist and statesman, a new vineyard was being created next door to the nearly lost Paderewski vinery. A physician, Dr. Stanley Hoffman, had begun planting the very first French varietals in the county.

As I, the crash course farmer, calculated how to pay the mortgage with Hereford husbandry, fodder farming, or even a dude ranch, Chardonnay and Cabernet plants were pushing out of the limestone soils of the Santa Lucia foothills. *Vitis vinifera* would establish a prominent place in this sylvan countryside and, eventually, into my citybilly heart.

ALONG CAME
JONES

Barley farming raised Cain with my rancher-baron vision. Like it or not, my years as a Hollywood actor made the make-believe world more real than the real world. Celluloid was in my cells.

I grew up on a lot of Saturday afternoon Westerns, none about grainboys. Cowboys, yes—cattle and cowpunchin'—that was for me. I owned 320 acres, just enough to establish a cow and calf program. I labored over the mathematics. I could buy twenty heifers and one bull. A hairy-chested bull would furnish twenty pregnancies, doubling my bovine ranks in one gestation period.

I felt as if I were playing God, and it was a good feeling. I was certain to make money. After an approximate $25,000 investment in my heifers and the purchase of a bull, I would sell at least ten of the calves at thirty cents a pound (each weighing 900 pounds), for a total of $270 each, earning about $2,700, which would pay most of my costs. My herd would expand by fifty percent. The following year I would have thirty calves, and so on and so on. I loved this business.

It hit me. The bull had better be good, a sure-fire performer, or my investment program would be seriously jeopardized.

I also had to hire a cattleman to run the program day to day. He and the bull were the key. I had to find a he-man; he had to find the he-bull.

Hereford was my breed of choice. Their sienna red bodies, broad white faces and stout stance were picture perfect for my landscape.

Life no longer imitated art; it imitated commercials. I needed a cattle wrangler, and he'd better be a Marlboro man.

Ted Jones was just that, from the tip of his Justin boots to the top of his Stetson. Jones was recommended by a neighbor, Frank Biaginni, who managed a ranch about six miles down Chimney Rock Road.

VINEYARD TAPESTRY *Oil* 11" x 13" 1993

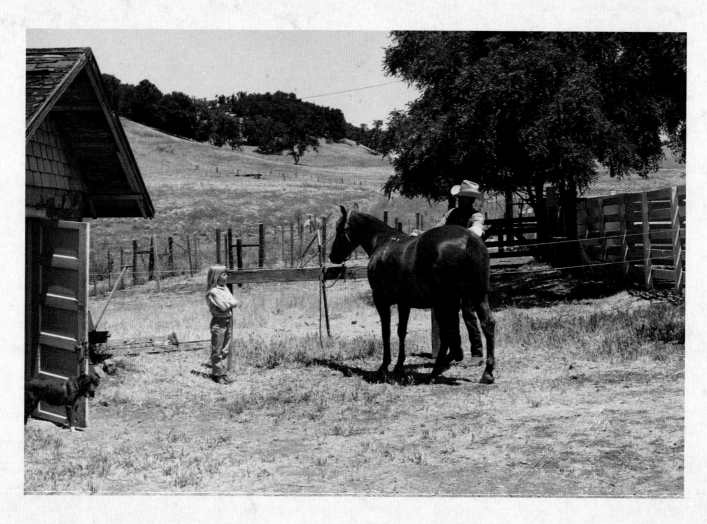

Kathleen with Ted Jones 1968

Frank suggested that his friend Ted Jones would be the ticket to handle my place. Jones had years of experience, knew his way around cattle, and most importantly he was "clean." Cleanliness was a personal attribute I hadn't considered. The comment was curious. Biaginni's ranch quarters were something close to a pigsty.

The following day, Jones drove up in an immaculate truck. He was clean and crisp as starch; the aroma of cologne about him seemed overpowering for an outdoor man. He shook hands with a serious grip, introduced himself in four words, and assessed the ranch with sun-narrowed eyes.

Casting was everything. My Hollywood experience reinforced Leonardo Da Vinci's edict that "anatomy is destiny." You had to look the part to get the part.

Jones was our man. I glanced over at Marian. She was impressed.

As we walked toward the fields, I felt everything working. I felt ranch; I felt cattle. I even talked in short sentences, mimicking the three- or four-word bites of Jones. "Good ranch." "Need a holding pen." "Fence O.K." "Thirty head."

Great! I was in business! One little item. Where would Jones bunk?

Our house had two bedrooms, and not much elbowroom between the kitchen, dining room, and parlor. The bedrooms were too close to each other. And with a single bathroom, things could get crowded.

We had to expand, either out or up.

The old house's roof indicated a high-ceiling attic. I studied the walls inside. There had been a second floor to this house, with stairs leading to a secret attic.

This was a job for a handy craftsman. Whoever I hired would be mostly on his own. I needed someone I could trust to give me a full day's work.

Time to enlist family. I fortunately had several in the building trade. John DeFelice was the cousin who fit the occasion.

Even among Italians, John was considered over-excitable. He was the last act of an opera that would never end. John's emotions ranged from fervent to impassioned. He was as quick to cry as to laugh, and somehow, in all of this was a carpenter with hands as nimble as his temperament.

John, a horse enthusiast, haunted the racetracks, and fantasized about raising his own sweepstakes winner. It took all of one minute to convince him to move up to "horse country" for a couple of weeks and build an upper story for my cattle (and horse) wrangler.

When John jumped out of his truck, he swooned, fell to his knees, and kissed the earth. He loved the place at first sight. He hugged me, tears in his eyes. One minute later he was toting a chainsaw toward the mystery attic.

John sized up the situation. He had me fetch a long ladder out of his truck while he loaded up with more tools.

John couldn't wait to be done with this attic. He saw that he would be living here for at least a year. After all, when he finished the house, there was the barn to straighten up, corrals to build, and a riding ring for his horses. (Would he ever get around to my art studio?)

Scheming how to convert his wife, Aurora, to ranch life, John chainsawed an opening into the attic almost quicker than I had the ladder secured. He climbed into the attic. I scrambled up the ladder, right behind him.

Inside the opening, pungent air enveloped me. Breathing raggedly, I realized I was knee deep in what looked like old coffee grains. I had experienced mustiness, but this attic was stuffier than King Tut's tomb.

John examined a yellowed scrap on one of the walls. "Look at this old-timey wallpaper. This must've been a bedroom." The wall paneling seemed to prove his point. Strange that this upper room was abandoned and closed up for what seemed like decades.

John mulled over the brown dunes on the floor. It piled high against the walls.

"Odd…"

The next moment brought something even more curious. The mystery attic came alive with weird squeaking sounds, emanating from behind the darkly stained redwood paneling.

John pried a panel section loose with a crowbar. He propped the panel against the wall—strange mounds covered the entire back side section.

As he started on another panel, a thousand flying objects filled the room.

Bats!

Instant city boy, I panicked, exiting in a leap and bound through the newly-made attic entrance.

I hit the ground, expecting John to land right behind me. Not so.

"John! Where the hell are you?!"

I shot a glance up at the attic opening. Bats streamed out like crazed demons.

"Help me!" He hollered. I couldn't believe it. John wanted me back up in the attic.

Was he nuts? Or was he in trouble? I imagined the bats swarming him, taking him to the ground.

"Get down here, dammit!"

But he kept calling. I had to find out what was going on. I shivered back to the ladder. I climbed resolutely and peered inside.

John spun in the middle of a swirling cloud of bats. Swinging wildly with a broom, he was not connecting.

In the most forceful voice I could muster, I ordered John to bail out of the attic. Then I scrambled down the ladder.

A few minutes later John was at my side, grinning like the Joker in *Batman*.

"Why did you stay up there so long?!" My tone was shrill. "And why were you calling me?"

"I just thought we could nail a few."

John DeFelice 1968

John mocked my bat phobia. But what did I know about flying rats? Only rabies and God knows what else.

John was a born outdoorsman. He knew these bats were harmless. I ate humble pie, a big piece.

John explained that the pile of muck in the attic was bat guano. Probably fifty years' worth. It was the world's best fertilizer. We would bag it up, and have enough to feed a tomato garden for life.

The bat episode unnerved me. I sure as hell wouldn't mention it to Marian. Thank God she wasn't there. If she knew a colony of bats was living on the other side of the ceiling and doing potty there for the past fifty years, Marian would torch the house.

John swore me to secrecy with his wife too. He was going to have enough trouble convincing Aurora to come up. If she suspected a bat in the belfry, that would finish it.

As to be expected, John knew everything about bats. That night as we gobbled up Chef John's pasta, he described how bats use the skin of their tails as braking flaps. To turn or stop, they bend their tail downward, much as an airplane does. The creatures produce high twittering sounds pitched beyond human hearing. These sound waves strike objects and echo back to the bat's ears. The echoes keep the bats from collisions as they fly. They don't need eyes to be great insect scavengers. In one night, bats could eat the entire ranch population of mosquitoes, and consume every other pesky insect for dessert.

When I was about to go to sleep, I sensed a few sonar navigating creatures flying in my room. I figured I better make friends. I watched them dive and swoop, admired their computerized flying skills, and then they were gone.

John whipped the attic into shape. He put in a skylight and fitted casement windows into a bay. He built a bathroom and restructured the ceiling with an interplay of old wood beams found on the ranch. He constructed stairs down to the living room and then painted everything crisp white.

It was a wonderful room. Only a couple of weeks before, it had been all bats and guano.

I introduced Ted Jones to his new quarters. The attic was an artist's garret with a north light. The only drawback was that the stairwell ran through the house.

For a moment I considered using the room temporarily for a studio, but I didn't think Jones would appreciate living amid the easels and oil paints.

Ted Jones seemed impressed with the new room and its antique woodburning stove. I had bought some pine beds, and Marian added decorative elements like pewter wall sconces and a braided rug.

Within minutes Ted had moved in. Everything he owned was in his truck.

With the living arrangements squared away, Ted and I planned our new business. I agreed to meet Ted the following week at the Tejon Ranch. We were going shopping. For a bull.

Tejon Ranch was a 20,000-acre monster spread halfway between L.A. and Paso Robles on the inland route. A hand-me-down from a Spanish land grant, the Tejon had the most of everything—from grapevines to cattle.

Tejon also had an impressive array of bulls for sale. Young ones and older ones. Big ones and bigger ones.

Ted and I wended through the lanes between the hefty bullpens. He scrutinized every animal with a professional eye. Sizing up each bull, Ted cocked his head slightly, smacked his lips in a curious way, and moved on to the next specimen. About every third bull he would spit decisively.

I followed, acting the part of a savvy cattle trader. At first glance the Hereford bulls looked as if they were all out of the same mold. But my bull had to service twenty or so heifers. We studied each one carefully for clues to his ultimate virility.

For Ted it was a serious process. I opted for aesthetics. Some bulls were glorious bruisers, emanating animal grace. A few behemoths, though their symmetry and balance were off, exhibited prodigious brawn. Others were simply works by Rodin.

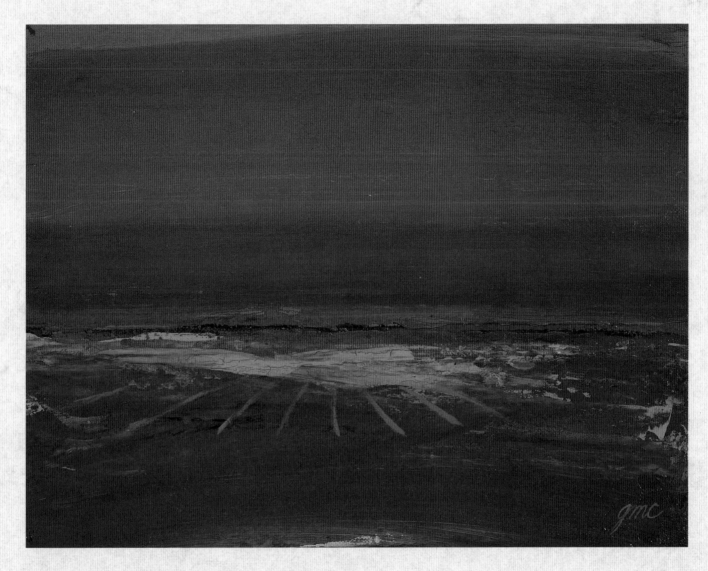

TEJON RANCH *Oil* 11" x 14" 1990

MOUNTAIN VINEYARD
Oil 8" x 14" 1991

One titan, massive as any bull in the yard, caught my eye. The face was fierce but intelligent. The body was a tower of strength but fluid. I suspected he had real sex appeal.

I tried to respect his dignity as I sized up his cojones. He was all bull.

Ted came back to join me. We silently appraised my bull. Ted took his time, but eventually turned to me. "You like him?"

I nodded.

"He's good for me."

There was something atavistic about selecting a bull. Some ancient intuition, the collective memory of remote forefathers who had made many such choices, took over.

Ted arranged to pick up the bull. He also made a deal to buy twenty heifers from my neighbor, Rudolph Wiebe. The cows only had to move from one field to the next, and once the bull was delivered, we were in business.

By this time, my *Burke's Law* days were over. In my actor-gypsy existence—the one where I earned my living—I had to find another series or it had to find me.

I did my share of guest starring roles, and then I was offered the lead in a new series for ABC called *Attack!* A very popular show, *Combat,* was ending its run, and the producer, Selig Seligman, wanted to continue with a program centered on the other side of World War II—the battle in the Pacific.

Arthur Hiller would direct. I was cast as the honcho, and my Marine platoon included Warren Oates, James Whitmore, and Dan O'Herlihy. ABC was filming the pilot on the island of Kauai for six weeks. This was a coveted getaway, but I was anxious about my cattle business. I wanted things to get off to a good start.

Ted Jones assured me that everything would be handled. I could go and play a gung-ho Marine. I wanted to play John Wayne in *Red River* here at the ranch.

Jones would hire a crew and erect the fence. Unsure we had discussed any fence, I was surprised at his $10,000 estimate. I sensed lurking costs. I was glad to be working.

I completed my well-paying tour of duty in the Pacific, grateful I had never been called to be a real combat soldier. I had done my Army stint after graduating from UCLA. But that was Fort Ord and a cushy job with my own Army radio show.

On the island of Kauai, with every whim attended to by a free-spending Hollywood film company, I still didn't like foxholes, insects that crawled faster than I could, and amphibious landings. I might be called spoiled. On the other hand, I could do the most menial work on my ranch and be a happy guy.

As soon as I returned from Hawaii, I headed for the ranch, flushed with excitement.

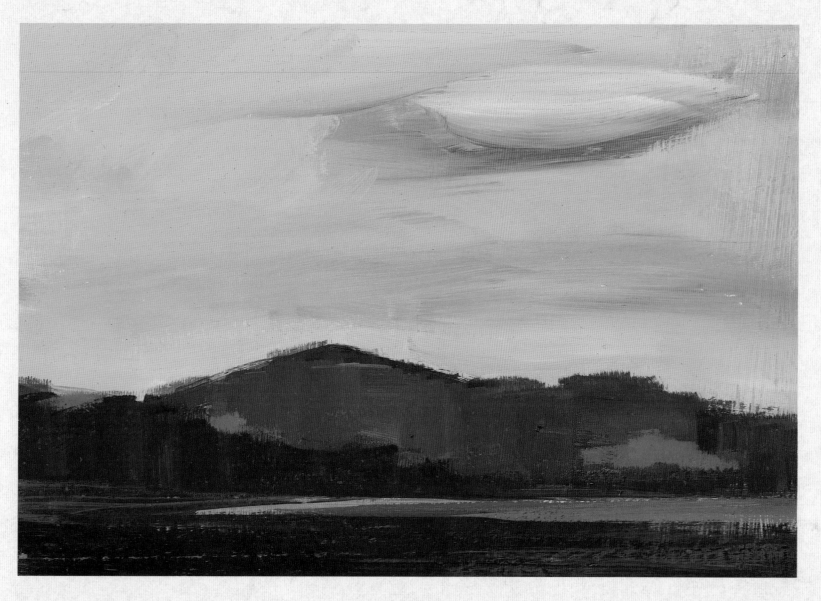

PASO ROBLES SUMMER *Oil* 7" x 10" 1992

The barbed wire fence along Chimney Rock Road was straight and evenly spaced, the wire glinting in the hot sun.

Best of all, twenty beautiful heifers were grazing on barley stubble. And one happy bull. It was a glorious sight.

They never stopped eating, and every pound they gained made money for me.

Jones met me on horseback. What a picture! This bona fide man of the West told me he had a surprise. He led me and his horse back to the barn.

And there he was. A rhone stallion. Well, not really a stallion, but a gelding beaut. His name was Tony. He was a seasoned cutting horse, and he was mine!

THREE

THE
ROUND-UP

ony and I became fast friends. He had the comforting quality of knowing what I wanted to do before I knew, an important attribute for any horse I would own.

I didn't look completely foolish on a horse. A few years earlier, I had taken riding lessons in Griffith Park for a movie called *Young Guns of Texas.* For several weeks in the desert outside of Tucson, I played a cowboy drifter in *Young Guns* with Mitchum, Ladd, and McRea—Jim Mitchum, Alana Ladd, and Jody McRea. Well, the movie at least had the real Chill Wills in it.

The whole show was on horseback. I was the lead, so I was always "leading" the pack. I got pretty good. Toward the end of filming I could actually refrain from saying "Oh, God, will I ever get this horse to stop?!" Some version of this prayer was usually voiced just before a halting pull-up at the camera focus mark. Of course, I expressed my fears without moving my lips. Later, on the dubbing stage, the appropriate dialogue would be inserted: "Get your guns out men, the Madding gang's set up an ambush on the other side of the rocks!"

Jones assumed that I would be secure on the back of an animal. Anyone who wanted to buy a ranch and raise cattle must be a natural in the saddle. So when he announced that we were going on a roundup, I presented the external manifestations of an excited ranchowner.

It was almost sunup. I followed Jones to the milk house, which he had converted into a small tack room. We readied our horses and saddled up. I learned not to ask Jones too many questions. He eased out information at his own pace.

He told me that Wiebe had phoned. Wiebe's herd had to be corralled because he wanted to sell a good number of them at the Templeton Stockyard. Neighbors were called on in such an event. An effective roundup took five men on horseback. There was a lot of ground to cover.

RED SKY #1 *Oil* 8" x 12" 1993

RED SKY #2 *Oil* 8" x 12" 1993

I mounted Tony. The horse knew something exciting was about to happen. The break of sunshine tempered the cold breath of man and beast. We moved up the hill toward Wiebe's, the keen scent of dewy grasses and musky herbs commingling with the leathery redolence of horse and saddle. The early morning sky was a wash of pale yellows, shades of lavender and wisps of pink.

I was Frederick Remington reincarnate, about to record the New West with paintings like the "Last Cowboy" and "The Dying Frontier." I would capture the organic beauty, the sombre peace…and sadness. But I balked at a vision of myself as the "western artist," sporting a turquoise bolo tie and hand-tooled boots, explaining mixed media at gallery previews in Tucson and Amarillo.

I returned to the embracing serenity. It whispered to me of a deep primal joy. This was man at his happiest…he and his horse working the land. Between my legs, Tony muscled powerfully up the slope.

Why had man become urbanized?

Then I saw him on the crest of the hill. My bull! He didn't seem to recognize me, and he damn well didn't consider me anything like a master.

I answered my own question. Man hightailed it to the city because he was fed up of being chased by bulls and any other wild beast that figured he was fair game.

Jones glanced back and wondered why I was stopping. I distrusted the grim, brooding expression on my bull. Outside of his pen, he looked like a menacing, four-legged tractor. I was reticent to ask if the bull was life-threatening. Such concerns seemed inappropriate.

There was not a hint of fear from Tony, so we moved on, making a wide arc around the bull. Jones couldn't care less, passing within a few feet of the bull. With this snorting monster loose in the pasture, I wouldn't be bounding up the hill on foot anymore.

And then, on a rise…the Wiebe gang. Horses and riders stood statue-still, a diffused silhouette backlit by the brilliant sky.

Real men meet on horseback. A nod of the head, a word or two, and everyone knew the plan. Except me. Fortunately, Tony was tuned in.

Jones and I fell in with Wiebe and two other leathery men. A pair of scrappy blue-eyed dogs—Australian shepherds—circled about the horses. The dogs knew the routine and were eager to show their stuff.

We started off. As we climbed a trail that led to the summit of Wiebe's property, Tony blended with the pack as if he had been in rehearsal.

Wiebe was descended, like Ramage, from original homesteaders. His family had obtained the ranch in the previous century. He and his father, and his grandfather before them, had made roundups like this for a hundred years.

Invited into this natural order, I savored an overwhelming sense of being rooted; I had found my people. I belonged with these men, though we would never converse about anything except horses and ranching. Discussions of the new breed of actors, abstract expressionism, or radical politics would never pass our chapped lips, and I didn't care.

As we neared the high point on Wiebe's land, I paused to absorb an unexpected view of my ranch. The long-sweeping pastures were gilded in newly-minted gold. In the distance, the oak-mantled Lucias drifted in a sea of mist.

Vibrant color and light redefined nature's immortal forms and begged to be painted. I was humbled, but I hoped I could be the artist for the occasion. The light was magically teasing, transforming this vista into a new work of art, still more splendid to the eye.

The men and horses were leaving. I packed up my imaginary paints and palette and resumed the serious work of the day.

Most of Wiebe's herd was gathered on a grassy knoll on the far side of the mountain. We rode closer, the Wiebe trio and Jones cordoning the cattle in a constant circling maneuver. The dogs worried the heels of the steers, tightening the pack.

Tony secured a position in the holding pattern. As we edged within spitting distance to the herd, they sensed that their bucolic days were coming to a close.

A steer bolted from the pack, then another. The wrangle was on for real. Horse, rider, steer, and dog…cut, thrust, and wove in some instinctual ballet. Tony, God bless him, charged into the fray with his own magnificent choreography.

I caught Jones's eye. I was holding my own…or at least holding on to my horse. It looked like the "boss" wouldn't make an ass of himself. Probably Jones and Tony had a pact.

The herd backed off from their getaway attempt. The two perpetual-motion Australian shepherds took control of the bovine assemblage. The dogs bit at every hoof in rapid fire until the herd was trampling down the draw toward the awaiting corrals.

But one steer took a last shot at freedom. And on my post. This guy was serious. He was the brain of the bunch. Number one: he knew the roundup meant curtains for him. Number two: he picked the weakest defender.

Tony rose to the occasion. He cut off the rampaging animal's desperate pass. After a few feints and parries, Tony had his beast at bay. The steer's liberty dash foiled, he turned back to his comrades and their inescapable fate.

The herd picked up speed as it thundered down the mountain. It was a heady ride. Secure on Tony, I began to assert some control, a wild cowboy hellbent for leather.

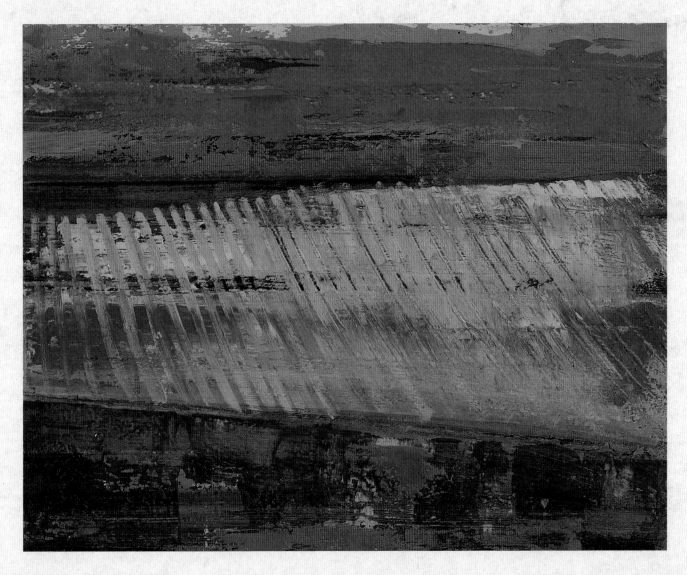

VINEYARD AT SUNSET *Oil* 11" x 14" 1992

I arrived back at the homestead on a Wild West jag. This was big John Wayne returning from the badlands. When Marian met me at the back door, big John Wayne had to take off his muddy boots—the floor had just been mopped.

Marian also needed immediate assistance in flower arranging and making a bed for arriving guests. My moment of cowboy glory was over.

Well, not quite…

FOUR

THE
BRANDING

HARVEST SEASON
Oil 8" x 5" 1994

The rugged West remained my idée fixe, but I needed an image adjustment. John Wayne was fun for roundups, but day-to-day the ranch had to be run by Roy Rogers and Dale Evans for my fantasy ranch to work.

While I rode the range each weekend, Marian ran the chuck wagon. When a man's been cow punchin' most of a day, he'll eat anything that isn't moving. Marian had her hands full slinging grub. She also had her hands full with everything else.

We lived and learned that an old, old house and lots of acres exact a load of work just to stay even. Soon after I bought the property, a farmer advised me that "the land can really whip ya." The old codger's words became annoyingly prophetic.

Each trip to the ranch had its minor crisis. The weekend agenda might be to paint at least one side of the barn, but no…the water heater blows up. Mineral well water eats up hot water heaters faster than rabbits breed under a farmhouse.

So while I tended the cattle, Marian got to locate a new hot water tank, schedule a plumber (more like begging), heat tubs of water on the stove to wash dishes, and—the big kick for the weekend—take cold showers.

The allure of country life under these conditions wanes. Trekking into town and spending half a day shopping saddles is fine. Squandering a weekend hunting down water heaters, ecology-correct rat bait, and obsolete electrical outlets can make a person pine for the city life.

Even Jones sensed Marian's need to be roped back into the romance. He suggested that we invite the neighbors to our first branding and celebrate with an outdoor potluck barbecue.

Except for a few gruff men who rode over to help with cattle chores, Marian wouldn't know a neighbor if bitten by one. Being naturally gregarious and instinctively neighborly, she embraced the barbecue idea with enthusiasm. But she insisted that she would prepare and cook everything.

Marian 1970

Jones stressed that the womenfolk were happy to pitch in with their favorite dishes, but Marian would hear none of it. If there's a little martyrdom in the city bones, it takes a few years of farm life to lose it.

Even though the branding was several months away, Marian began to prepare the menu. In fact, arrangements for the event preoccupied her. Proper tableware was essential; paper plates were out. We had to begin to think about a seating plan.

I tried to talk her out of invitations. In the country, I figured, word just leaks out naturally.

We no longer had time to fix the things that broke between trips; we had to get ready for guests. We'd bought the spread in the first place to be with friends and neighbors and to entertain at our ranch house. Now we were stuck with it.

Around this time Marian learned she was pregnant with our second child. She wanted more time up at the ranch with virgin air and an unspoiled environment.

Our cattle were fattening by leaps and bounds; I saw big dollar signs out in the pasture. In fact, the cattle were whoppers. Natural grazing, in combination with the additional feed and supplements that Jones provided, was doing the trick.

Jones pointed out that they were gaining so much weight because most of the cows were pregnant. In fact, some were close to dropping their calves.

I was surprised but elated. I was also impressed. I glanced up at the bull, always poised on the high ground, and tipped my hat. My pal, the bull, had a hell of a technique.

He was also a loner. When did he make his play day or night? He certainly was discreet.

The whole ranch was pregnant. Fertile land and fertile studs, the place was pregnancy central. We all did our part in nature's grand design.

The branding was a critical juncture. It forced Marian and me to think of the ranch in a social way. Up to now, it had been a constant fixer-upper. In our Los Angeles house I never fixed a thing. I never had time. I always came home from the studio too late to do anything but learn lines for the next day. But in lotus land, I could patch, mend and repair to my heart's content.

A branding is an outdoor event, of course, so we had to get serious about our yard. Several acres of yard. I needed help.

John Westerdoll was a friend from UCLA days. John, who for some inexplicable reason preferred to be called Oscar, was a landscape designer and had been dying to visit the ranch. It was time to recruit his help in planting a lawn and starting some flower beds and ornamentals.

Oscar was more than eager. He offered to put in three weeks and really transform the grounds. I had been avoiding spending the bucks, but I had to hire some expertise.

Oscar traveled up with us, discussing the landscape plan and the costs. He would also oversee a facelift on the farmhouse, resurrecting the sagging porch in particular.

Oscar was up front about his alternative sexual orientation. In fact, he boasted about several alternatives. I was apprehensive about he and Jones hitting it off, especially since Oscar would be Jones's housemate for a few weeks.

Jones didn't blink. With the parade of actors and other Hollywood folk that had passed through the ranch, Jones was apparently immune. Jones's criterion for maleness was uncomplicated; just carry your weight at work. Oscar more than fit that bill. He was strong and tireless, and he was a walking horticultural encyclopedia.

Oscar started right away. His landscape plan was striking, with an eye to keeping things indigenous and natural looking.

This project would cost a bundle, but it would be worth it. I had poured money into the cattle program. That was going great guns. Time to start making the place presentable.

Well, my cattle program was going great guns until one night Jones called. He'd found two of the heifers dead, along with their calves-to-be. One had stumbled into a ravine during a rainstorm. The other death was a mystery. The vet was coming out to check the cow for anything unusual.

I was afraid to ask the next question. Was there a disease that could wipe out an entire herd? I wasn't ready for that answer, so I asked how Oscar was doing. Jones assured me he was a hell of worker and had things "spruced up real good."

VINEYARD ROAD *Oil* 11" x 14" 1993

52

I didn't have the heart to mention the death of the two mother cows to Marian. She was bound to take it personally.

At least the landscape project was "ridin' tall in the saddle." I was ridin' high too. Oscar had ordered more than two hundred trees…pines, firs, sycamores, and trees and shrubs I didn't recognize. He had started a fruit orchard and had created a new sweeping driveway. The house had been painted, and he'd added Georgian-like columns to the porch. He'd christened the place "Tara," in honor of Marian's Southern roots.

I was impressed, until Oscar handed me the bill. He'd gotten carried away, he admitted, insisting the scope of the ranch demanded no less.

Jones also presented some unexpected bills. The vet had inoculated the entire herd with some concoction, and I also got news of a third cow death, probably attacked by a wild boar.

Jones further trampled my sinking spirits: cattle prices were down, and it would be a good idea to hold on to the cattle until prices picked up again. He declined to predict when that would happen. He did predict that we would need a lot more feed.

To say prices had "slumped" was putting it mildly. The cattle were actually worth less than when I'd started out.

How could prices dive so drastically? Jones explained that cattle prices are a commodity. I thought he was saying comedy, but I wasn't laughing. On the other hand, he pointed out with his other hand, sometimes you make a lot when prices shoot up. Jones's lessons on farm economics always seemed to come after the fact.

My branding party was turning into a wake. Jones was going to pen up most of the cows and feed them alfalfa hay. He showed me a mini-feedlot he was constructing and tossed in the lumber bill, along with a stack of charges for a few truckloads of hay.

The one thing working smoothly at the ranch was the Oscar/Jones relationship. Oscar was helping out Jones with some new fencing, and he had some clever suggestions on the expandable cattle pens and sorting gates. He was also assisting Jones on the squeeze chute that we needed for the branding.

In turn, Jones had introduced Oscar to an unexpected nightlife in the Paso Robles bars and card parlors. Oscar, a great lover of yachting, opera, ballet, and theatre, reveled in the culture shock of Paso Robles.

Branding day was coming fast. Marian, pregnancy now showing, ventured out to unlikely places for all the things needed to make a ranch guest-friendly. She found stainless steel mess hall trays at the army surplus store. Quite a kick at the ranch. Practical too. We discovered appropriate flatware at the Sports Chalet. Marian uncovered a buy on wooden stacking chairs that were actually comfortable.

Every weekend, our station wagon was stuffed to the gills, and an extra carload on our roof rack. Rear window visibility was rare. Little by little, trip by trip, the ranch of our dreams took shape.

My painting studio, however, was not taking shape. I wasn't even a Sunday painter. My Sundays were devoted to the ranch.

Oscar had to wrap things up, he had a big landscape job in L.A. Things weren't quite finished, but I was way over budget anyway. Actually, it was hard to say budget with a straight face.

Everything was a first time experience, and there was always a chasm between vision and checkbook. Oscar and Jones were earnest, but little things they overlooked added up big. Then again, projects at a ranch are inevitably superscale, and there is no practical guide to ranch budgeting. I coughed up a dry laugh when Jones, in a rare moment of wit, revealed how to make a little fortune in ranching: "Start with a big fortune."

I lacked a big fortune, and also a little one. With only a kitty from acting and residuals, I began to worry. I had committed my heart. Dangerous. I had a ranch and a mortgage. A herd of Herefords and a herd of expenses. I had something between Tara and Old McDonald's Farm. I could seat fifty guests on the lawn, each with his own tray, but I couldn't fit a dishwasher in the kitchen.

The day came. The neighbors arrived. Men on horseback ready for the branding. Women, ignoring the stern warning on the invitation, bearing food and gifts. Bright-faced kids scrambling in every direction searching for frogs and any other little ranch creature.

We had bought a man-size barbecue for the event. Assembled outside on the lawn, it looked puny.

Jones saved the day by towing in a Santa Maria barbecue, an outdoor cooking monster that dwarfed his truck and had room enough to roast a side of beef and a few suckling pigs for hors d'oeuvres. He stoked it with oak logs and packed the tray with a brood of chickens and some tri-tip steaks. Oscar pitched in with his "killer canapes." My parents had come up to double for servants.

Marian surprised me with a "Kiss my Grits" apron; Oscar crowned me with a chef's hat. I was in appropriate attire until I mounted my horse with the other men of the West to round up the cattle for the branding.

All the calves were crowded into the pen. I felt like a proud father as we sorted the feisty little males from the females.

As Jones and a few other men directed the calves into the loading chute, I checked to see how Marian was coming with our lunch alfresco.

Marian reigned over a fête champêtre. She had pulled out all stops and her most intriguing recipes. Along with Oscar's ginger scallops in lettuce leaves, Marian served her potato, leek, and cheese souffle for starters. Mouths agape, the neighbor ladies stood by, clutching their canned peaches and pears as Marian dazzled with cuisine magic.

Marian asked me to carve the chickens and slice the tri-tip for her next production, something like a poulet with persimmon sauce and chopped tri-tip on garlic toast, but I insisted, much to the annoyance of Marian, that everyone gather around the squeeze chute for our main attraction.

Jones had the first calf in the chute. As everyone pushed close, Jones presented me with my personal branding iron. It was a special moment.

Oscar

There was my seal: C/C, a work of the ironsmith's art.

In rapid succession, as we were sucking on our souffle, the "precious little calves" were locked into the squeeze chute. Without missing a beat, testicle sacks were peeled away, and with the brandishing of a mean-looking pincer, castration commenced in front of our bulging eyes.

"Changes his mind from ass to grass," chortled one of the ropers as he pitched testicles into a bucket. The empty scrotums were swabbed with some vile-smelling solution, and the calves' ears were cut for easier identification on the range. Writhing in agony, the calves were treated with my beautiful branding iron. Smoke rising in the brander's face, my monogram seared flesh.

If that were not enough, a big syringe vaccinated each animal with multiple jabs, followed by a drenching gun shoved up the rectum for parasite removal.

I turned to see Marian retreating to her banquet. I was drawn back to the spectacle. Jones snipped off one of the young heifer's teats with a sharp pair of scissors.

My hand went to my breast, then I too retracted from the mutilation extravaganza. I had no more appetite, especially when the bucket of skinned testicles, "good ol' mountain oysters," was dumped onto the grill. My parents were queasy, and Marian, in the middle of her tri-tip dish, skipped the course entirely.

A month after this featured event, my son, Gareth, was born. Thank God he wasn't a calf. Marian had her hands full with two children, and her enthusiasm for the ranch, such as it was, dropped off. How could I fault her?

Any residual excitement about being "ranch barons" had worn away. We never had time for any weekend diversions because we always had to be at the ranch.

Marian had the good sense not to rub in the failure of my cattle program. Prices never recovered. Ted Jones was having a great time—after all, he got to stay at the ranch every day. I had to stay close to my home. With two kids to feed and twenty calves, I was anxious to nail down another television series.

Something about paying a salary to someone else every week and not receiving any myself ate at me. I was collecting unemployment and paying Jones. It didn't feel right, and it was hard to explain at the unemployment office.

Also, at this time, Marian and I were becoming health-store variety vegetarians. Marian had gotten on the jag while nursing Gareth. We were convinced that meat, especially the force-fattened steer variety, wasn't very healthy. What was I doing raising the stuff? It would be different if I were making money at it, and not a vegetarian Hollywood cattleman who was losing his hairshirt.

I found the aesthetics of a cattle program wanting. I preferred seeing my land in a farming tapestry, with ever-changing hues and textures. First, the autumn plowing would overpaint the vast canvas with rich umbers and sepias. With spring, the fields and everything else would turn a miraculous green, challenging the electric blue of the sky as the purest, cleanest color on earth. Summer brings the richest hue: pure gold, sun burnished, spilling over the barley fields.

With cattle, the pastures are not plowed and seeded, and the tones are somber. The farming process seems to rejuvenate everything, painting the landscape from the brightest palette.

My concern about painting such moods was confined to my mind for the most part. The little work I accomplished in my cramped L.A. studio was primarily about the human figure.

I kept my drawing fingers in shape by attending evening sketch classes with a live model.

FIGURE DRAWINGS
Acrylic Wash and Charcoal on Board
12" x 8" 9" x 12"
1968

I envisioned a time when things would settle down enough at the ranch to have nude models posing under the oaks and in the wildflowered hills. I would invite fellow artists, armed with sketch pads, pencils, and inks to join me in drawing "en plein air!"

There would be that time…

FIVE

ARTIST
FARMER

ATTIC WINDOW *Oil* 10" X 11" 1994

I called Jones to tell him I wanted to sell my herd, regardless of the price. It was not a good day. He told me he had another job even before I started to hem and haw. He knew I was at the end of my lasso. A lot of hot shots plunge into the cattle business and then want the hell out of the bottomless dry well. Jones had a parting joke on the subject. It was about the cattleman who won the lottery. His friend asked him how in the world could he spend all that money. "Easy," the cattleman replied, "I'll keep raisin' cattle."

Jones could move his one truckload on to the next roundup as easily as he'd come to this one.

Next time I went to the ranch, I was alone. Marian, or family, or friends, had always been along. Now it was just me and open space. The cool cleaning winds had a melancholy voice.

I went up to the attic. Jones had left it tidy, not a scrap of his was left behind, although a faint aroma of his drugstore cologne wafted through the bathroom.

At the window bay, I admired my cousin John's craftsmanship, especially his clever use of old barn wood for the window mouldings. They looked as if they'd been installed a hundred years ago.

My eyes took in the fields stretching into the dense oak forests. Everything seemed deserted of living things.

I glanced at the corrals. One gate swung back and forth in the last of the afternoon breezes. The creaking hinge was the loudest sound on the ranch.

Down in the living room, I stared out toward the Santa Lucias shimmering faintly as the sun slid behind an avalanche of clouds sweeping down from Big Sur.

I marveled at the paintbox of this sunset masterpiece, mind-matching the celestial hues with my own palette—here was the madder violet I favored, and the Wedgwood blue, also a brilliant cadmium orange, and a subtle tea rose fusing into Venetian red. I couldn't keep up, intimidated by Nature's virtuosity as a colorist.

SUNDOWN

Oil 7" x 11" 1992

But I was game to try. One problem: my paintbox was many miles south. Mother Nature wouldn't wait, she had the deep-tone colors of the night to display now, by God.

The evening settled swiftly. I gathered logs for a fire. It would be a cold night. Cold and lonely.

I didn't feel like running into town and eating alone at Wilson's. I rummaged through the refrigerator and the pantry. Peanut butter and anchovies. Corn flakes and canned orange juice. Raspberry jam. The milk in the refrigerator had soured.

I filled my bowl. I saw tints of the sunset. I knew I could paint that color frenzy, but I had no future as a chef.

After dessert—a half jar of candied ginger—I turned on the television. The single channel we received at this end of the rainbow had a rerun of *Bonanza*. I didn't want to torture myself.

Cold air from outside crept through invisible cracks that seemed to be everywhere. We never solved the insulation problem. The house was built panel against panel, without post and stud construction, leaving no room to install the stuff.

I was drawn back to the fire. Any feeling I had for the place was suddenly sucked out of me. Why this "return to the soil?" Why in hell was I out in the boondocks trying to keep warm? I could be at a party in L.A., playing it for laughs with actors and writers, and maybe impressing a producer with my ideal suitability for his next project. Would any of my Paso Robles neighbors, if I knew where they lived, trade places with me?

The ranch had turned seedy again—and almost overnight. The pastures were a tired, arid brown. The grazing cattle, probably over-grazing, had made shaggy, unkempt stubble of the wild grasses.

A hairy, barbed thistle, impossible to touch, was flourishing everywhere on the ranch. With my luck, if this godawful plant was discovered to cure baldness, it would die out instantly.

From day one, I labored under self-delusion. I was going to build my ranch studio and paint wonderful landscapes. Why was I never compelled to pack my paints and canvas up here? Hell, not even a pencil and a drawing pad. I had been kidding myself mercilessly.

I beat myself to a pulp. The fire was low. I had no desire to go out on the porch and drag in more logs.

"The land can really whip ya." That harebrained farmer. I remembered an expression from Shakespeare. From Macbeth. Just my fate. "Here's a farmer that hanged himself on the expectation of plenty."

Paradise Lost 1969

I threw a blanket on my bed and slipped between frigid sheets. My father had given me a couple of books for the ranch. I felt like reading myself to sleep.

The most wonderful thing in the world for my father was a book. With his master's degrees in English, literature, and history, his ideal vacation was to spend all his time in a library.

My parents had unhesitatingly helped me in the down payment for the ranch. Their son, J. Paul Getty, had sunk a small fortune in the cattle business. It would be a while before I could repay the debt, unless I found a market for the thistle.

From what side of my family had I inherited the farming chromosomes? My father, John Carmody, was pure Irish. His mother and father were Boston physicians, but my father's grandfather on his mother's side, Pat Conway, had a farm in the Berkshires in Western Massachusetts.

I'd taken my "acting" name from this farmer Conway. Back as a young UCLA art major, fairly serious about becoming a painter, I was offered the lead in *I Was a Teenage Frankenstein* (about a kid who loses a few body parts). Being known as the "Teenage Frankenstein" was inconsistent with my teenage Van Gogh self-image. Then again, Van Gogh did lose an ear.

So I changed my name from Carmody to Conway, borrowing from the farming branch of the family tree. Along with the name, a love of farming was part of the same package deal.

Pat Conway had come to the United States during the potato famines, a farmer who couldn't raise potatoes. Maybe that was my problem.

My mother's family were immigrants too, from Sicily. My grandfather, Angelo Monello, was no farmer. A union organizer and a political outlaw in a fascist cauldron, he was kicked out of Sicily as a very young man, and sailed to America. Angelo was followed to the United States by my grandmother, Rosa, who fled the clutches of a prearranged marriage.

After trekking for months through Europe and stowing away on a steamship, Rosa was apprehended by surrogates of her very wealthy, much older husband just as she was disembarking into the arms of Angelo, her real and only love.

Back in Sicily she was jailed. My grandfather toiled ceaselessly for two more years, sending her money so she could escape again. This time she made it.

No farmers, these Sicilians, but they had the grit to pick up their lives and seek greener pastures.

About to turn off the light, I noticed that my father had added several pages of notes on Ignace Paderewski along with the books. The curious fact that this world renowned pianist had planted a vineyard on the west side of Paso Robles at the beginning of the century intrigued my father, and he jumped into a self-assigned research project. He combed his favorite libraries for anything to do with Paderewski.

My father intuited that I needed support in my quixotic adventure. He was rooting for me to succeed, although neither of us knew exactly what I was trying to succeed at.

So he plunged into the saga of Paderewski, uncovering underlying life values to reinforce his son's self-appointed quest, his son the castle-builder of the Central Coast. I loved my father deeply for never trying to talk me down off of my clouds.

My father had boldly underlined the words artist-farmer. This hit home—it was a term to describe the essence of Paderewski. My father further underlined: almost super-natural artist, yet a simple man of the earth. Artist-farmer…man of the earth…my father knew.

The epic of Paderewski is a story, movie, and (God forbid) TV series enough for two great men.

Born in Russian-occupied Poland in 1860, Paderewski was driven very early by music. Like myself (my dear father helpfully pointed out), he knew from the first moments of life that he must be an artist.

NIGHT *Oil* 10" x 11" 1992

There was another side of Paderewski, created out of his mother's tragic death soon after his birth, and the imprisonment of his father by invading Cossacks. These forever haunting memories would mold the future statesman.

His father arranged for whatever few music teachers were available in the country provinces where the family lived. The child's early training was haphazard; in fact his first music teacher, when Paderewski was six, was an itinerant violinist who knew little about the piano. (My father was quick to note that I had studied the violin at a very early age, and, paradoxically, my first teacher was a pianist.) The boy's prodigious talent would not be denied. At age twelve, he was sent off to the Conservatory in Warsaw, leaving home for the first time, leaving his beloved father and sister.

Even though this was another era, another society, I identified with this youth Paderewski. I, too, had committed myself to art at an early age. Devoted to painting, I had been encouraged by my family and my teachers. While still in high school, I was granted a scholarship to Otis Art Institute in Los Angeles. I attended high school in the mornings only, freeing the afternoons for exciting art classes at Otis. I felt this Paderewski in my being.

At sixteen, Paderewski convinced a violinist pal that it was time to launch their public careers. There was one hitch. The Conservatory forbade their students to perform in public. Should stupid rules stand in their way? The boys confidently assumed the tasks of being their own road managers, booking agents, and financial advisors.

Into the Polish countryside they set forth, into Russia, down into Romania. At sixteen, perhaps the Russian winters aren't so desperate; the cheap taverns not so miserable; the primitive wagons less wretched. Living on tea and bread for weeks at a time is a small price for a sixteen-year-old to pay when he's proving to the world that he is a concert pianist.

The madcap adventure was ultimately discovered, and the Warsaw Conservatory wasn't forgiving at first. But the Conservatory could administer no punishment equal to the deprivations the two boys had suffered for the music of their dual concert tour.

Bravo, Paderewski! Dedicated to a tenacious artist ideal even before he was shaving. His creative power and energy were still relevant and alive.

I glanced at my watch on the night stand…two o'clock. It was hauntingly quiet and dark under the still-glowing star of the young Paderewski.

I turned out the light, consumed with the notion that I was connected with Paderewski in a real way. In the night stillness, thoughts of reincarnation, transmigration, and metamorphosis enveloped me. It was better than counting sheep…or cattle…

The next thing I knew I was entering a stage. The audience seemed infinite, and I wasn't sure whether the theatre was outdoors or if I was inside a spacious auditorium.

I spotted my parents in the front row. I couldn't catch their attention. Somebody who looked like Ted Jones was sitting close to them. I saw other familiar faces too.

The lighting was odd, as if the audience area and stage were candlelit. For no understandable reason, the restless audience paid little attention to the stage.

A young boy at a piano looked toward me as I made an agonizingly slow entrance. At my next step, I realized that I held a violin under my arm.

Was I scheduled to perform? Perform what? I hadn't practiced seriously in years.

The boy at the piano seemed to be playing something. The music was familiar. I glimpsed Marian in the wings, looking confidently at me. I had no idea what I was expected to play. In fact, there was no violin piece that I felt secure with in front of an audience.

The boy was now performing a spellbinding polonaise. Several more musicians were positioned around the stage. They were all playing.

This would be my chance. I tucked the violin under my chin. I played along, faking it, and no one could tell the difference. It all became very easy. I had the fingers of Paganini, in fact I was actually playing a caprice by Paganini. Whatever I was doing, I was showing off.

Then I noticed a row of judges perched in the front. They were caught up in my fiddling. I had it made now. To what end, I wasn't sure. I think the recital had something to do with earning a scholarship to music school.

The boy at the piano began to take bows to a thunderous ovation. He looked at me with the most intense gaze I had ever seen. I tried to reach him, but everything faded.

Sunlight streamed through the window as I opened my eyes. It took a moment to orient myself. I was alone at the ranch…and it was morning.

My father's papers on Paderewski were on top of the blankets, a few scattered on the floor. I worked my way out of bed and gathered the pages, tucking them between my father's books.

The dream flashed brightly in my consciousness. I forced myself to recall its details. I remembered playing the violin in front of a large outdoor audience. How odd.

In my dream, I seemed to have traveled back to my early teen years at Mt. Vernon Junior High School. I had played violin in the junior high orchestra. We had won first place in the state championship. While still in junior high, I was chosen to play at the Hollywood Bowl with the all-city high school orchestra, an overwhelming experience for a fourteen-year-old boy.

The story of Paderewski's first tour overtook me. Such amazing confidence and artistic courage at that age is what genius is made of.

I slipped into my pants and shoes and went out the back door. The skies were suddenly overcast. A storm gathered over the Santa Lucias. Swirling gusts of wind played in the fields, kicking up little clouds of dust. Everything began to smell like damp hay.

My eyes lifted to the drama of the sky, dark brooding colors reflected my defeat. With the constant work that had gone into the ranch, the endless trips, the money, not much had actually changed.

A tumbleweed—an actual goddamned tumbleweed—rolled by the driveway. It taunted me. The tumbleweed—the symbol of ghost towns and my present state of mind—tangled in a stand of that awful prickly thistle. They deserved each other.

Then I noticed the thistle had blooms on it. A soft blue-purple flower that I begrudgingly admitted was rather striking. Well, at least something was blooming.

I walked listlessly. The water tank was leaning and dripping. The sagging barn looked worn out, ready to be cast to the winds. Jones's newly built corrals were already swaying and weather-beaten, weeds were pushing up aggressively. I decided to quit ruining my day and started back to the kitchen.

I spied fruit up in the old pear tree. I jumped and grabbed a branch, bent it down, reached a big pear that looked good and ripe, and plucked it for my breakfast—orange juice over sliced pears, topped off with the last of the corn flakes.

Sitting at the breakfast table, I was drawn back to my father's notes. He had stapled a few papers together and headlined them: GREAT MOVIE SCRIPT!

After I became a television and movie actor, my father developed an interest in motion pictures. A sensitive writer, he concentrated on poetry most of his life. Now he saw stories in terms of "scripts." He titled this one *Tragic Muse*.

During the final months of Paderewski's senior year at the Conservatory, he became intrigued by a new student at the school, a bright-eyed girl who happened to have the same name as his sister, Antonina. The passionate young man at the core of Paderewski fell in love, at the age when falling in love has its most heart-wrenching reality.

Antonina not only adored Paderewski, she had unswerving faith in his musical genius. She clearly envisioned his profound destiny, a glorious future they would share, forever bonded by their love.

With the pittance of half a ruble per hour at the Conservatory, and Paderewski's slim hope of earnings as a composer, the couple became man and wife. With Antonina's encouragement, the young husband centered upon his musical goals. Teaching each day, he composed and practiced his piano most of the night, tirelessly supported by his artist partner.

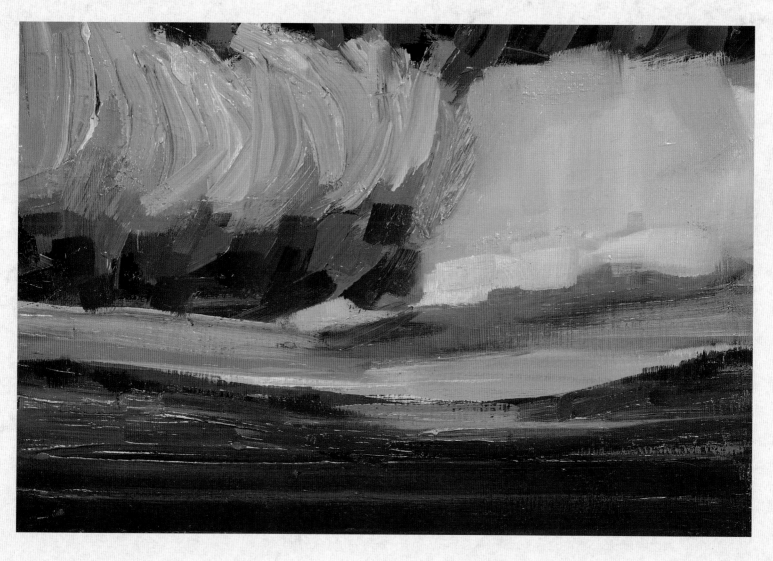

STORM FROM THE COAST *Oil* 8" x 11" 1993

A few months after the marriage, Antonina announced that Paderewski would be a father. Could anything be more joyous? Quartered in one cramped room, they were living in a cloud-castle.

Antonina's parents were more practical. Desiring earthbound guarantees for their grandchild, they presented their daughter with a dowry for her first baby.

Paderewski and Antonina anticipated the birth of their child as they would the arrival of a divine creation. But, like the last chord of a thunderous symphony, everything came to a stunning finale for Paderewski. Antonina became seriously ill. With horrifying irony, she drew her last breath exactly at the moment of birth.

Lovely Antonina, so pure of heart, had only enough life to bring her son into the world and to command her grief-stricken husband to use their son's dowry to pursue his studies with new resolve.

With the last flicker of life, she repeated her steadfast belief in Paderewski, her only love for all eternity: "My dearest Ignace, you are a true genius. You must swear to me that you'll now study with the best teachers in the world. When you are the great success I know you will be, you'll repay our wonderful son many times over."

Antonina made him vow that he would do her will. And then she died in his arms...

I could not continue. I rarely cried, but salty tears stung my eyes. How could young Paderewski bear such a devastating loss? How could he go on? But, of course, he had a little son to think about.

The pathos of my spirit-neighbor's last moments with his young dying wife dragged me into lower depths. It was somehow easy to transfer this sadness to my own crushed dreams of a home on the range.

I wallowed for a while, but why go off the deep end so early in the morning? I considered my own family. No man should be mortally shattered if he has a beautiful and healthy wife and children. Working my way back from despondency, I went for the phone and dialed Marian.

I wanted to reveal to her the real meaning of existence, but before I could express my epiphany, she interrupted. I hadn't called as I had promised. She had tried to reach me all night and into the morning, but the phone had been busy. She was angry. She was so worried, and I was so thoughtless. And selfish.

I launched into my comeback, but I heard boots on the porch, startling me. A man stood at the back door. "Gary? Is that you?"

I muttered the obvious. It was my neighbor, Rudolph Wiebe. I motioned him in.

Marian had hung up, or the phone was dead. A strange noise buzzed on the line.

Wiebe entered the kitchen, taking note of my teary eyes. He asked how I had been. I answered with the customary "O.K." He clued me in about the busy phone. His line was also out of order. Once in a while he could call out, but no calls could come in.

I started to offer Wiebe something to eat, but he probably wouldn't care much for pears and orange juice. So we awkwardly sat down at the table.

Wiebe got to the point. He asked what I was going to do now that I had sold all of my cattle.

I wasn't sure. I could just imagine what this old farmer thought about my cattle venture. Big cattle baron one day, crying at the kitchen table the next.

Wiebe proposed that he farm the ranch. He offered me one third of the crop proceeds, the typical farmer-owner split. Wiebe had been farming this place for fifty years. He farmed with an innate sense of aesthetics. Neat and tidy. It was something to be admired.

I agreed to give his offer serious thought, and I told him I was reassessing my relationship with the ranch. Wiebe appraised me with a blank look, wondering what I meant, and if it had anything to do with farming. I wasn't sure either.

I asked if Wiebe had ever heard of Paderewski. He pondered for a moment. Did I mean that "piano playin' fella?"

I said Paderewski was one of the world's greatest pianists, if not the greatest. Then it struck me: Wiebe had probably been alive when Paderewski first came to Adelaida. He could well have heard him play at the former Paso Robles Spa.

Wiebe knew enough of Paderewski to tell me precisely where his vineyard had been. I was excited. It had never occurred to me to ask one of my neighbors for the exact location of Rancho San Ignacio.

Paderewski's vineyard was an accumulation of acreage between Peachy Canyon and Adelaida Road. I unfolded a county map at the kitchen table. Wiebe pinpointed the area, and I traced it with a pencil.

A surprise of thunder rumbled outside. It had grown dark.

"Storm's comin'."

Wiebe motioned out the window. The sky seethed with inky blue clouds.

"I better hit the road." I had to be down in L.A. to interview that afternoon for a television series, *Long Hot Summer.* Twentieth Century Fox was producing a TV version of the popular motion picture. They wanted me for the lead.

I dreaded getting caught in some hard driving rain, and then going straight into the producer's office looking half drowned.

It would be best to explore the Paderewski vineyard on the next trip. It would take some time. I wanted to have my camera, if not my easel and paints.

I said good-bye to Wiebe and promised to get back with my decision. I had no idea what that decision would be.

I had lost something over the weekend—my dream of a shining little utopia. I was fiddling a new tune.

SIX

CRIME AND
PARADISE

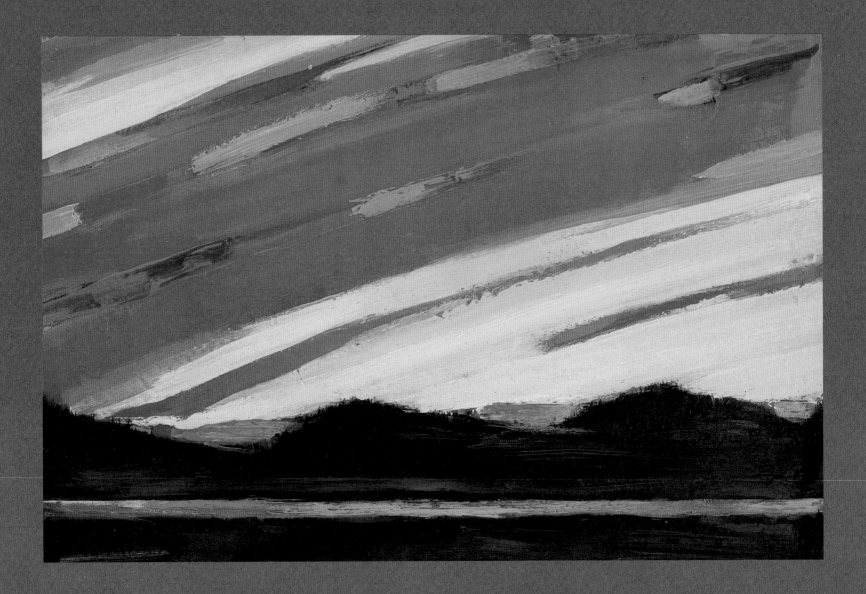

*B*efore *our* next trip north, I made a momentous decision: I promised to change into a rational person in regard to Paso Robles. No more passionate weed-defoliator, quixotic road-builder, or manic plumb-bobber—straightening the barn for the hundredth time. Normal, well-adjusted folks browse the Cambria galleries, take the tour at Hearst Castle, motor up Route 1 and lunch at the Ventana Inn, a spectacular crow's nest at the Big Sur headlands. We would become "howzit goin' neighbors," inviting our across-the-fields friends over for some "hog jowl and turnip greens" (no more gourmet branding dinners).

We were long overdue for an Archie Hansen invite, hardly having seen him or Mary since the crash landing. I'd never found out whether he'd fitted his helicopter pieces back together again.

But the guest list came to a screeching halt with Archie. Inviting the Wiebes seemed a stretch. What would Wiebe and I talk about all evening?

As I chewed that over, Marian reminded me that I was the great tractor-jockeying farm lover, and surely Wiebe would carry on a very informative confab about farming. Marian added that Wiebe actually made an honest-to-God living from farming. The observation was food for thought, a full meal. To suit up in bib-denims is to gain an appreciation of the modern day-in day-out farmer's travails.

I assured Marian that I was psychologically ready for the transition to normal person. I even convinced myself. Studio or no studio, I vowed I would finally do a little painting at the ranch. This adventure was to be about capturing the great outdoors on canvas, exploring the land and the light like a nouveau French Impressionist. Renoir on the range!

I might even take up my violin and practice at night, after my plein air light waned. Not only were the Adelaida colors and earth shapes so nurturing, the pure sounds of nature called to the spirit of the music maker.

SKIES OVER CAMBRIA *Oil* 12" x 19" 1993

"We'll train for the Olympics too!" We reached for the sky with fever-pitched exhilaration. Marian and I had recently started jogging for heart and soul, but running in the infamous L.A. smog was a lung-buster. In Adelaida we could run Chimney Rock Road and inhale California's purest air. We also decided to buy ten-speed bikes. All gentle hills and curves—a feast for the eye at every turn—the roads were everything a biker could wish for.

Idyllic days devoted to art, music, and an Olympian physical regimen. Then, in the early evening, a lazy ride to Cambria to catch the cosmic sunset on the Highway 46 summit. As the last moments of dusk coruscated over the Santa Lucias, we would wend our way into Cambria village. In the quaintest seaside restaurant, we would ponder the wine-dark waters and the catch of the day.

Marian reminded me that I would be practicing violin at night. I was sure we could work it all in. Motoring expectantly toward this glorious weekend, I was a born-again normal country boy!

The FM station was playing lilting bagpipe music. Inspired by the ethereal, haunting strains, I announced that I must take up the bagpipe in my land of art and bliss! "Follow every creative urge" was my new motto! Marian reminded me of the definition of a true gentleman: "A man who can play the bagpipe and doesn't."

Undaunted, I proclaimed the ranch a cultural, physical fitness, and spiritual retreat. A return to paradise. A Grecian ideal…Mt. Olympus. Valhalla.

The tone of Marian's voice indicated that, to her, our slap-happy land was shaping into a romantic getaway. She was hooked now!

Paso Robles's first supermarket had just opened. We stocked up for the long weekend at this new, gleaming Safeway. I would still prefer to shop at the old market with the wood floors and the homemade beef jerky on the counter. But I'd promised Marian I would act normal.

Marian's shiny shopping cart was soon overloaded. I reminded her about our candlelight dinner in Cambria, with its moon-washed view of the Pacific. Everything she was buying could be saved for our next trip. She betrayed no skepticism about actually making it to the romantic rendezvous.

As we arrived at the ranch, dusk descended. Amber twilight sequestered us in the sublime peace of nature's magic moment. I stopped the car at the gate. We beheld the flaming spectrum of the setting sun and slipped into each other's arms. We were consumed with the ennobling beauty of this day's end…and our love and commitment to one another.

Our beings harkened to the wonders of this universe—the chanting frogs in the creek, the bird songs overhead, the marvelous, playful sounds of the outdoors, free from man's aural assault.

We walked the rest of the way to the house to experience the evening spectacle—the moonrise over the mountains in the east. The silvery sphere, dazzling and voluptuous, crowded the sky.

Quite spontaneously we were singing, in reasonable harmony, "Shine on Harvest Moon," a celebration of the harvest of life and love.

Hand in hand we strolled toward the aged, unbowed house.

The spell broke as I remembered the groceries in the car. I handed Marian the key to the back door, but it was ajar. I pushed it open and turned on the light. We walked into the kitchen.

Something was missing…like the furniture. Well, not all the furniture. There was one chair in the kitchen—the broken one I had promised Marian I wouldn't try to fix this weekend.

The dining room was naked. The carved walnut library table had vanished. I recalled the difficulty of carting it up from L.A., the unwieldy maneuvers through the back door. We had to take the door off its hinges. It had taken three of us.

Marian sank to the floor in tears. I wanted to join her; instead, I took stock of the rest of the house. Everything was gone, except the beds…that was about it.

Upstairs, the woodburning stove from the steam engine train was missing. The thieves had to pull off another engineering marvel. We had hoisted the stove through the attic opening before John installed the windows. I had figured it was in the house to stay. These thieves had managed to whisk it out. I was amazed, stunned, and seething with anger.

There was no place for groceries except on the floor. The refrigerator was loot. Marian remembered the antique Singer sewing machine. Gone. They had ripped-off the paintings I had brought up here, thieves with engineering skills…and good taste.

Marian grieved over the stolen Singer more than my missing paintings. I could always paint more (maybe even up here); the old-time Singer was one of a kind.

It was dark outside. The empty house seemed terribly violated. Marian opened a sad box of crackers and stared at the hollow rooms.

I nibbled at a cracker. Do we call the police immediately? Do we cancel dinner? Do we return to L.A. and forget the whole damn silly ranch idea? Or do I just scream and burn everything to the ground?

Marian read my thoughts. Let's not have these bastards totally ruin our time up here. Let's ride to Cambria for our candlelight dinner. We'll buy ice and store our perishables in the cooler. We'll call the police in the morning, there will be a time to deal with it. Marian didn't feel like screaming right now.

The burglars had stolen the Indian artifacts uncovered on the ranch over the last hundred years or so: bowls, pottery, arrowheads. We had intended to buy a display chest for this wonderful collection. I'd break the news to Marian later, after she recovered from the loss of the Singer.

Several hours after sunset we crested the summit of Highway 46. An otherworldly glow illumined the vast bank of clouds pushing against the coastal mountains. The lights of Morro Bay sparkled like a scatter of Christmas decorations, and the great granite Morro Rock loomed above the low-lying mists as if defying gravity.

The night coastline traced the confrontation between dark shining land and ocean. The vast God's eye view calmed our spirits. Our mini-tragedies seemed inconsequential measured against the bold panorama of sea and shore and mountain.

We descended the canyoned coast range into Cambria, through the dark woods, into a mysterious kingdom. The sea-beaten pines lining the road, the visual essence of Cambria, seemed wonderfully eerie and welcoming.

A quick left off the highway, and we dipped onto Moonstone Drive, skirting the water. We drove by a string of vapid motels, then, surprisingly, the coast-clinging road veered up to the highway again.

"I'll be damned! I could've sworn there was a little cafe right here."

I dimly remembered passing a cottage restaurant the last time we were in Cambria, about a year back.

"Maybe it's closer to town, and we should've turned off sooner." Marian's voice was serene. The fog-shrouded sea had restored the soul and spirit for our candlelight dinner.

I saw lights and a sign on another road that headed toward the black sand beach.

"Of course, that's got to be it!" I spotted a restaurant that had the proper isolation, it was actually on the beach. Perfect!

Marian made out the sign: "Chuckwagon—All You Can Eat."

"All you can eat?" Was there room for romance in a pig-out place, where the wine list was "all you could drink" and the candles were "all you could light"?

It was too late to turn back. And to what? We parked and entered the Chuckwagon.

They were closing and beginning to clean up, but a chuckwagon-size man with a friendly face and a hearty smile assured us there was still "plenty of homemade olallieberry shortcake."

It was too late to cry and too soon to laugh (and the olallieberry shortcake was a perk-up). We took seats in a floodlighted booth that looked out on pitch black windows. Our view to the kitchen was oozing with charm.

THE ROAD BACK *Oil* 10" x 14" 1994

NOCTURNE (Detail)
Oil 10" x 14" 1993

We were the only customers. Dare I ask to lower the space-odyssey light fixture above us a few thousand watts? Were romantic candles not available?

The man with the buttoned-down grin figured we were in the middle of an up-from-L.A. tourist tryst. He gamely supplied his establishment's only candle for the sake of this "liaison." The love candle was hefty, with a scent to discourage insects, but we weren't throwing in the towel. Especially at this point.

We loaded our plates from the buffet island. There still seemed to be plenty of food and a mountain of shortcake.

We perused the beer list, made our selection with the phantom sommelier. When the Heineken was served, we toasted the invulnerable romantic spirit beating boldly in our breasts.

* * *

Waking up in the empty house the following morning was like an unexpected icy shower. In the new day's light, the place stood bare and forlorn—like its owner.

Not to dwell on things, I took a shower, which turned out to be icy cold. Either the thieves had also taken the hot water heater, or it was on the blink and I would need a new one. This was a lose-lose predicament.

Resolutely, I called the cops. Burglary was a high priority major crime for the Paso Robles Sheriff Station. By the time Marian had heated water for her sponge bath, Paso Robles's finest had arrived.

The deputies introduced themselves as they walked in. They might as well have called themselves Columbo and Amos Burke. Columbo and Burke were the entire Paso Robles Sheriff Station.

Amos looked a little too neat to be an officer of the law. He wore spit-polished Justin boots with his form-fitted, perfectly pressed uniform. On the other hand, Columbo needed ironing, and the color and cut of his uniform didn't match Amos's.

Columbo cocked his head, as if he were concentrating with one eye and requested a complete list of the things that were missing. This was going to be painful. They asked about the barn, then followed me to the aged building that wanted only to die in dignity.

Sure enough, the new tools were gone, but the thieves had left me a few rusted, broken antiques.

Columbo and Amos were pointing at something on the hill as we walked back to the house.

"What's up?" Had the burglars left a trail?

COLUMBO AND AMOS *Pencil and Oil* 8" x 9" 1994

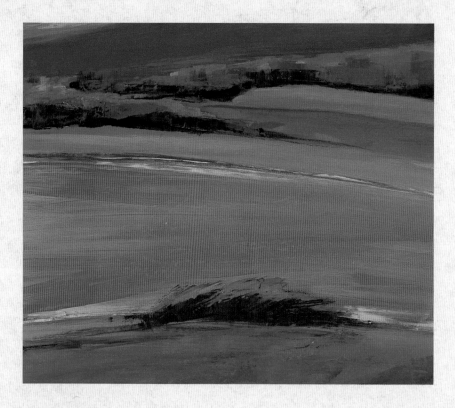

BOAR HILL *Oil* 10" x 14" 1993

"They've been rootin' over there." Columbo's face brightened. "Wild boar."

Amos had hunted this ranch when Ramage had owned it. "Loads of pigs up in these hills."

Both men looked at me, expecting an invitation to a boar hunt. I kept my expression vaguely absent.

Amos Burke came right out with it: "Ever do any pig huntin'?"

I shook my head. The furthest thing from my mind was hunting down wild pigs. Hunting down thieves was more like it.

"Y'mind if we came out here'n get a couple?"

Amos chimed in, "Split the meat with ya."

My ambiguous act stayed intact: "I guess…When I come back up. Yeah, I'll give you a call." I should cut a deal with them: find my things, and they could hunt their hearts out on the ranch. Then again, I preferred to believe they would diligently pursue justice without the added incentive of pig meat.

The two lawmen talked about wild turkey hunting, also good out here in Adelaida. And the longhorn sheep.

As Columbo was finishing his report and writing my name in for my signature, he looked up with one of those Columbo part-suspicious, part-inquisitive looks.

"You're an actor?"

"Uh huh."

"Yeah, that's right, I heard that some actor bought a ranch way out here. What was the show?"

"*Burke's Law.*"

Nodding in unison, both deputies appraised me with new interest. They had seen the series. Amos liked the idea of riding around in a Rolls-Royce: "That's the way it's done in L.A., huh?"

"That's the way it's done on TV."

"Lots of fine lookin' women on that show." Amos wanted the inside scoop.

I rolled my eyes at Marian. She had been impatient with this fledgling fan club, but she seemed interested in my response. I switched the subject back to the reality at hand. We had just been wiped out of our household of possessions, what were the two deputies going to do about it?

They would file their report. Sometimes stolen goods show up here and there, at garage sales and swap meets; they just nabbed a thief recently at the Oaks Drive-in flea market. It was important to get details like serial numbers, I.D. marks, and even photographs if possible. With droves of people coming up from L.A. to Lake Nacimiento now, there would be more and more of this kind of occurrence.

The two lawmen indicted Los Angeles and not Fresno or Bakersfield, or the rest of the country for that matter. Los Angeles was Babylon. Anybody coming up from L.A., including myself, was suspect.

I slid into my TV role and asked about fingerprints. They figured it was too long after the fact for fresh prints. The chances of getting anything usable were slim.

"I hope you got good insurance." Columbo tried to be encouraging. He handed me a duplicate of his report. "Just give this to them. You should come out O.K."

As they climbed into their car, Amos asked for an autograph.

"You have it on the robbery report." For a moment, they took me seriously. I asked Amos for a pen and blank paper.

"Could you make that two?" Columbo handed me another piece of paper.

I tried to think of something clever to sign, but my heart wasn't in it.

The lawmen reminded me about the hunting. I responded even more obscurely than before. They started to get the point, and drove off.

Marian, her overnight bag packed, was heading for the car. She was ready to cut this stay short. I couldn't blame her.

The message was forming. We were city folks; worse still, from Hollywoodland, a suburb of Babylon. We were fish out of water. Square pegs in an ever-rounding hole. Unadaptable. And we had just been stripped clean, easily fitting into the role of victims.

As we left the ranch, I resignedly closed the big gates at the front entrance. I wished that I had gotten a giant padlock, but no lock would hold out determined thieves, especially the engineering geniuses that these thieves had been.

I got back into the car and asked Marian if she had any desire to explore the Paderewski ranch. Wiebe had told me where it was. A pause. The echo of my words seemed to reverberate into infinity. Marian said something about next time.

I picked up a new tone in her voice…cool and world-weary. "Next time" wouldn't be soon, if ever.

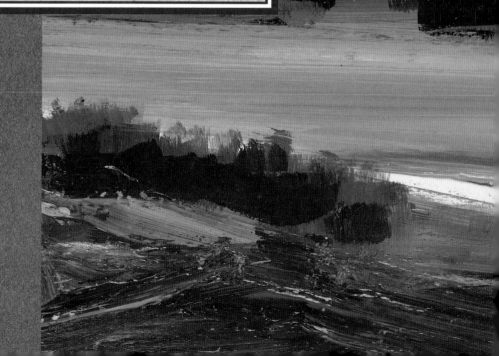

DIVORCE AMERICAN
WEST STYLE

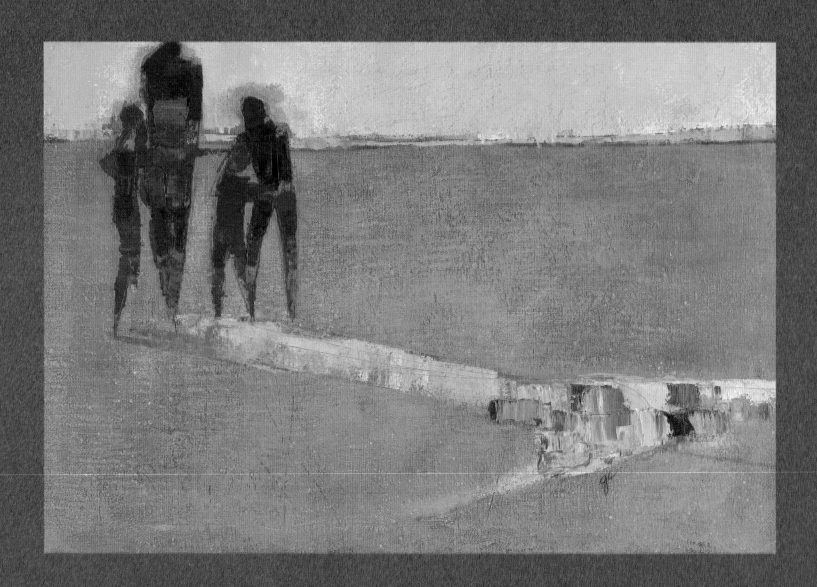

*T*he next few weeks were like going through a trial separation. I felt that I had to cut myself away from the ranch once and for all.

Every time I thought about our empty and forlorn house sitting out on an empty, forlorn farm, I felt heartsick, but I was at a turning point.

I focused on all the painful and annoying aspects of the ranch. I dwelt on my disappointments and built on them, aspiring to such intense desolation that I would actually sell the land and let it all go. A real divorce.

Fortunately, I had a lot of things to preoccupy me. As an actor, I was very busy. I could pick and choose my roles—well, almost. I had accepted some theatre engagements in regional productions across the United States that took me away in heart and mind. The dinner-theatre circuit thrived on television stars, and *Burke's Law* reruns kept my price more than generous.

My first professional play was a New York production of S.J. Perelman's *The Beauty Part.* Most of the cast became famous in television later on, including Larry Hagman. The play starred Bert Lahr, and we rehearsed in New York for an out-of-town tryout at the Bucks County Playhouse.

My most vivid memories of that production, besides visiting the dark side of Bert Lahr, have little to do with acting. The cast was invited out to S.J. Perelman's farm in the glorious Pennsylvania countryside. As the production members shared stories in the humorist's antique-filled living room, I drifted outdoors and dreamed about owning such a farm.

I walked the fields. Perelman's Pennsylvania-styled stone barn fueled my imagination. For a century, the barn had stood as beautiful and bold as when it was built by the farmers who depended on it to shelter their livelihood. Someday I would build a barn like it in California. But a barn for what purpose? I had no idea. Where would my barn site be? I hardly ever left Los Angeles. No call for barns there.

THE FAMILY *Oil* 24" x 36" 1966

The play was a hit in Bucks County. By the time it went on to New York, I was in California again, working in front of a camera instead of an audience.

On top of theatre engagements, and film and television appearances, every spare moment of time was now applied toward preparation for my first one-man exhibit of paintings.

Richard McKenzie, a fellow student during my days at Otis Art School, years later opened a gallery on North La Cienega, L.A.'s gallery row. The very successful McKenzie Gallery was well respected by the art crowd. McKenzie told me that he had always admired me as an artist, a compliment that I yielded to graciously. He urged me to produce a one-man exhibit. I accepted with alacrity, committing myself to at least thirty new paintings. This investment of my passions and vital fluids would show the spread up north that I had a truer love.

My work at that point was preoccupied with figurative interpretation. I was especially involved with the abstract human form played against mystical inner landscapes, far distant from the robust colors of earth and sky that characterized Adelaida.

Under the gun to ready the paintings by show time, I had no chance to get back to the ranch. The estrangement was progressing beautifully. I had not returned since the burglary. By now, I imagined, the entire house had been carted away piece by piece. The land would return to its natural state, and I would go the way of the Indians. A hundred years from now, some transplanted megalopolitan would find one of my bowls, discarded by some burglar as he carried his loot to his moving van.

I did call the Paso Robles Sheriff Station for an update. Columbo, the distinct twang of "forget it" in his voice, detailed the progress, which took about ten seconds.

He asked about another autograph, for his niece. "I didn't realize she was such a big fan of *Burke's Law.*"

I promised to send a photo and I cut the conversation abruptly. He was about to mention our planned pig hunting party.

Recovery of our belongings looked hopeless, but I didn't have time to dwell on the fact, thank goodness. Opening night was close, and I needed every unscheduled second, and then some, to churn out paintings.

I worked on four or five paintings at once, shortening drying time with hairblowers and gobs of Japan drier so I could paint in a continuous frenzy. As opening neared, I vacillated between an out-of-body and an out-of-mind state. Coherence returned, but only long enough to fulfill McKenzie's request for names of friends, family, and film world associates to add to his invitation list.

The big night arrived. Most of my guests showed, as well as McKenzie's. A wall-to-wall crowd of people spilled out onto La Cienega.

These were the worst of circumstances for viewing paintings, so people concentrated on the champagne and finger food, and tried to identify my actor friends, and which shows they had been seen in.

In the course of the evening, I confronted my lifelong artist's fear of changing art into money. If I liked a painting, I could not part with it. If I felt a canvas was a failure, I wouldn't let it out in public. I would be more comfortable selling almost anything, even shoes, as long as they were shoes I had not created. Thankfully, I could make a living just selling myself. It seemed less personal. The audience never signs the check and hands it to the actor.

As my one-man show progressed, through the balmy L.A. night, I awkwardly tried to talk my friends out of buying my paintings. As we sipped champagne and flicked crumbs off our tuxes, I intimated that no one was expected to actually buy the stuff. If they really wanted my work, I, as a friend, would give them a painting if necessary. I was drinking a bit. Barely comprehensible, my odd sales philosophy was tramping over some strange psychological terrain.

Several paintings were purchased by representatives of institutional collections, both public and private. That was a pleasant surprise, free of psychological problem. Artists throughout history had created their work for church, government, royalty. They were paid by these institutions rather than directly by the public. I was obviously a throwback to that time.

Nonetheless, despite my efforts, all my paintings sold. Friends scribbled out checks, waved them in my face, thrust them in my hand, and I survived. It was a maturing experience.

After the show, I knew I had to make the basic decisions about the ranch. The exhibit had taught me that I could manage the business aspects of even the most emotionally-charged components of my life.

I decided to treat the ranch as a pure real estate venture. A land purchase for profit, if it were not profitable...well, I would deal with that eventuality rationally, like an investment banker.

I would evaluate the annual appreciation potential. I would set up proper books and take advantage of tax leveraging opportunities. Trips up to the ranch would be "write offs." I would test the ranch against other available investments. If it made business sense, I would be at peace.

BREAK IN THE STORM
Oil 7" x 11" 1994

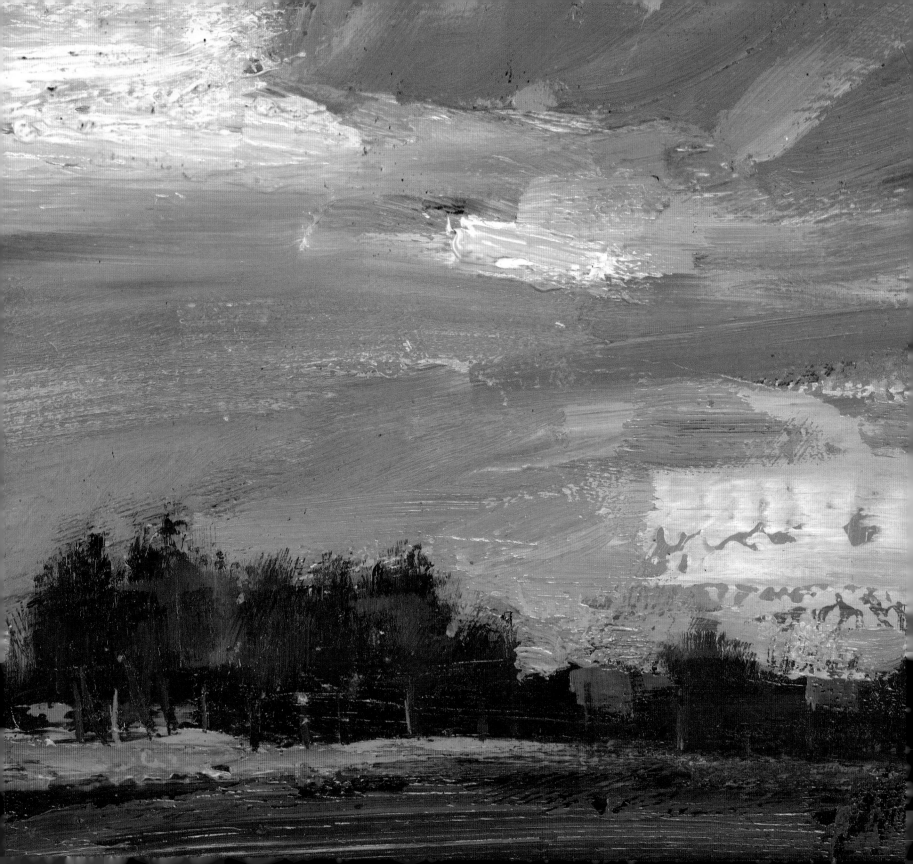

Making money on land is somehow calming. Talking to myself, I openly used such words as subdivision and development. I ran the numbers and felt an inner glow when I found the "bottom line."

I excluded Marian from my capitalistic metamorphosis. My business plan was mostly in my mind. My visions of the ranch had already gone through one too many modifications to suit Marian.

In the middle of this, Marian found my "file." Tucked away like some kind of pornography, my file was on barns, beautiful, beautiful barns. Seductive barn pictures torn out of *Architectural Digest, House & Garden,* and any other magazine where I found a barn-house picture or plan.

I had barn books, the complete collection, from Eric Arthur's *The Barn* to Eric Sloan's *An Age of Barns.* Not to be a purist, I also had books on carriage houses and stables and even one on silos as living spaces.

I confessed that I would happily spend my life...in a barn (or a reconverted stable). I clipped an advertisement for century-old English barns that could be shipped to any site, hand-hewn beams and all. I wrote for more information.

I treasured an article on Willem de Kooning's studio barn. He was a favorite artist. I was convinced that his original, unrestrained work came from the freedom of painting within the enshrining space and light of a church-like barn.

Marian indulgently accepted my collection of barns, and marveled at its extent. As she went through the reams of material, I tried to remain impassive. She made it plain, finally, that she would never live in a barn. I didn't blink.

Of course, the whole idea of its contents flew in the face of my capitalistic conquest of Paso Robles. So as not to be inconsistent, I opined that the barn motif would be interesting in a subdivision. Marian looked at me curiously. I didn't pursue the subject.

I did pursue my business plan. I wanted to make as much money as possible, but most importantly, tax-wise, my ranch had to be a functioning enterprise for allowable deductions.

I telephoned Wiebe at his ranch. I apologized about not giving him a prompt answer on his proposition to farm my place.

He wondered where I had been. He'd seen lights on at my place, and he was sure a car had parked there for a couple of days.

"What kind of car?"

"One of those Volkswagen vans. When I finally drove in for a close look, it was gone."

I asked him to jot down the license number of any strange car. He urged me to join the Adelaida Community Patrol and support it with contributions. I promised to send up money immediately. Then I got down to business.

I agreed to the one-third/two-thirds split on a farming contract for barley. I questioned him about growing barley for seed. Could I realize a bigger return if I followed that strategy? I might make a few extra bucks, nothing significant.

I suggested that I wanted to maximize my farming ground. Some sizable sections needed clearing. We could cultivate more usable acres. I told him to farm as close to the house and barn as possible to pick up extra yield.

I would prepare a contract, and I wanted him to get started at once. "I have a feeling that this is going to be a good year."

Wiebe had the same feeling. Too bad I was too late.

"Too late for what?" I was puzzled.

"Too late for plowing. Too late for planting."

Wiebe's barley was already out of the ground.

"So we're a little late?"

"Most of the rains are over by now. Couldn't get a crop no matter what you did."

The cool, calculating tycoon was a raving screw-up. I kept a lid on my turmoil, I couldn't let Wiebe know that I was utterly upset.

I was upset with him, too. He could've called and reminded me before I was too late to plant. Dammit, that was the least he could've done. Then again, I had no one to blame but myself.

So what if I'd missed a whole damn year! I told Wiebe that I would prepare the contract anyway. We would be early for next year.

I wanted to hang up. Wiebe felt that if I wasn't coming up very much now, I should get somebody in my house. Empty houses attract the wrong people, especially with all kinds of characters going to the lake. A man had stopped and asked about renting my house. Wiebe had told him he didn't know what the situation was next-door. The man said he would stop by again.

"If you could get the guy's number next time, I'll give him a call." This was a step I had to take. Renting the house would be additional income, and I wouldn't have to worry about more break-ins.

This was a good idea. Then why was I so depressed?

Marian and I avoided discussing the ranch much. She knew that fresh schemes were making the rounds of my mind, and she would rather let them stay in that confine.

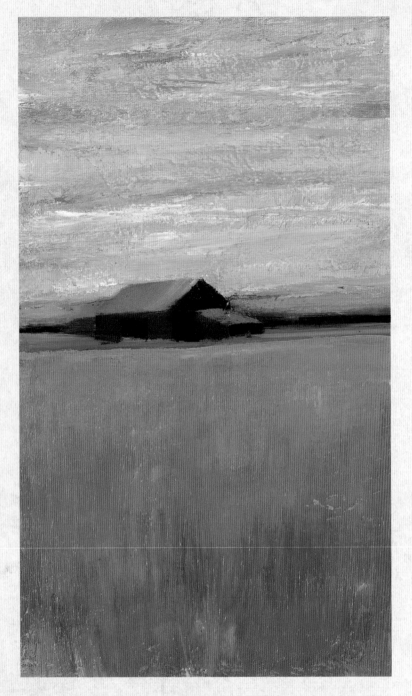

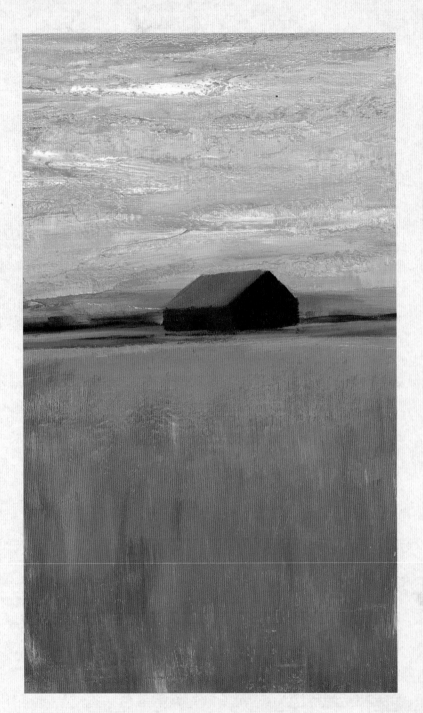

BARN #1 *Oil* 6¹/₂" x 11" 1994

BARN #2 *Oil* 6¹/₂" x 11" 1994

98

She began talking about a place at the beach...Malibu. We both loved the water, and Malibu was a hell of a lot closer than Paso Robles.

Maybe if I started looking for a house in Malibu, I would get Adelaida out of my mind. We drove out to the beach on Sundays to look around. It was amazing how much time we had to ourselves if we didn't trek up to the ranch.

During one of our Sunday trips we happened upon an imposing piece of property just south of the old Sandcastle restaurant. On one side, the land had a sweeping view of the Pacific's cobalt splendor, on the other side, a dramatic vista of the bold purple Santa Monica Mountains.

Most of the land of this three-acre miniature farm was situated on a commanding bluff, with a little path that rambled down to the beach. A one room cabin on the sand and set on concrete piers, was part of the property.

Marian could really warm up to this one. I marched to the front door and met the winsome, elderly, Mrs. Clara Allport. She and her recently deceased husband had owned the property for almost fifty years.

After a few moments of conversation, she invited us in, and with a little gentle probing, told us about her history with the property. She and her husband had originally bought the place as a truck farm. For the first few years, before much of anything was developed in the area, they raised vegetables to sell at a farmer's market in Santa Monica. Her eyes glistened as she recalled the sweet memories.

Similarly, my eyes must have glistened as I attempted to sweet-talk Mrs. Allport into selling her land to me. I had no idea of price. I had no idea if she would even sell. I had no idea of what I was doing. I already had a farm.

Marian would gladly make sacrifices to acquire the Allport place. Driving home that evening along a coast dressing for sunset, Marian alluded to a little rubber-tired John Deere in the small barn at the back of the property. That was the first thing I'd seen. Marian reminded me that many viable farms in Europe, including world-renowned vineyards, were not over two or three acres.

By the time I got to bed, I was dreaming about a storybook farm in Malibu. Maybe with a studio thrust out into the Pacific. I would be Winslow Homer, painting the roaring winds and rain, recording the war of the elements while ensconced in a sea-wrapped studio, surrounded by the raging waters battering the coast of Maine. But this was the coast of California.

I took control of myself. I would quit fantasizing until I found out if Mrs. Allport would actually part with her property.

The following morning I called Mrs. Allport and told her that we were especially smitten with her wonderful home. Could we see her again? She accepted my self-invitation, a clue that she would be willing to sell.

A couple of days later, sitting in Mrs. Allport's living room, she revealed an ambivalence about leaving, but she was getting old and her sister insisted that she come live where she would have an easier time of it. I feigned objectivity, but I agreed with her sister. As I made the case for Marian and I as the perfect couple to buy the place, the fog swept in from the sea. Everything became gray, and the corners of the room filled in darkness.

Mrs. Allport turned on a table light and an electric heater. Marian was getting cold. I worked in one more angle: Mrs. Allport could visit anytime she wanted. Marian cringed, but Mrs. Allport promised to get in touch with her attorney. I should contact him and make arrangements.

By the time we left, fog had enshrouded the place, everything seemed damp and gloomy. I scrutinized the house. It was a plain one story construct of concrete blocks; we were looking at serious work and expense to update the place. There would be building code problems.

Mrs. Allport's attorney advised me to make an offer. He also suggested that other offers were possible now that Mrs. Allport was ready to sell. He gave me no clue as to what my offer should be. He stressed that the size of the parcel was considerable, and Malibu property had become extremely expensive. For a moment, I wondered if I was a pawn in a real estate game.

The Allport place was turning into an investment with serious implications. For starters, it would be necessary to sell the ranch. Next, my house in town would have to be sold. I could not maintain two houses in Los Angeles.

"You could become a fisherman," suggested Marian. Malibu real estate seemed more and more impractical, for fun or for profit.

In the middle of my Malibu mini-farm deliberations, the man who was interested in renting the ranch house called. He wanted to meet me on the property and make a deal. He and his wife were living at the Farmhouse Motel in Paso; they were eager to settle into a place.

The ranch needed a lot of work, perhaps he could do most of that cleanup himself in a trade-off for rent. I saw my rent profits swallowed up in the maintenance vortex, but I agreed to meet him in a couple of days.

Mike McCutcheon reminded me of Paul Bunyan. He was huge, with a wine barrel chest that stretched his flannel shirt like spandex. Wide suspenders held up his pants over a waistline lost somewhere beneath the wine barrel.

McCUTCHEON *Pencil and Oil* 8" x 9" 1994

McCutcheon was chopping oak logs from a tree that had fallen near the barn. While waiting for me, he had stacked up a full cord. He had a Bunyan-sized axe and a log splitter and barely stopped to talk.

McCutcheon's wife was in the house. I was curious. How had she gotten inside? Her husband answered simply, "The door was unlocked." I sidestepped the subject.

Between powerful swings of the axe, McCutcheon proposed to take care of the place for "free rent." I countered that I needed at least $250 a month. He could work off the rest of the rent in maintenance.

These negotiations were awkward. I was sure the work he had in mind was general upkeep—expected from any tenant living on a ranch.

In the kitchen, McCutcheon's wife, attractive even with no makeup, seemed far too fragile for Paul Bunyan. Cleaning the kitchen vigorously and arranging fresh wildflowers in vases, she had already moved in. My bargaining advantage dissolved.

I finally agreed to barter rent for work for the first three months. A lot of cleanup was needed right away. Then we would take it from there.

We shook on the deal, and McCutcheon was quickly back to splitting wood. As I observed his form, he suddenly offered me his axe. He made chopping look easy. He was handing me a two-fisted test.

What the hell. Chopping wood should be a technique at my command as a rancher.

McCutcheon placed a log on an oak stump for me to split. I took a wind-up and powered my body into a definitive swing. The axe veered, missing the log altogether.

My pride was on the line. McCutcheon adjusted the log for my second attempt. I thought about my form, lightened up on the brawn and let the axe do the work. Legs apart for better balance, I wafted an easy, well-aimed arc, plunging the axe dead center. The log split in half; so did my back.

I didn't let McCutcheon know, but I was crippled as I returned the axe. He resumed chopping, and I headed out to the fields, hoping to work the pain out of my back in private.

The afternoon shadows deepened, underscoring nature's random forms and colors. As my back improved, I thought about my recent exhibit and my attempts to create landscapes beyond nature, my version of the surreal. The Adelaida vista commanded my attention. Centered in its power, I was forced to admit how man's efforts at art were trivial.

The ethereal breeze, which each afternoon ventured from the coast to visit this little valley, caressed me like a long-waiting love; its scent, derived from wild mountain herbs and flowers, seduced me once again.

I loved this place. I worshiped its unspoiled beauty, the land was true to itself and to me

THE POND *Oil* 8" x 12" 1992

This was the gallery to fill with paintings, a visual story to tell through art. But I was unprepared to record the wonder. My paints and canvas were too far south.

I glanced down toward the farmhouse. Smoke drifted from the fireplace. The McCutcheons had moved in. I felt a tinge of jealously over their simple life, uncomplicated by a thousand goals and aspirations. They had moved into the house, and I had to be moving on.

I went into the kitchen to say good-bye to my new tenants, walking forcefully erect so as not to disclose the tightness in my lower back.

Half a cord of oak was stacked in the living room. The fireplace was roaring. The McCutcheons, sitting on logs, told me that they were taking their furniture out of storage in the morning. They asked me to stay for dinner, a guest in my own house.

Nighttime arrived. In the light from the fireplace, McCutcheon and his shadow took up half the room. With this giant around the place, axe in hand, neither burglars nor strange Volkswagens posed any menace.

They asked me again about supper, but I insisted that I had to leave right away, which was untrue. I did need, however, the solitary drive back home to convince myself I was doing the right thing. I had become a visitor in a place I had made sacrifices to own. Would it ever become my place? Would I ever be faithful to my feelings?

The McCutcheons didn't want a TV or phone. I didn't care about the TV, although that's how I made my living. I cared about the phone, and I agreed to pay for one so I would be able to check on the place. Also, in case of an emergency, McCutcheon could call me.

I didn't figure McCutcheon read much. Without a TV or interest in a phone, what did he do with his life? Then I remembered the stack of wood.

I wondered if I had made the right decision about this guy. I kept wondering all the way down to L.A.

EIGHT

A COUNTRY
EDUCATION

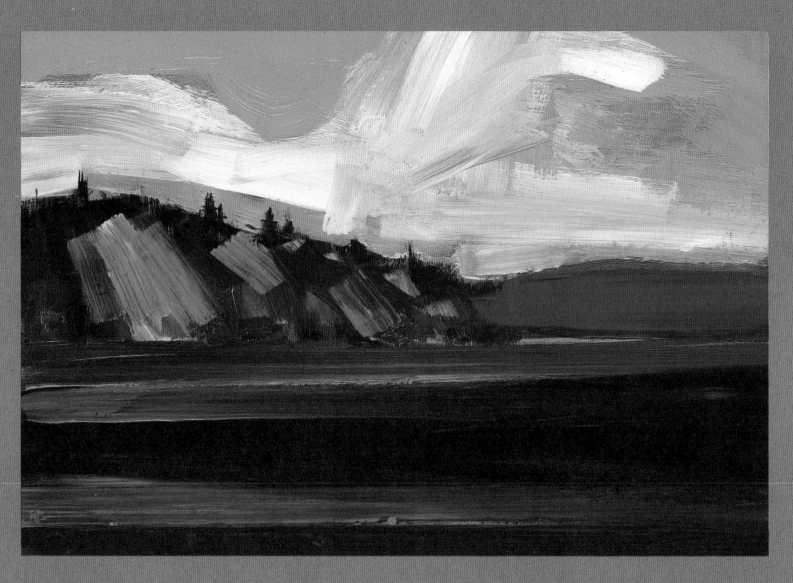

CAMBRIAN HILLS *Oil* 7" x 10" 1995

My family revered education. During the 1930s, my father couldn't land a job, so he spent the entire Depression going to college and waiting to be rescued by the WPA. Those were tough, lean days, but my father prospered intellectually. His treasures were to experience the poems of William Blake…or the philosophical insight of John Dewey's *Ethics…*, or *Reason and Common Sense* by George Santayana. He sought the adventure of the mind.

My father always had a book on him, along with a notepad in which he recorded his own perceptions. My mother often scolded him for sneak-reading during visits by friends or at family gatherings.

My father had never read for enjoyment until the day he broke his back playing football. He'd been a scholarship athlete recruited by "Iron" Major Frank Cavanaugh, Boston College's legendary football coach. Protective padding would be introduced during the next decade.

In the hospital, immobilized with absolutely nothing to occupy his mind, there was one thing to do…read (this was before the "advancement" of television). And read he did.

After that hospital stay, my father devoured books and began a lifetime of meticulous notetaking and margin critiques. My father wasn't much for throwing a football back and forth, but if you were struggling through a literature course that included James Joyce's *Ulysses,* he could interpret Joyce's every obscure word, phrase or concept.

My sister, Belle, followed in our parent's educational path, founding a private school on the west side of Los Angeles. Her school was devoted to a caring and nurturing education and committed to a generous teacher-to-student ratio, principles that the public schools were sorely missing. Belle called her school Wildwood, and for a period of time my children attended classes there.

Belle

Education and its implications were in the air when my cousin, Wendell Monello, a teacher married to a school administrator, casually asked one day about going up to the ranch. I had to tell him there was a tenant in the house. Until things worked out, I, myself, would have to stay in town at a motel.

Well aware of my zealous love affair with the ranch, Wendell was surprised. Why wasn't I permanently encamped there?

I couldn't begin to explain.

Wendell had taken a few trips to water-ski Lake Nacimiento and visited the ranch on those occasions. He'd like to go again. He had a camper. Was there any problem if he stayed over on the property? He would be no bother whatsoever to the tenants.

I called McCutcheon to tell him about Wendell's trip and to establish that I retained unlimited use of the ranch. His wife answered.

She went outside to get Mike. I wasn't positive, but I thought I heard the sound of an axe. I didn't want to believe that he was still chopping wood.

McCutcheon came to the phone, and I asked about his progress in getting the place in shape. He gave a fuzzy answer. I told him that my cousin would be staying over in his camper. McCutcheon didn't say much, but he coolly indicated that Wendell would be an intrusion in his life.

"You don't have a problem with that, do you?" I insisted, firm and uncompromising.

I wasn't going to let him get away with his hostile posturing. Paul Bunyan was simply renting the house and not paying. I could only hope he was doing some work.

I was acting the landlord, a new role and one that I tired of after five minutes. Here was a guy who was living off me—and he was giving me a hard time. I never imagined that I would be sympathetic to landlords, but if my first experience was any indication, theirs was a suffering class.

I decided to meet Wendell at the house. When I arrived, my worst fears were realized. My cherished retreat had been turned into a wood storage center. Untold cords of oak surrounded the house, a lifetime of firewood.

McCutcheon was hunkered down on my ranch, for the long haul. One glance revealed that not much cleaning had taken place. McCutcheon had no interest in maintenance. His life was about chopping wood.

Inside the house, McCutcheon sat at a table, wolfing down lunch. He nodded at me, indicating that I should join him.

McCutcheon's wife, Ellie (I was introduced this time), asked if I wanted a sandwich. I lied that I had eaten at Wilson's. We had business to discuss, and I didn't want to do it over lunch.

With his bulging shirtless chest, McCutcheon seemed huger than I remembered. His axe leaned ready near the kitchen door, and although it was a warm day, logs were burning in the fireplace.

I noted a layer of soot on the fireplace bricks. The living room walls seemed smoke-stained, and the clumsy pieces of furniture appeared greasy. Country charm was absent here this day.

I talked about everything except the issue that was foremost in my mind. McCutcheon continued eating.

I finally asked him how the cleanup was going.

"Can't you see?"

"See what?"

McCutcheon smiled, nothing friendly in his expression. A real hard-on.

I plunged in. The worst that could happen is I would be chopped up for the fireplace.

"We had a deal." I slipped into a movie drawl, natural to the occasion. "I expected to see the ranch in better shape."

McCutcheon waited, his smile fast-frozen to his face.

"I see lots of wood chopped out there, but not much of anything else."

"So?"

His one word was both bored and belligerent.

"So...I agreed to rent my house to you in exchange for work. Chopping wood is fine, but I want the place cleaned up."

McCutcheon looked right through me. I wouldn't say another word until he spoke. And he'd better say more than a single syllable question.

Seconds ticked by in a war of silence. Mute mountain man wasn't budging, not a peep.

The sound of a truck rolled up the driveway. McCutcheon, rising from the table, lifted his mighty frame and ambled to the door.

McCutcheon's Oak Pile

"Who the hell is this?"

The arrivals were Wendell and his wife, Betty. Quickly out of the camper, Wendell barreled through the back door and hugged me like a long lost cousin. Betty was right behind planting a kiss on me with gusto. I introduced my tenants, the McCutcheons and Wendell voiced the obvious.

"What's all the wood for?" Wendell looked at me and I passed the look over to McCutcheon, who was cleaning remnants of his lunch off the dining table. I was more eager for an answer than Wendell, but McCutcheon wouldn't play in this conversation either. His chopping prowess was a sore topic.

Firewood, as a subject, failed to fascinate Wendell. He was anxious for me to see his new camper.

Once outside, while showing off the camper's compact efficiency, Wendell asked, "Who's the Paul Bunyan?"

"He rented the house…sort of."

Wendell, detecting my frustration, dropped the line of inquiry. Sitting at the camper dining table, he pointed to a stack of books.

"Your father gave me these to read."

I opened one of the books. It belonged to my father—notations on every page.

"I mentioned to your dad that I had read a poem by Byron to one of my classes. The next thing I know, he's giving me books on all the poets of the Romantic period."

"A little reading for the weekend?"

"For the next hundred weekends."

While Wendell was still a high school student, my father had urged him on to the groves of Academe. Inspired, Wendell devoted his life to teaching, which my father considered the highest calling. Wendell's wife, Betty, had also been drawn to education—she became an administrator with a private school system in the San Fernando Valley.

We talked about things as Wendell drove the camper up to the highest point on the ranch. The camper was self-contained so Wendell could make the hilltop his habitat for the weekend. The oak-groved knoll's vantage of the ranch's glory was far better than holing up in the old house.

I had whiled away many an hour at this very spot, planning my ranch castle in the clouds. None of the early pioneers had settled on the lofty Adelaida hilltops, preferring to homestead the more protected low spots.

We city folks always headed for the heights, situating every new house on a prominent hill. The old farmers, even when they built brand new homes, stuck with the low ground.

It was the time of day for a meditative walk. The sun slipped to the west, sculpting everything in light and shadow. The oak trees on the hill were a gallery of living forms enhanced with a patina of verdigris-hued lichen. Wendell and I assessed the trees as we would rare works of art, which indeed they were.

Wendell was an audience of one. I inundated him with every thought and idea I'd had for the ranch. He listened compassionately as I rambled on about my soul-stirring return to the land.

As we drifted down into the long sloping fields, splashed with the vivid pinks of owl's clover and the blue-purple lupine, we worked at the meaning of life, or the lack thereof.

We were soaring somewhere between cosmotheism and transcendentalist pantheism when Betty shouted down to us. The hot dogs were ready. Somehow a hot dog always smacks of sober reality.

Into the early evening, we sat around a camp table, feasting on Betty's wienie roast banquet, and discussing our relationship with the earth and other pressing issues.

Whether listening or talking, I was roaming the hilltop, constructing my outpost for the hundredth time. The angle and placement of the dining room were critical to framing the incredible color spill of sunset, as designed by the storms over Big Sur. Every view must feature the Santa Lucias, the mighty sentinels holding back the silvery fog banks of the Pacific. Sky-windows were paramount in my plan, to draw the starlight and welcome the evensong.

I slept in town that night at a motel on a spot where Jesse James was supposed to have once holed up (Jesse's uncle Drury James was one of Paso Robles's founders). I had declined an invitation to spend the night in Wendell and Betty's camper. With the eternal space that surrounded me and the castle I had created on the hilltop, I would've found it too difficult to crowd into a little camper, sleep in half a bed, and continue with my illusions.

Directly across from the motel was a bar, the Loading Chute. Hank Williams's "Your Cheatin' Heart" floated across Main Street. I hadn't been in a honky-tonk for years, never in Paso Robles. I changed into clean clothes and ventured into the cool Paso Robles evening. The jukebox was jammin' with "In the Jailhouse Now" by Webb Pierce. I was ready to study the Paso Robles night culture.

Music to the contrary, the Loading Chute was not jumping. Two men arched at the bar, caressing their drinks. I took over the middle seat.

Hat to heel, these guys were real-life cowboys. Here, on either side of me, were Randolph Scott and Gary Cooper.

Randolph Scott, I could tell, was ready to shoot the breeze. Gary Cooper, on my other side, stared misty-eyed into his beer. Cooper would be harder to engage in chitchat.

After a little small talk, Randolph Scott opened up. He worked at the Jack Ranch in Shandon, a one store town about fifteen miles west of Paso Robles. Randolph was an honest-to-God Oklahoma cowpuncher. He had been in the Paso area for about five years, mostly at the Jack spread.

Having been in the cattle business, I carried my end of the conversation with some aplomb. I pretended my cattle operation had been some kind of success, until Randolph revealed that, "The way they got things worked out now, no honest hard-workin' man can make a red cent in the cattle business."

Gary Cooper chimed in. He was running a ranch owned by a "fella from L.A." Didn't matter if his fella made money or not. He was a doctor who wrote everything off his taxes.

For Randolph, taxes were the reason the cattle business stunk. Most everyone in it didn't have to make money. "Fact is, they're better off if it's a losin' proposition."

I gracefully avoided fessing up that I was from L.A. They were neighborly enough not to pin me down on that point.

Randolph did figure you could raise horses in a small operation and make money still. His common sense approach to the horse breeding business interested me. He had convincing numbers, and the hand-me-down country wisdom that horses and breeding were better than farming: "When you work behind a plow, you see as far as your mule's ass…working from the back of a horse, you see as far as you want."

Just about the time I was ready to jump into a thoroughbred farm with Gary Cooper and Randolph Scott, two waitresses from the Paso Robles Inn sashayed into the Loading Chute. My beer-laced conversation with my prospective foremen was at an end. The ladies knew the right tunes on the jukebox. The two cowboys danced with them in a way that said the best part of their evening lay ahead.

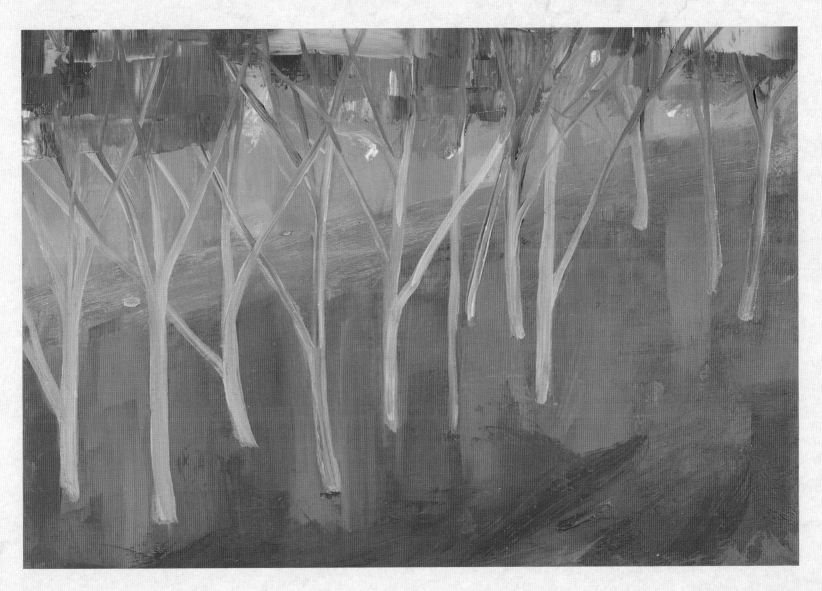

YOUNG TREES *Oil* 8" x 12" 1995

Mulling over the possibilities of horse breeding, I made my way back to the motel. I worked the numbers in my mind. It was better than a nightcap.

In the light of day, my horse business faded. Closer to L.A., reality reared its head (one of the annoying aspects of city life). Marian knew I wasn't a horse person. A few years back she'd had to bone up on her horseback riding for a lucrative television commercial. She asked me to go along to Griffith Park, where I once had riding lessons. I convinced her she didn't require an instructor, since I was more than capable.

On the trail, as we were walking our horses, my nag took off like Secretariat. Marian's horse followed like Swaps, running away with her in a screwy race, throwing us both into panic.

I was just as amazed as Marian that horses sometimes followed their own lead. Marian finally took a fall, bruising the side of her face. Even with makeup, she couldn't fool the camera the next day, and my reputation as a horseman never recovered.

In my mind's eye, the horse breeder life was filled with big and little thrills, from foaling to winning the Derby. But since buying this ranch, I had learned to think before I leaped.

I was thinking about horse breeding…but only thinking. I was maturing.

* * *

I got a call from Wiebe. The McCutcheons had cleared out. I wasn't surprised. As far as Wiebe could see, "everything was left just fine."

That meant the ranch wasn't in any worse shape than when the McCutcheons moved in. I asked Wiebe where they went. He said they found a place near Salinas. I started to ask why Salinas, but I didn't really give a damn.

If I wanted to, I could get hot under the collar. This McCutcheon moved in with nothing more on his mind than a few months' free rent…what a pathetic, pitiful hustle.

I also got a call from Wendell. He had enjoyed the long weekend at the ranch. He thought it was a hell of a place for an artist. Why wasn't I painting up there all the time?

He wanted to get together. He had to tell me something, face to face.

I also got a call from a guy named Clint Rhodes. He had heard that McCutcheon had left my place. He knew McCutcheon. McCutcheon was rather weird, according to Clint. That news was a little late.

Rhodes asked whether he could rent my place. Real rent, not like McCutcheon. He would stay on top of things, and, as a single guy, he would hardly be in the way.

I took down his phone number. He offered to send a check for the first month's rent in advance.

SCOTT
Pencil and Oil 8" x 9" 1994

COOPER
Pencil and Oil 8" x 9" 1994

I liked the sound of his voice. I liked the sound of "rent in advance." I still needed someone around the place. A single guy would be easier to deal with. He seemed enthusiastic about keeping the place in shape, and he understood work was part of being a ranch tenant.

I met Wendell for lunch on the set of the television show, *Daniel Boone*. I was dressed like some range-whipped wrangler. The horse opera setting seemed appropriate for talk about ranch matters, especially since we couldn't be at the ranch.

Wendell sprang his plan on me. I had thought he wanted me to play real estate agent and help find him some land in Paso Robles, or that he might ask to store his boat at the ranch, convenient to water-skiing on Lake Nacimiento.

But a ranch school? It took a few moments to comprehend what he was proposing. Words came out of his mouth, describing a plan to establish a school on the property. He outlined a program that would start with a summer camp and evolve into a full year curriculum.

Wendell, of course, was a teacher, and Betty, a young but experienced administrator. They had the required credibility and credentials.

Wendell had organized many summer camps. He was a fine athlete, an outdoorsman, and terrific with kids.

The more Wendell talked, the more excited I got. My ranch was looking for a purpose, and what finer purpose than education and physical fitness in a pristine environment? This was more than a purpose…this was a cause.

Wendell assured me it would work economically. That's where Betty came in. She knew how to keep a school profitable. And any school with a mix of summer camp and, eventually, regular sessions would be a solid earner.

Wendell was convinced that the resurgence of learning as a meaningful adventure was ultimately dependent on reconnecting young people with the earth. The air, soil, plants, animals and people are of a piece; in the final analysis, all must be organically integrated for spiritual health.

The students would grow their own food and raise their own animals, they would reestablish a clear link between people and the planet, while learning everything about farming and self-dependence. Wendell would establish a physical education program compatible with natural law, guaranteeing his young students a harmony of body and mind for life.

Wendell sounded genuinely profound, almost mystic. I was in makeup, wearing phony clothes, and sitting in a fake Western street on a made-up Hollywood set. But we were creating a utopia.

I loved this idea passionately. I had the urge to embrace Wendell, but I would've smeared makeup on him.

"I'll be the first to sign on. I want to relive my childhood, and this time do it right." I was an actor. I knew I had a luster in my eyes.

Wendell understood. There would be no real separation between student and teacher. All grades would be included, indeed, all ages.

The assistant director tugged at me to visit makeup and wardrobe for an after lunch touch up. I was in the next shot.

I glanced at my script. In the upcoming setup, I made a daring escape from prison. I saw the scene as a metaphor for the farm-school fantasy—casting off the psychic incarceration of the city and its cultural mean streets. And my cousin was leading the breakout.

* * *

Back at the home, my onslaught of enthusiasm for the project warded off any thoughtful reaction, let alone actual criticism from Marian. I was ensuring my children's educational future. My dream ranch now included the intellectual and social well-being of Gareth and Kathleen.

Marian brought up financing—the land would ultimately have to be used for collateral. She was sneaking sobriety into my fantasy, but I was not ready yet.

Wendell's plan seemed so obvious to me now. My crop would be kids…kids who would sprout and grow in spirit and in intellect.

A Wiebe could raise barley or wheat, but I had the calling to raise boys and girls. I had a glimpse of myself as Albert Schweitzer (Marian made the suggestion in an off-handed way). I proposed the image of Mother Teresa for Marian. Only I wasn't kidding.

I cast about for school mottos: "The health of the soul is dependent on the health of mind and body." "There is no second-guessing nature. It is always true; it is always the teacher." Even Wendell began to show a little concern for me.

My father would support the idea of a ranch-school. I saw him as mentor emeritus, the master oracle, the elder intellect of the school. Our soul-healthy students would eagerly gather about him in the oak groves of Academe to partake of his wisdom.

Or so I thought.

My father, in actuality, figured this grand vision was some kind of shaggy dog story. As I maniacally outlined our lofty plans, a "there he goes again" smile played at the corners of his mouth.

My father, may his life force never die, fell for two, maybe three of my dream trips.

LAKE AND PASTURES
Oil
7" x 16¹/₂" 1994

He'd gone along with my farming fancy and my chimeric cattle. He'd listened attentively to my thoroughbred racehorse musings. But the ivied halls of ranchdom?

He abruptly changed the subject to ask me whether I had found Paderewski's vineyard yet.

I had identified the old Paderewski ranch and stumbled across a twisted half-dead orchard, but nothing there indicated where the actual vineyard had been located.

Derailing my farm-school phantasmagoria, my father launched into Paderewski. The pianist had arrived in Paso Robles while reigning as the world's consummate performer. Indeed, Paderewski had invented solo performing—before him, performers always shared the concert stage with other headliners.

My father, sounding like his son the zealot, went on to recount Paderewski's sojourn into the Central Coast of California. Paderewski discovered Paso Robles in 1914, the year the Great War broke out and engulfed the world. "It was at that fateful time that Paderewski bought his ranch...just a stone's throw from your labor of passion."

My father thrust a typewritten page at me. "Read this...it's from his memoirs."

I obeyed my father, reading aloud from Paderewski's published memoirs:

"I now want to tell you of an important new interest in my life. It was in February, 1914, that I bought my ranch in Paso Robles. There were two reasons for buying that large property, which has since been a cause of much trouble and expense."

My father was grinning, knowing how I, as much as anyone, could appreciate "a cause of much trouble and expense." I continued:

"First of all, I was under a feeling of great gratitude to the place itself for my recovery..."

But my father interrupted again, reminding me that Paderewski, suffering terribly from neuritis in his arms and hands, had cut short a concert tour on the West Coast. His friend, the violinist Sir Henry Heyman, advised him to shun doctors and go immediately to the hot sulphur baths at Hotel El Paso de Robles.

Why, I asked myself again, were those extraordinary healing springs no longer available? But I continued with the memoirs:

"...and secondly, the physician of the establishment had a decided passion for the real estate business...He used to come to me and preach about acquiring land there because it was such an opportunity for investment for the future. He was as deeply interested in that as he was in his patients, apparently. It had its amusing side, of course, because I was helpless—at his mercy.

"His attacks upon me took place when I was in the baths—in mud up to my neck! I could not protest, I could not resist, and he never let up. I was in a trap.

"I must add in justice, however, that I was probably quite a willing victim, for I really loved the place and was very grateful besides.

"There are plenty of those healing mud baths on my estate and I know there are several sources of mineral water of the same kind used in the thermal establishment in Paso Robles, so there was reason in the arguments of my physician."

My father, student of history and its drama, went on: While Paderewski was curing himself of his crippling pain, the terrible storms of war approached Europe. The Polish plains would shake under the awful thunder of World War I. Cruelly sectioned for a hundred years, the divided Poles would be forced by the Germans and Russians to fight family against family, father against son, brother against brother.

"Now this is a movie!" exclaimed my father, the writer-director of terrifying epics portraying man's inhumanity to man.

"But your spiritual neighbor, the artist Paderewski, ultimately became one of the most effective and revered statesmen in history. You see, art has a socially practical side. His life proves that message."

On April 6, 1917, the war finally sucked in the United States. Paderewski organized Poles from the various Allied countries to fight in a separate Polish division. At first the Allied leaders resisted his plan, but by force of personality and intellect, Paderewski finally won full support. His Polish Army was born.

This great body of expatriate volunteers, in turn, inscribed Paderewski's name on each regiment's roll. In the mornings, when the roll was called, and the regiment commander barked out the name of Ignace Jan Paderewski...

My father paused for effect.

"A hundred thousand soldiers called out 'Present!' "

My father took in my eyes.

"Can you imagine that scene? Was it not made for film?"

This was already the biggest budgeted motion picture of all time. It dwarfed *Cleopatra*. But for the moment, my father was making the movie, and it wasn't costing anybody a dime.

My father sparkled, weaving the interrelationship between Woodrow Wilson and Paderewski into a compelling coda. In 1918, before a joint session of Congress, President Wilson announced his Fourteen Points plan for a peace settlement. Point Thirteen stated

that once and for all an independent Polish state would be guaranteed political and territorial integrity.

After the war, Paderewski returned to Poland as prime minister, to confront the inevitable warring factions, the power stalkers, a population raging with disease, famine, and the destitution of war.

"Yes, only the artist could be trusted with such awesome responsibility," stressed my father. "Yes, the artist-statesman."

But Paderewski and the rest of the world would have to wait. My father was late, he had to pick up my mother at a bridge game. He threw out one last question as he left:

"Wouldn't that be a hell of a script?"

NINE

NEIGHBORS AND
OTHER ODDITIES

CLOUDS
Oil 12" x 9" 1993

drove up to the ranch alone. I wanted to get a few hundred things taken care of before the family arrived.

Marian was traveling up with my sister and her husband, Steve. Belle and Steve's two young children, as well as my own kids, would be along. With Wendell and my parents also on the tour, the house would be jampacked for this overdue tribal gathering.

My first order of business was sizing up Clint Rhodes and deciding whether I would make another try at renting. Rhodes was younger than his phone voice, clean looking...

I had to stop and laugh...cleanliness first, the landlord's quirk.

Rhodes seemed easygoing, but as we talked, I noted a stiff discipline about him, a sense of deep forces held in check. It wasn't enough to keep me from saying yes when he bluntly asked if I was ready to rent to him.

"All right...$225 a month."

Rhodes scrutinized me. He wanted to haggle. Instead, he smiled in a lopsided way and took out a checkbook.

"First of the month O.K.?"

"That's just a couple of days."

"Right...suits me fine."

He scribbled on his check and handed it to me. I started to demand a security deposit, but the concept didn't fit a ranch that needed a lot of fixing up, maybe even an overhaul...which reminded me: "The place needs some work."

"Like I told you...I'll stay on top of things. This ranch will be standing tall real soon."

I wanted to believe him. I checked his eyes for something trustworthy and was stopped at the pale lashes. I still went ahead in good faith. "I want things looking neat and farm clean."

From our angle, the tractor was visible in the barn.

"Can I use that?"

I sized Rhodes up again. I glanced at his Ford pickup; it was in reasonably good shape.

"Yeah…sure."

I explained the concept of neatness. Rhodes readily accepted my orderliness, cleanliness, godliness sermon.

I warmed up to him, enough to indicate that I wanted him to sleep in the attic. "Once in awhile my wife and I will be using the house."

He consented to this arrangement even though it was the first time I had mentioned it. I impressed him with the idea that he was, in effect, a house and groundskeeper. He didn't have a problem with the guidelines.

This was the ticket. Rhodes would be around all the time, watching after things, and he would pay his own way. Yes, I liked this program.

As he climbed into his truck to leave, he cautioned me about the check. "Do me a favor…don't cash that for a couple of days."

"You mean this 'advance' check?"

"Next Tuesday or Wednesday, O.K.?"

I nodded. I had a hunch. But at least I was getting some rent, a sweetheart deal compared to the McCutcheon arrangement. I felt like a real landlord. Things would work out fine.

The weekend was all brightness and laughter. On the first day, everyone piled into the truck for a wild excursion to Lake Nacimiento.

The dirt road that wound to the lake was dusty with summer clay soils. The truck kicked up a chalky-gray cloud and we arrived at Nacimiento looking like ghostly apparitions, covered head to foot with a cloak of fine dust. The children, delighted with their mantle of powdered clay, flitted along the lake shore, playing Casper the Friendly Ghost.

The azure depths beckoned, and we all made a mad dash to the lake, but at the water's edge we sank fast into quicksand-like mush.

Lake Nacimiento was formed by damming the Nacimiento River and hundreds of streams and creeks flowing from the Santa Lucias. At certain water levels and locations on the lake, the shoreline is a bed of oozy mud.

We couldn't resist. The appropriately absurd course of action was to slip into the black muck up to our necks. Mud baths—impromptu!

"If these Paso Robles muds made Paderewski's hands work again, it'll do wonders

for my little aches and pains." My father's head perched atop a mound of mud. His grand-children screamed with laughter.

The mention of Paderewski intrigued most of the party. Wendell and my brother-in-law, Steve, had heard the name, but not much more.

My father eagerly accommodated their interest until I interrupted. If they wanted to know more about Paderewski, they would have to see our movie.

"What movie?" My sister took me seriously.

"Dad is researching the script. I've committed ten million to the budget."

The mud wrapped us in its earthen blanket, and we became flushed with well-being and the love of life and family. Nature's therapies were healing whatever ailed us. We had only one problem—we were in black face and black body and looked unbearably silly to each other.

We finally emerged from the primordial ooze and slid like giant *Star Trek* amoeba into the clean waters of Lake Nacimiento. Luxuriating hedonists, we floated in the warm, gentle lake and gazed up into a flawless sky, the perfect follow-up to a Paso Robles mud bath.

Later, as evening descended, the glow of summer and sun was still enveloping me. My father and my young son, Gareth, walked with me in the pastures and fields, gathering kindling and wildflowers. The mossy oaks that lined Chimney Rock Road were a ghostly patchwork in the waning hour. Behind the shadowy stand of trees, the densely wooded Santa Lucia foothills yielded their gray-green hues to the gathering dusk.

As we hiked through the brush-stiff stubble, I reminded my father that he had left our neighbor and kindred spirit, Paderewski, as Poland's prime minister and representative to the Paris Peace Conference. It was Poland's most precarious hour, intoned my father, engaging Gareth's interest too. Paderewski was on the hot seat. He had to secure the political and geographic integrity of his country, still in the labor pains of birth.

When Paderewski arrived in Paris, Georges Clemenceau, the "Tiger of France," held out a gloved hand to welcome this rare genius. With a wink, the French minister and president of the Peace Conference asked the new premier of Poland, "Are you related to the celebrated pianist, Paderewski?"

The Pole bowed, playing the moment to its fullest, "It is I, Monsieur Le President."

Clemenceau retorted with mock surprise, "You, the famous artist have become prime minister? What a comedown!"

Gareth liked the notion of the gloved hand. My father explained that the glove was needed because the famous French minister had a skin disease. Gareth was sure he had seen the movie on TV.

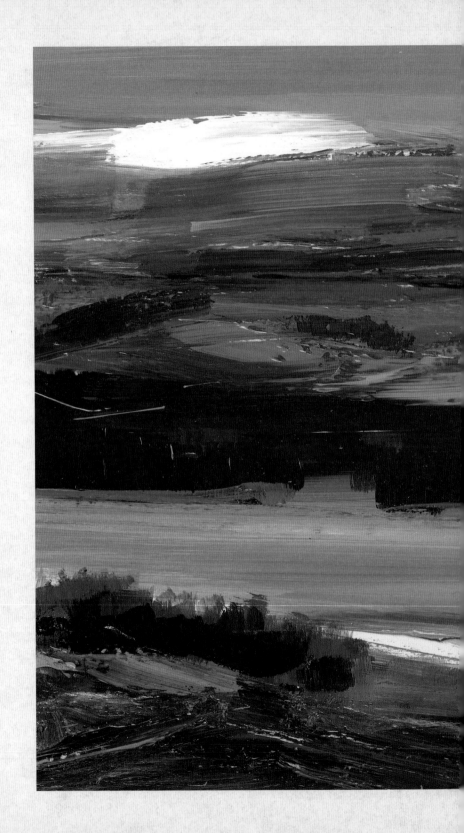

NACIMIENTO
Oil 8¹/₂" x 14" 1994

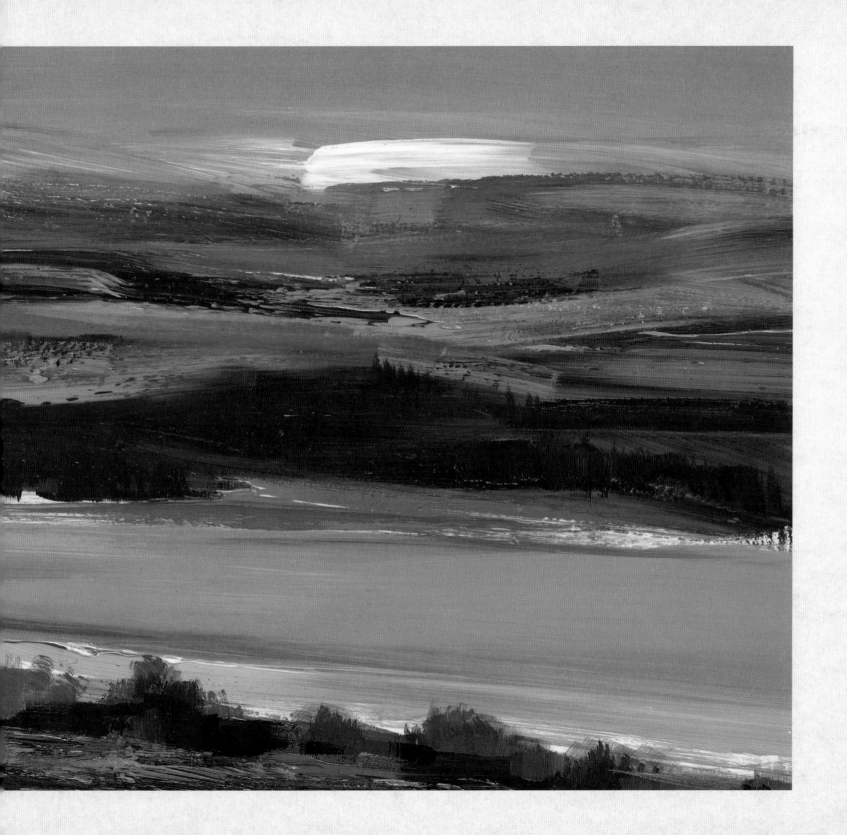

Clemenceau's repartee was the lightest interchange the pianist-prime minister would experience during those tense days. Paderewski, though he signed the treaty for Poland, was ultimately crushed by the outcome of the Conference.

By the end of the year 1919, Poland was embroiled in political intrigue, cunning Machiavellian back stabbing, and behind-the-scenes subterfuge.

On December 5, 1919, in a stunning act of principle that defined his particular statesmanship, Paderewski resigned as premier of Poland. Even his political supporters misunderstood the soul of the artist and the voice of his conscience.

He was a rarity then. And, my father added, "A rarity now. Everyone assumed that he would simply and submissively follow the rules of the game."

"Politicians who don't sell out are discarded with as much relish as artists who don't sell out," I added, anticipating my father's concluding moral for the Paderewski story.

But my father surprised me. "Paso Robles is where our final act begins. A setting for the celebration of the creative spirit."

"Paso Robles, really?"

My father explained that Paderewski, into his sixties, decided to resume his concert career. He was painfully aware of his age. He was painfully aware of the pain throughout his body, especially in his fingers and hands. Paderewski's creative courage never abandoned him, but he had only one chance and one place to regain his strength of body and mind.

"Don't tell me," I said to my father.

"Paso Robles."

To perform again, he returned to the only place on earth that could provide the rejuvenation he so desperately required. He came back to his farm and the glory of the Paso Robles sun, to the sulfur baths and healing waters.

"Paso Robles worked its wonders. He resumed his career and enjoyed a personal artistic triumph that would have no equal, even to this day."

When Paderewski died in this country on June 29, 1941, President Roosevelt ordered that the pianist be buried at Arlington Cemetery. In the chapel, his glass-covered casket rested before his piano, closed forever. A stream of mourners passed silently by, day and night.

Leaders and artists around the world expressed their sadness. The Supreme Court's Chief Justice, Harlan Fiske Stone, voiced the judgment of the world: "Paderewski is certainly the world's greatest pianist, and he is perhaps the world's greatest living man."

My father had me hooked, and he knew it. "So what do you think?"

"Think of what?"

"The Paderewski story." My father was earnest. "The Paso Robles theme. The artist as political saviour. The artist crucified. The artist resurrected."

"I like his story, but we gotta change his name." I was playing studio mogul.

My father winced. I continued teasing, "Who would play Paderewski?"

My father had that covered. "Your mother took a survey at her bridge game. The winner was Liberace."

I was unnerved. Such casting was actually probable.

"We should write the script."

"I have a school to build first. You can teach a course on Paderewski."

"I don't know, but I'll do the research for the script. We can work out a schedule."

"I've also got to feed my kids. I have to work that into the schedule."

Gareth

Kids? I realized I had not heard a peep from Gareth. He had disappeared.

I was seconds into panic when a shaggy blond head bobbed up from the willow-lined creek. Gareth had muddied his shoes in hot pursuit of the frogs that were warming up for their evening chorus. I argued that frog legs were not on the night's menu. Our objective was the collection of kindling for the fireplace and flowers to brighten the dining table.

Not dissuaded, Gareth conned his grandfather into joining the hunt for little jumping creatures. As they followed the creek into frog territory, I succumbed to the lonely splendor that engulfed us.

We were three generations. Our lives would ultimately span more than a century. I was gripped with a primitive euphoria, painfully ecstatic and overpoweringly sad, a precious moment that would never be repeated.

I wanted to freeze-frame this time fragment. There was an age not very long ago, when fathers and sons and grandsons, as a natural part of every day, worked the land together, linking their precious time between eternity.

I resolved to make the ranch-school a reality. I desperately wanted the primal time-bonding as shared by the thousands and thousands of generations before this father and son and grandson.

* * *

The next morning, skipping breakfast, Wendell and I roamed the hills determining the ideal orientation for classrooms and dormitories. The architecture would be rustically simple. My father had offhandedly proposed the basic, native style.

During the frog leg course (yes, he and Gareth caught a few croakers which Marian gladly cooked to my son's specifications) my father floated the name Henry David Thoreau of Walden Pond, the poet-naturalist-philosopher whose *Walden* is the classic guidebook for anyone shaking off the yoke of materialism.

My father, never one to waste a captive audience, just happened to have some of Thoreau's works with him. Over Indian pudding (Marian's appropriate desert), he shared the wisdom of Walden Pond's patron saint:

"I went to the woods because I wished to live deliberately, to confront only the essential acts of life, and see if I could not learn what it had to teach, and not, when I came to die, discover that I had not lived."

My father turned to me as he finished the quotation. He tried to top it: "If you have built castles in the air, your work need not be lost; that is where they should be. Now put the foundation under them."

I plucked *Walden* from my father's grip and went to bed. I read myself to sleep. My last compelling thought was to build a reproduction of Thoreau's cabin. Its simplicity and purity would be a symbol for the land, the school, and maybe someday for my life.

Wendell and I were inspired to use indigenous materials for the buildings. Everything would be harvested from the land. Slender pine logs, sturdy oak for planking, creamy white limestone—all in abundance around the ranch—would ensure harmony between building and land.

Initially, to save costs and perfect our architectural theme, Wendell thought we should construct tent camps with wood plank floors and tarpaulins overhead.

The idea made a lot of sense. Over time, the students themselves would erect the school structures as part of their curriculum.

Thoreau thought it was a shame to relinquish the pleasure of construction to the carpenter. He would be proud of us as we confidently advanced our dreams.

THREE GENERATIONS *Oil* 10" x 13" 1994

133

VINEYARD SKY
Oil 8" x 12" 1992

134

Wielding a big pad and pencil, I drew the overall layout. We clustered our first permanent constructions in an oak grove at the ranch center. A hub building, divided into offices and classrooms, would be the base of school operations. Another barn-like edifice functioned as the mess hall. Smaller cabins, scattered about the area, served as sleeping quarters. Six to a cabin.

We designed through lunch, possessed with acute designitis.

Marian and Betty brought us roasted green peppers and olive oil on Italian bread, all in a picnic basket, and ice cold beer in a cooler. Wendell and I wolfed down our favorite sandwiches, made famous by our grandmother, Rosa.

While our mouths and hands were full, our wives insisted that we join the family after lunch. They reminded us that the weekend agenda was to unwind, relax, and have fun in the sun.

Wendell explained that nothing was more relaxing, more unwinding, more deliriously fun-filled than master planning Thoreau University. I resumed drawing. Sure enough, Betty and Marian got sucked into our site planning mania, putting in their two cents.

"I think all the buildings should be up in the hills."

"Oh, really." An oversensitive, peevish artist, I tried to contain my annoyance. Marian and Betty were unable to comprehend the natural architectural continuity in the location that Wendell and I had so carefully chosen.

"Listen Frank Lloyd Wright, you're frankly wrong." Marian snatched my pad from me. Flipping through my sketches, she and Betty adamantly opposed our initial tent concept.

"Completely impractical."

They also made mincemeat of our living-off-the-land second-phase architecture. They hit us in the pocketbook, depicting our layout and our evolutionary student-built architecture as a mine field in hidden expenses and potential lawsuits. "What if a beam beans junior carpenter?"

Thoreau had made no impression on them.

They had ruined our play hour, and Wendell and I wrapped it up for the day. We would come back another time when no grown-ups were around.

Upon reflection, our master plan was a little goofy; affectedly "natural" and "organic." In reality, cutting and shaping hard, hard oak planks would be a hard, hard task. Very few soft pine trees, in fact, grew on the property. Building in stone would be no lark either.

The next few weeks were a marathon of mad design. A 320-acre building site encourages endless obsessive-compulsive drawings, layouts and schematics. I would drop off to sleep buried in sketchpads and sourcebooks. There was no known cure.

After exhausting Post-Thoreau Primitivism, I went to Classic Barn with a Palladian twist, then flirted with Bauhaus and American Industrial. I played with Greek Revival and Romanesque. I took a run at English Domestic and French Country and finally ran out of steam with New England Colonial and Neo-Prairie.

Wendell and I returned to the ranch to hammer out the details of our plans. Clint Rhodes had moved in, but conveniently he was going away for the weekend.

Clint's check had stumbled at the bank; insufficient funds. He apologized for the bank's "screw up," and I believed him. He promised to leave a "good one" on the kitchen table.

Wendell and I needed a survey and an elevation map, so we went about interviewing engineering firms. Choosing a company was simple. Anxious to get started, we hired the first candidate who was willing to jump in on the following day, which was Sunday.

Waldo Willoughby of Willoughby Engineering was ready to jump. He agreed to meet us out at the ranch early Sunday morning.

Despite plans for a no-fat, vegetarian protein powder dinner that night, Wendell and I went into town and pigged-out on Wilson's barbecued pork ribs. Idealistic concerns about diet and the evils of fat somehow disappear in the smoke of a Paso Robles barbecue.

Wilson's glorious grease concoctions were a lodestar that evening, pulling us in to celebrate our first step toward the realization of Thoreau U.

While meticulously gnawing my last pork rib, I noticed a familiar face at the booth opposite Wendell and me. Familiar face recognized me. I was looking at Randolph Scott, the Jack Ranch horse wrangler I'd met at the Loading Chute.

I waved. He nodded, tipped an imaginary Stetson, picked himself out of his booth as if he were sliding off a saddle and ambled over to our puffy plastic table.

I introduced Wendell and invited the cowboy to sit for a moment. Randolph brought up our conversation in the Loading Chute: "Still interested in a horse operation?"

"Well, I postponed the idea for a while."

"I've been meaning to look you up. Had a proposition."

Cleaning rib grease off his face and body, Wendell glanced at me curiously.

I sputtered in my vague way, "Well, a few things have come up." I stopped. How could I explain that I was building a Walden-inspired school on my pasture land?

Randolph cut in: "My friend is pulling up stakes in a horse operation near L.A. I've a chance to move it to Paso. If I could use your land, I'll split everything with you fifty/fifty."

I envisioned the sculpted perfection of muscle-etched stallions prancing across manicured fields. I painted a picture of crisp white fences crisscrossing sparkling green pastures. Sleek mares and their foals grazed in tidy corrals...

Wendell took advantage of my reverie to engage Randolph Scott head on: "We're starting a camp on the land."

"A camp?"

"Summer camp at first."

"For Boy Scouts?"

"No, just a camp. And later, a school."

"Is there good money in that?"

While Wendell searched for a cultivated Thoreau-like answer, I pondered another question: Why not establish both enterprises? Why not a school on a horse ranch?

Wendell read my mind and didn't like it. His answer to Randolph was directed at me.

"The money works out…if you don't bite off more than you can chew."

"Unless you got a big mouth." Randolph tipped his imaginary Stetson and headed back to his booth. "Give it some thinkin' time. You can find me at Jack Ranch. Here's a card, my number's on it."

I took it and thanked him, not sure for what. I turned to confront Wendell. He was reassessing the depth of my commitment.

"I'm not fooling around with anything," I assured him, "except getting this school going. It would be a good idea, though, if we fell into the right deal, to bring something very ranch-real onto the scene. A little thoroughbred operation wouldn't be bad for…well, atmosphere."

Wendell squared away. Creating this school would take all our energies and brilliant ideas, and a good deal of money. No distractions, please.

I couldn't disagree, and I couldn't explain, not to Wendell or to anyone. I simply wanted it all, the whole package. I wanted horses and cows and sheep and fruit orchards and row crops and acres and acres of vegetable gardens and barns and barnyards with hens and turkeys and ducks and a pond with catfish and bass…and now I wanted a school too.

The next morning, a knocking at the back door woke me up. It was Waldo Willoughby. Shaking sleep away, I greeted him. He apologized for waking me up, but I had told him to get there early. This was early.

Wendell came down from the attic, looking more presentable. I offered Waldo breakfast, but he was anxious to start.

We guided Waldo's Jeep to the spot where we wanted to group the main school buildings. I handed him my version of a plot plan and some elevations and perspective renderings. The drawings gave him a good idea of what we had in mind. He pointed out that we needed an overall survey map with metes and bounds.

VERDANT LAND *Oil* 7" x 8" 1992

"Have you been to the county yet?

Wendell and I shook our heads. We wanted to get a little further down the road before we hassled a building permit.

"I'm not talking about a building permit." He studied my elaborate drawings, some in color. "A project of this size is going to need an EIR."

"What's that?" Wendell turned to me.

"Environmental Impact Report." Waldo told us that the EIR would involve engineering, which he could handle, and also things like our proximity to a fire department, traffic considerations, and our water supply. "They cover everything. It's a pretty big deal."

My stomach was suddenly a gnawing pit, and not because I had skipped breakfast. I got to the heart of the matter. "What will it cost?"

"The engineering part won't set you back much, but by the time you pay all the consultants, it could run as much as fifteen to twenty thousand dollars."

"Twenty thousand dollars?!" Wendell and I were a duet of disbelief.

"There's also a public hearing."

"Public hearing?!" The chorus of gloom continued.

We were barely out of the blocks. And, as Waldo explained it, you pays your money, then it has to be approved. "And it's never a sure thing. Right now the county's anti-growth."

"Even with a school?" I pleaded for some encouragement from Waldo. "They turned down a hospital recently," he said mercilessly, then tossed us a ray of hope. "Of course, you're way out in the boonies here, I don't see how a project like this would get anyone's dander up."

"Of course not! Who in the hell would object to a country school for city kids?"

With that settled, the thought of the fifteen to twenty thousand dollars came back to clobber us again. Wendell and I had never discussed how the project would be funded. If start-up costs were limited to a few thousand dollars, no big deal. But to invest the bucks Waldo predicted, before a building permit could even be secured, presented a major hurdle.

A couple of glum guys, Wendell and I, followed Waldo around the ranch, lugging his surveying paraphernalia. Wendell was deep in thought; I was deeper. We had to come to terms on money, and who was responsible for what. Wendell was a teacher, and teachers pretty much make it from paycheck to paycheck. But he and Betty would put in most of the work.

On the other hand, I was supplying the land, and I'd already devoted a lot of time to the project.

We were not ready. We needed to think and discuss it with our wives.

As we headed back to L.A., Clint Rhodes drove up in his truck. I introduced Wendell and mentioned to Rhodes that we were surveying the ranch. He didn't seem to care why.

I started to ask whether he had begun to clean up the ranch, but obviously things were exactly the same as when he moved in.

He reached into his truck and took out two guns to bring inside the house. One strange looking weapon, Clint explained, was a police-issue automatic shotgun with a swiveling recoil yoke at the rear of the receiver. He proudly pointed out a fitting for attaching a special flashlight on top.

"Great for frog hunting." Clint had an offbeat sense of humor. He claimed that noisy frogs sometimes kept him awake at night.

Equally proud of his other oddball piece, Clint called it the Enforcer, a pistol-stocked version of a military carbine. "This baby has a magazine capacity of up to thirty rounds, and it's super compact."

I feigned interest. I hadn't held a gun since my pathetic Army days. Wendell seemed slightly curious. Clint loaded up the gun, showing my cousin how it operated and where to hold it for best aim.

Wendell followed instructions and drew a bead on an oak tree about a hundred yards away. It disturbed me to shoot at an ancient oak, and I insisted that Wendell simply aim at the hill. Besides, the hill was a target he couldn't miss.

Wendell fired. I had forgotten how damned loud a rifle is. Clint and Wendell took turns blasting away, and I walked off to protect what hearing I had left.

Later, as we drove back to L.A., Wendell asked if I had gone up to the attic. I had forgotten to. Wendell said that he had opened the closet and thought he'd stumbled into an Army Reserve unit armory. He had never seen so many guns in one place. Was Clint a gun runner, or was he planning an insurrection?

"He just loves guns, I guess. I've seen the type."

The guns might've bothered me, but I was preoccupied about rent checks I hadn't received. Clint had made a big production about his first payment finally clearing the bank, but he'd been living in the house going on three months. He actually owed me three rent checks.

I was a pitiful landlord.

I calmed myself. If any low life broke into my ranch again, he'd be confronted by a hundred rifles and shotguns. A one-man army was guarding my house. That was worth something.

Back in the land of peace and tranquility—Los Angeles—Wendell and I tackled the Environmental Impact Report issue. I took a one-day trip up to the San Luis Obispo County Building Department to verify that we were subject to the costly report.

Indeed we were. Also, the report would be reviewed by the county supervisors. After a public hearing, the supervisors would vote to either approve or reject the project.

The clerk droned on about the procedure. For some unexplainable reason, I thought of Clint's houseful of guns.

I pictured myself blocking my ranch entrance. Armed to the eyeballs with Clint's pistols, rifles and bandoleers, I pronounced to the shrinking, trembling inspectors and supervisors that I would build exactly what-in-the-hell I saw fit to build on my holy domain.

Back in law-abiding reality, I compliantly accepted all the forms and explanation pamphlets on the EIR procedure. And I said automatically, if not politely, "Thank you for all your help."

Wendell and I agreed to split the initial costs. Most of the EIR expenditures, mainly the survey map, site plan and architectural renderings, had to be undertaken anyway. So we hired another company out of San Luis Obispo to prepare the report and guide us through the labyrinth.

In the following weeks, I spent more time in Paso Robles than in Los Angeles. Wendell worked Monday through Friday, so his visits were confined mainly to weekends.

We stayed at the house, but Clint Rhodes was seldom there. It suited me fine. Conversation with Clint, once we finished discussing rent, was quite lacking in content. Clint's gun collection had grown, or else he was leaving more guns around. I thought it wasn't a good idea to have so many lethal weapons strewn about (except when county inspectors or supervisors show up). Clint would grudgingly put them away. But next time, more firepower than ever before would be on display.

I didn't know which of my two tenants annoyed me more: McCutcheon, with his piles and piles of firewood, or Clint Rhodes and his ammo dump.

I finally got another rent check. Two in six months was a victory for me. I was perversely entertained by all the excuses that Clint made up. After the incompetent bank routine, this ex-buddy who owed him money had bounced a check on Clint. His mother's emergency operation was a touching story and good for one month. Quitting his job got him by with almost two months. When I thought he couldn't possibly come up with any more excuses, he laid one on about his girlfriend's horse coming down with a mystery virus.

I wasn't getting any more rent checks, bouncing variety or not, out of this guy. He was unemployed, his only friends bounced checks on him, and he had to look after

his sick mother and his girlfriend's sick horse. I, frankly, saw no money coming my way.

Rhodes also hadn't done a lick of work. The ranch looked a little sadder every time I went up. Clint was not even around enough to be an effective watchdog.

I left Clint an eviction notice one morning before I went back to L.A. It was a thirty-day notice. I wanted Clint and his guns off my property.

Wendell and I received the final EIR and submitted it to the county. We were told that the project would come up for public hearing in forty-five days. Notices would be mailed to all surrounding property owners affected by the project.

We had done all we could. It was a question of waiting out the county's say about our future.

Wendell and I had come to a consensus. We would concentrate on the camp program for the first year, perhaps even the first two years. Betty had arranged with Pinewood, the multi-campus private school that she administrated, to sanction our summer camp, ensuring a successful foundation for our school to follow.

Wendell was prepared to take a leave of absence from teaching to devote full time to the project. Everything was falling in line, and even better than we had anticipated.

The public hearing took place on a Monday county supervisors session in San Luis Obispo. Instead of driving up on the Monday, we made a weekend of it. There were plenty of things for Wendell and me to do at the ranch. I wanted to meet a couple of contractors about a swimming pool for the camp.

The Clint Rhodes situation made staying at the ranch uncomfortable. I had extended his eviction notice for two weeks. It was Wendell and I and the guns.

On Sunday evening, I took a solitary walk up to my hill, the hill at world's end. As a sweet breeze played about the oaks, I gazed dreamily across the majestic composition of interweaving pastures and fields and woods, muted in colors and textures from the fading sun. It was a warm, embracing night. As moonlight spilled upon the little valley, I built the school once again. Carefully, I clustered the buildings in among the oaks, respecting the calmness and flow of the hills. I worked to keep the school consistent with the land, creating a farmscape of barns and stables and silos.

I envied the boys and girls who would come to our camp. I envied that time when life was shining, a time of simple but intense moments, possessing a passion that would never quite be the same. That moment when your fingers first slip into the hand of your camp crush. The moment around the fire when you hear the love song that you will remember forever. The moment you decide to swim naked in the starlight and the wonderful embarrassment when you think you've been discovered. The moment you say good-bye.

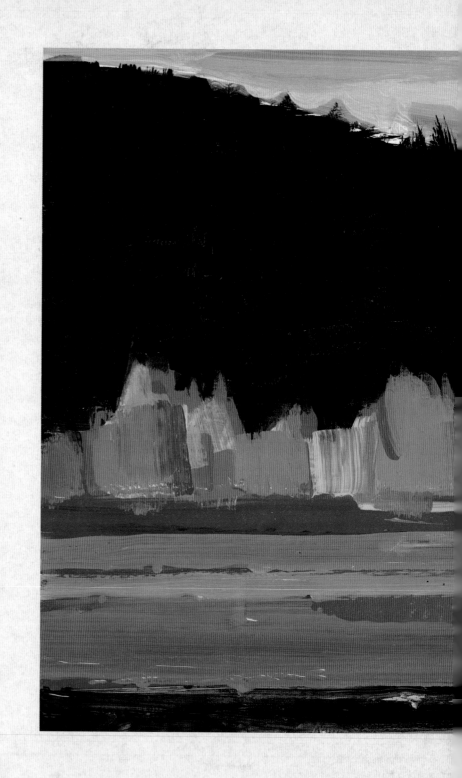

AUTUMN
Oil 6¹/₂" x 9¹/₄" 1993

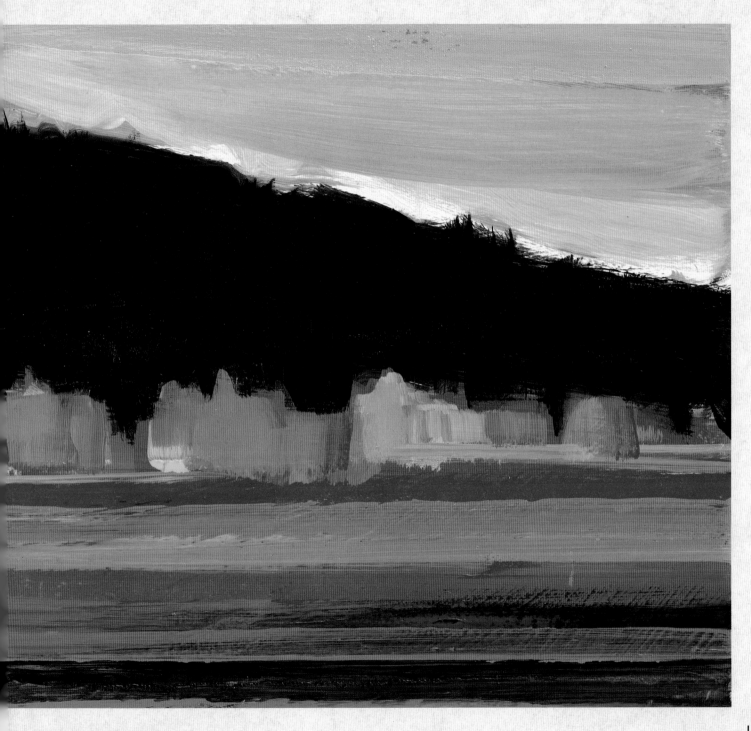

145

My parents had dragged me kicking and screaming to my first camp, a Unitarian Church summer program in the mountains above Los Angeles. I hated leaving my school friends just to go to a wimpy church event, and I sure as hell didn't want to spend all that time with my parents.

Those were dark days for Unitarians with loyalty oaths, blacklists, red baiting, a very cold war, and nuclear destruction, a nightmare that would not end. The Unitarian Church in Los Angeles, with Reverend Stephen Fritchman as its beacon, was a bulwarked refuge from witch hunts and a world gone mad.

Camp Radford was a blessed parcel of land above the tumultuous fray. My parents, too, enjoyed the respite from a society pressing hard for mindless conformity. For one week high in the mountains, those gloomy days brightened a bit in the mountain sun and in a universe filled with stars and tall pines. This was camp: a communion of nature and spirit, of contemplation and introspection, and for me, it turned out, a joyous celebration of youth.

The memory was ever-glowing as I sat on my enchanted hill. I was about to have a hand in another camp, in another time tense with conflict, with war in far off Vietnam. Perhaps this camp would be a refuge, and yet be the springtide for boys and girls.

But dammit, why wasn't I painting this subject matter? In high school, I briefly fancied myself as a Social Surrealist. Painting my apprehensions about atomic war, I was convinced that the true purpose of art was protest, if not agitation. I had ached to spread my message to all the people in all the world.

Absorbed in the matrix of the night, I knew that when art simply revealed a little of the secret of one existence, it had served its purpose well.

On Monday morning, Wendell and I shared a tart apple from the old orchard. It was the only apple overlooked by the birds that had not rotted on the ground. I cut it in tiny chunks and sprinkled our cornflakes. I made a point of having something farm-grown with every meal…no matter how it tasted.

We were relaxed and confident. Our camp was about to be sanctioned by the friendly little autocrats on the other side of the hills.

The San Luis Obispo Government Center is a chummy place. Blown-up historical photos line the walls, black and white recollections of the county's pioneer spirit of individualism. I assumed that spirit would rule this day.

Wendell and I found our way to the hearing room. A crowd milled about, waiting on the day's hearings. As they shuffled into the chambers, I recognized several of the good folks. They were neighbors, usually open and friendly. But today, oddly, they avoided my eye.

Wendell and I grabbed front row seats. The room filled quickly. Our project was first on the agenda. I spotted my closest neighbor, Rudolph Wiebe, toward the back of the room. Strange that he would show up. I couldn't catch his eye either.

The county supervisors filed in, taking seats at a long table on the platform. They seemed like farmers and small-town folk, regular people who would look kindly upon a camp and school.

After a few introductory remarks by the head honcho supervisor, he and his county cohorts were talking about our project. A studious looking soul from the planning commission read from a report he had prepared. The supervisors, each given a copy of our EIR, leafed through it as the planning commissioner plowed ahead.

The planning commissioner placed a chart on the wall, an enlargement of our plot plan. Next, he fielded questions, mostly technical, by various supervisors.

The commissioner wrapped up his report, and the head honcho called for comments from the audience.

With the first words, everything went wacky and out of sync.

In a blur, neighbor after neighbor (and even neighbors I never knew existed) stood up and spoke against approving our country school. At Wiebe's turn, his comments, although measured and unemotional, hammered my gut like slugs from one of Clint's automatics.

Wiebe warned about traffic problems. Such a school would create a constant danger with youngsters driving back and forth on a narrow, windy country road. Wiebe embellished his case, positing that the agricultural character of the community would suffer from an influx of wealthy private school kids from L.A.

Simply put by citizen Wiebe: "A private camp and school like this is just not right for our farming community."

I couldn't comprehend this turn of events. Wiebe, my neighborly next-door neighbor, a man of few words whenever we discussed anything, was swaying a packed council chamber with homespun oratory.

At the end of the onslaught, I sprang to my feet, but my words, disjointed at best, fell on deaf ears. The damage had been done. My neighbors were adamantly opposed, and we were unprepared for a proper rebuttal. Wendell and I, in effect, were seen as L.A. promoters attempting to make a fast buck at the expense of the peaceful, rural character of the community.

The supervisors called for a vote. It was a voice vote—each supervisor was asked for an aye or nay.

Our Walden school was soundly defeated.

Everything drained from me, but I mustered one clever retort. Under my breath, I muttered, "You can all go to hell."

On the drive back to L.A., Wendell and I discussed our next move. We would hire lawyers. We would appeal. We would go to court. We would go to the media.

We were exhausted by the time we hit the city. It was late. Marian was asleep. She awakened and asked what had happened.

In my heart, I knew that we would not recover. Fighting the community and the county would take a long time—years. It was a monumental task that would drain our money with no guarantees at the end of the road.

I told Marian there would be no camp, there would be no school. Not now and probably never. She had already read the terrible disappointment in my weary eyes.

I climbed into bed, hissing and gritting my teeth. I made my vow: "I'll tell you one damned thing for sure, Marian. I'm going to build Thoreau's cabin on our property. And it will be done without a county permit, or I'll go to hell!"

STAR
ROVER

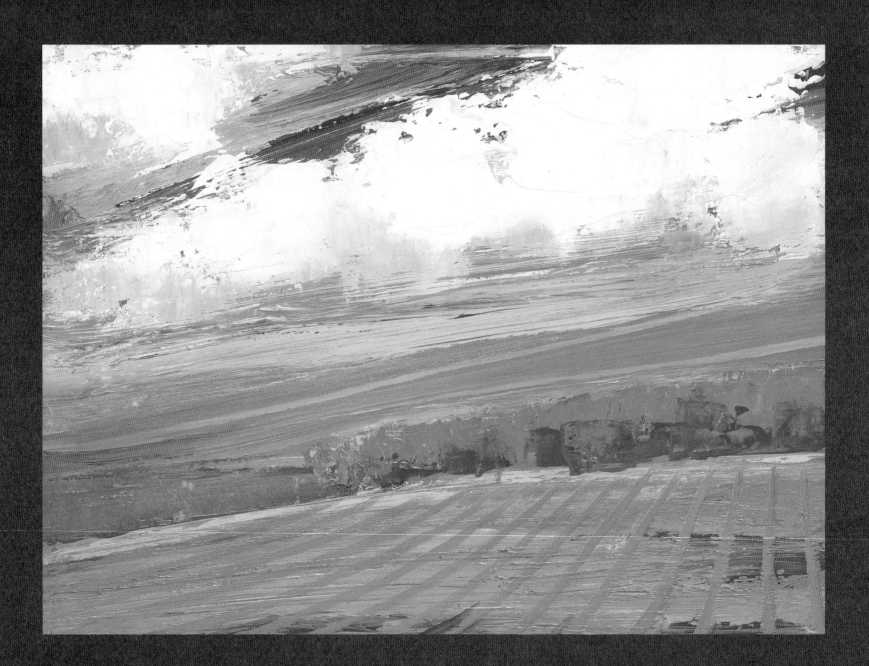

The obvious course of action was to stay home, sulk, and burn all my barn books, but being the actor/vagabond is emotionally handy on such occasions. I'd been denied my farm fantasy school, so I zoomed off to another planet.

While my Paso Robles neighbors were busy trampling my soul, my agent had been trying frantically to contact my terrestrial body.

If an agent can't reach his client within fifteen minutes, panic begins. Particularly if a job is at stake. And even more particularly if that job is a lead in a major series.

Marv Keller was the hot young comer at Hollywood's super-agency—GAC. Marv looked like a goatee-less Trotsky (my father's observation), but Marv didn't have a clue what a Trotsky was. A compulsive talker and bored listener, Marv was engagingly shallow—the consummate Hollywood ten-percenter.

Marv knew I was always "up north," out in the sticks. He couldn't fathom why. He seemed to comprehend that I had a ranch, and I liked riding horses, but couldn't I have horses somewhere in the Valley, like Calabasas or Newhall? Then I wouldn't have to be on the road all the time.

The morning after my farm-school balloon plummeted to earth, Marv was all over the phone with an offer on a "sure-fire hit" network series. The most powerful producer in television at that time, Irwin Allen, wanted me for a new show. This wasn't a pilot, Marv stressed. It was a "sold" series, and it was on ABC.

ABC, in love with Allen's concept and presentation, had bought the show, a full season, without a pilot. I had starred for ABC in *Burke's Law*, and the network wanted me as the lead in the new series. As Irwin Allen told Marv. "This show is out of this world!" Knowing Allen as a master of special effects and sci-fi, I suspected it would be a space opera. I was intrigued.

Acting in a television series is a real job. You show up every morning on time, work a long day, and go home very late every night—Monday through Friday.

This degree of commitment would severely crimp my habit of taking off for the ranch any time I wanted. A TV and film "freelancer's" obligations tend to be sporadic. A job lasts a few days, perhaps a few months. But a TV series contract requires full services for a year, unless it's a hit, which ties you up for God knows how many seasons.

After Marv's pitch, I asked what the series was about. In his enthusiasm, he had overlooked that detail. He explained that it was "like the *Shrinking Man,* except you travel to another planet. It's called *Land of the Giants.*"

"A modern day *Gulliver's Travels*?"

"Yeah, I guess."

I wouldn't bet that Marv was up on Jonathan Swift. Marv didn't read much. A writer friend once tried to get Marv to represent a script my friend had written. Marv liked the two minute pitch and agreed to sell the project. My friend asked when he wanted to read the actual script. "Read the script?" Marv replied, "I'll see the movie!"

My earliest memories of a darkened theatre were the captivating adventures of *Gulliver's Travels,* Max Fleischer's feature-length animated version. Years later, I was fascinated by the intrigue and timeless political satire of Swift's novel. The opportunity to play a modern day Gulliver wouldn't be such tough work after all.

I didn't let Marv know that. I had to negotiate my price.

There wasn't much to negotiate. Irwin Allen and 20th Century Fox, for the most part, agreed to my terms. In a matter of days, I was signed to play the captain of the ill-fated spaceship, the *Spindrift.* I was ceremoniously invited to the studio to view Allen's presentation and the special effects that would be a first for television.

So I didn't get to go to endless summer camp on my own property, but I could fly to another planet and play hide-and-seek with giants.

Wendell called a couple of times, trying to put things in perspective. We compared notes on sweet revenge and mulled over the possibilities of resurrecting Thoreau U. It was hard to quit a project that had fused with our very beings. It was tougher on Wendell. I at least still had the land and a fantasy television role. Wendell had reality.

One thing that remained was "The Rifleman." Clint Rhodes actually sent a check and a little note. I was so flabbergasted, I dropped the check. It didn't bounce.

The note said that Clint was looking for a new place, but he hadn't had any luck yet. I didn't think luck had much to do with it. He wanted to buy another month.

I sent a reply, thanking him for the check. I would apply it to the past months that he owed, and I expected him out of my house immediately. That's not what he had in mind.

I became very busy with the premier episode for *Land of the Giants*. Wardrobe fittings, learning lines, and network promotions ate up my day. I had no time to get up to the ranch and figure out what to do in the aftermath of our school debacle.

I wanted to recruit my cousin, John, again to handle some long overdue repairs. My barn, still leaning precariously, needed to be rebuilt once and for all. I didn't want to lose my future studio—at least one of the sites under consideration.

The problem with John was his endless rhapsodizing about his turning my ranch into a thoroughbred farm. I had my own daydreams to resist.

I also had to decide what to do about the new season's crop. I couldn't face Wiebe. I needed some other person to farm the place.

Winter was coming on; the storms seemed to be arriving early. To a city dweller, rain means morning traffic snarls, but farmers live and die with the weather.

During the second week of filming *Land of the Giants,* I received a call from Clint. Paso Robles had just been creamed with one hell of a squall. Power and phones were out for a day, Chimney Rock Road was washed away in several places, and…my barn…

He paused. I held my breath.

"Your barn blew down."

I reeled from Clint's weather report. A huge limb from the giant oak in the front yard had snapped. Everything was a mess. My poor barn crapped out! It hit me, and I buckled with remorse. A death in the family…it was my fault. Always procrastinating. Postponing the basics while flying to the moon.

"How bad?" I croaked in self-reproach.

"How bad, what?"

"The barn."

"Totaled. All on the ground. Pieces everywhere."

I had one filming day left. It had been a relentless week. Irwin Allen, television's Otto Preminger, was directing the initial episode. He was no picnic. Up every morning at 5:30, I'd worked at least twelve hours every day. I had planned to sleep in on Sunday, take it easy…

I had to get to the ranch and assess the damage. I wanted to find a miracle to salvage the barn.

"I'll be up on Sunday."

"I'd like to see you and discuss things, but I have to go to Bakersfield. My mother's sick."

I muttered something close to, "Oh, really?"

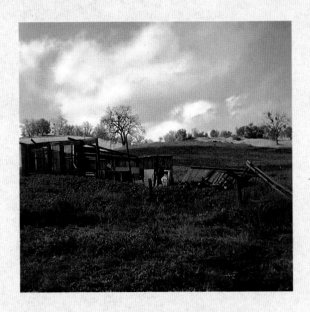

The Barn 1969

I was glad Clint wouldn't be at the house when I faced my barn tragedy. I also didn't want our inevitable confrontation on my day of "relaxation." I had to kick his gun-totin' butt out of my house, and I probably needed a lawyer to do it.

When I arrived in Paso, it was raining again. Despite scattered mud slides and fallen trees, Chimney Rock Road was passable.

I finally reached the ranch and parked my car at the gate. The washed-out road to the house was too muddy and slippery for a car, as evidenced by the side-drift tire tracks from Clint's four-wheel drive truck.

I tramped up the drive. Closer to the house, I saw the open field where my barn once stood. Clint's description was accurate: "blown flat." Barn siding and tin from the roof were flung everywhere. A couple of pieces had lodged on a hill a hundred yards away. It looked like a tornado had hit.

My mud-caked shoes sank deeper with every step. A drizzling rain picked up momentum as I slogged toward the barn's concrete slab. I glowered down upon the naked, forlorn foundation. I glanced up. The angry heavens pelted me with rain. I voiced an epitaph for my dearly departed barn: "Shit!"

After a silent reflection or two, I headed for the house. I got to the rear porch and realized that the house key was back at the car. Hell. I stepped under the covered entrance way, removed the gluey mud from my shoes, and dried off a bit.

I squinted through a glass panel in the rear door. Guns were visible everywhere, even in the kitchen. A couple of days' worth of dishes were stacked in the sink. Trash lay in between the guns. I gave Clint the benefit of the doubt. It was hard to take trash out in the mud.

The fireplace was surprisingly free of ashes. Next to the fireplace were a couple of paper-wrapped, "instant" logs, bought at a market. There wasn't a stick of real firewood anywhere, about the house or yard.

What a duo I'd had in this house. The world champion log-chopper, with stacks of logs dwarfing the house and fires roaring all of the time. And the world record gun-hoarder, with two dinky store-bought logs despite a forest all around him.

Looking at the guns, I wondered how the marshalls would react when they tack my notice of eviction to the door. Then I realized the sheriff's department would be doing the dirty work up here; probably stellar detectives, Amos and Columbo, who were such a big help on my robbery.

Clint would invite them out for a pig hunt. With five or ten guns apiece, they could obliterate the entire countryside. Maybe they'd miss the pigs, and shoot out the windows of a few of my neighbors.

I tried not to be bitter.

After several intense weeks fighting giants, I had to tackle the jolly green variety. I called Archie Hansen to find out exactly how he handled his farming. Hidden Valley Ranch's several hundred acres of cultivation were exceptionally orderly.

Archie had a contract with Warren Stemper's Central Coast Farming, Inc., the largest contract farmers in the area. Stemper's company farmed about thirty ranches in the region. Archie assured me I would be happy with him.

I phoned Stemper. The down to brass tacks voice at the other end didn't seem to care whether he farmed my place or not. I tried to convince him that farming my 320 acres would be good business for his company.

Stemper, in fact, knew more about my Chimney Rock Road farm than I did. We skirted the issue of Wiebe. I assumed he knew about the stinging defeat my neighbors had dealt the Thoreau school project. The word must have been all over town.

Nothing about the previous year's non-farming was raised in the discussion. In fact, it wasn't much of a discussion. Stemper essentially gave one or two word answers to complex questions. At the end of the chat, I was almost certain I had a deal with Central Coast Farming, Inc.

The Stemper conversation showed how modern farming had come down to associations with city-bred oddballs such as myself, who were possessed with the idea of owning and working a farm, and had a regular job (must be high paying) to support this addiction.

It's more efficient to contract with a farm management corporation like Central Coast. The companies, fully insured and well financed, have up-to-date equipment, and trained and licensed operators. Dealing in large numbers, they have leverage to negotiate the best prices when selling their clients' crops.

It was time to get my farmhouse in order. Serious about throwing Clint Rhodes out once and for all, I looked up attorneys in the Paso Robles *Yellow Pages.*

Just at this point, a cousin of a friend of a cousin (I might have it backward), Armando Pepitone, heard that my father and I were writing scripts. (In Italian families, confidential information travels fast.) Armando sent me a huge envelope stuffed with a couple of hundred typewritten pages. After glancing at the rambling mess, I tossed it aside.

A few days later, Armando called. His blunt, thunderous voice was an assault weapon. I pretended to have read most of his pages and that my father and I weren't interested in the subject matter at this time.

Armando asked what I was interested in. Presently, my father and I had been discussing a script based on the mathematical genius, Evariste Galois.

"Who the hell is he?"

I patiently explained, Galois possessed the most astonishing mind of all time. Armando breathed heavily. There had been other geniuses—Aristotle, Da Vinci, Einstein— whose achievements had been more universally recognizable. "But Galois's great work, an incredible mathematical breakthrough, was set down in the last thirteen hours of his life…a life cut short at twenty."

"How come I never heard of him?" Armando sounded unimpressed with the tragic story of Galois.

"For that very reason, his life would make a great movie. We're also very interested in the story of Paderewski."

Armando wouldn't bear listening to my Paderewski pitch.

"Instead of writing about people from a hundred years ago that no one ever heard of, why not write something about now, that every Tom, Dick and Harry would be interested in?"

Armando could be running a studio. Armando insisted that every incident in the pages he had sent me was true. He wouldn't admit to witnessing everything in the story, but he swore it all really had happened.

"You write it, and I'll make you a partner in a gold mine." Armando began to fascinate me.

"Did you say gold mine?"

"Yeah, it's out on the way to Vegas. Baker. Y'ever hear of the place?"

"I think I know where Baker is."

A few years back, Armando had helped out an old desert rat, giving him money. Later, on his death cot, the prospector had signed his claims over to Armando, along with a secret map to the exact location. I was skeptical.

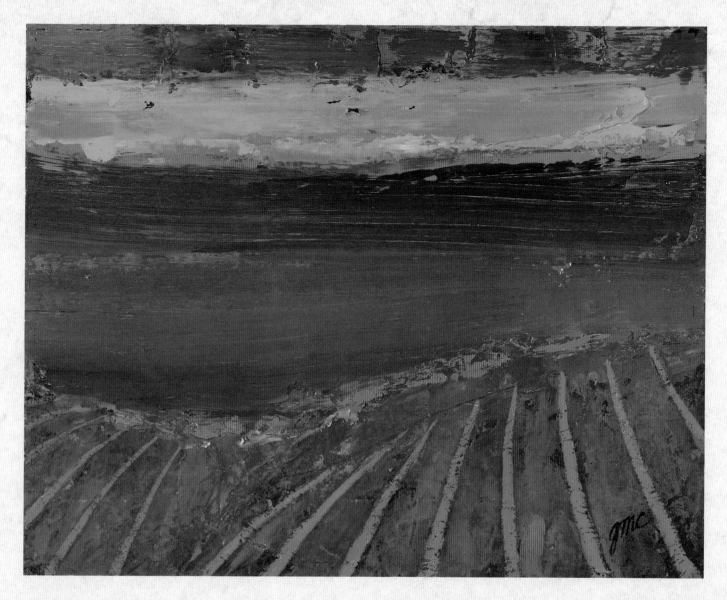

VINEYARD COLORS *Oil* 11" x 13" 1993

Armando sent me recent assay reports of ore recovered from the mine. He underlined some of the assayer's notations. The word "gold" stood out in several places. It looked good enough. I agreed to accompany Armando, his wife and his son, to the desert "to check out our mine."

Armando was a craggy man-mountain. His bulk and his stories took up most of his Buick. A captive passenger for the several hour ride to Baker, I was now "family" to Armando, and he made me privy to his unusual past.

Gangland…Little Italy…the Mafia and the Black Hand…the rackets and the Teamsters. Armando only owned up to his work for the Teamsters. He kept people alive, most of the time, and he had the scars to prove it.

He'd come out to California and left that world behind, for "good." He bought into an ice cream business…a little fleet of ice cream trucks (Teamster influence, presumably). He also owned rental buildings in the toughest parts of town, places no landlord in his right mind would consider.

I was curious about his eviction techniques. I imagined that he had his meaty hands full, considering the neighborhoods he was talking about.

Armando downplayed his problems with the deadbeats and dopers. No rent? Out on the street, pronto! Of course, not too many were close enough to Armando's weight class to argue.

"Eviction notice." Thundering with laughter, he made a big, gnarled fist. "This is my eviction notice!"

His tenants knew the rules. Armando made it clear from the get-go.

"If they don't pay, they're out the window. I take their welfare check, their booze, lizard shoes, their gold teeth…to get my back month's rent."

And I thought I had a tough tenant.

We spent the rest of the day prospecting and guzzling soft drinks and water. And more soft drinks and water. Baker makes Death Valley seem like a mountain summer camp.

I had no idea what I was doing. The "Enforcer" didn't have a clue either. He took more, bigger samples for further assayer tests and tried to figure out how much land "our" claim covered.

By that night, my prospecting days were about over. If there was gold in them hills, it would take a pot of money and most of a lifetime to recover it.

A couple of weeks later, I showed the assay reports to a cousin who had spent twenty years in the desert looking for gold and other precious minerals. He said the reports didn't mean much. Traces of gold could be found anywhere.

Now that I was a "partner," Armando kept pressing his script material on me. He wanted to talk my father into writing for him. I made excuses for my father, saying he was much too busy. Armando wanted to hear this excuse for himself.

One weekend in Santa Barbara with my parents and kids, we celebrated my father's birthday. Armando had contacted my mother, claimed distant cousin status, and finagled an invitation to the family celebration.

While we were all walking the sands along the bay, my mother mentioned that she and my father would like to drive up the coast and stay at the ranch that night.

I dissuaded them. Clint Rhodes was still occupying the house. My mother thought I had gotten rid of him. He hadn't paid his rent. That was all Armando heard.

My Parents

"Didn't pay his rent?!"

"Yeah, there were a few times."

"How many months does he owe ya?"

I downplayed my ineffectiveness. Good thing Armando didn't know about my previous squatter.

"Four or five months, I guess." It was twice that amount.

"Let's get in the cars. We gotta take care of business."

The Enforcer had surfaced.

"But it's a good hour and a half from here."

"What's an hour and a half compared to five months?"

"What if he's not there?"

"We'll wait for the loser."

We were back to the cars. I drove my family, including my parents, in my auto. Armando, his wife and his twelve-year-old son, headed up in his Buick.

I hoped that Clint wouldn't be at the ranch when we arrived. Usually he'd be tending the sick horse or broke mother.

My parents and Marian were oblivious to the impending confrontation. They didn't really know Clint the tenant, and they knew little about "cousin" Armando. I knew, but I didn't want to spread my panic.

Armando was brutally single-minded—pay your rent, or out on your ear. Big, all-macho Clint surrounded himself with guns and loved to use them. Armando wore heavy topcoats to deflect bullets at close range. He wasn't deterred by the guns of some rough and tumble clown who refused to leave a rental that he wasn't paying for.

We got closer to the ranch. I had to disengage Armando from his self-contracted mission. We were on a collision course. I would stop Armando at the front gate and simply tell him that I must handle my own business in my own manner.

But the driveway gates were wide open. Clint was home. I slowed my car at the entrance. Armando zipped past, not realizing, apparently, that I was signalling him to stop.

Armando pulled up to the house and jumped out of his Buick. I drove up. Clint was at the back door, meeting Armando. I was too late to stop it.

Face to face with Clint, Armando didn't bother to introduce himself, simply asking the man standing in front of him if he were "this Clint."

Clint nodded. Armando brushed past him into the kitchen. Off balance, Clint couldn't size up this ponderous man, or figure what was up.

Clint followed Armando into the house. They drifted into the dining room, where Clint was in reach of at least a dozen guns. Armando had barely spoken three or four words. Clint was equally silent, but he knew bad news had arrived.

Surveying the house, Armando ignored the artillery lying around. He glanced out the back door. Our families had left the cars and were heading toward the house.

Armando told me to keep them away. I quickly did his bidding. Whatever was about to happen would not be a scene for women and children, or for my father.

As I came back into the house, Armando was staring Clint down with a cyclopean evil eye. Armando had grown a foot taller. Clint seemed to be hanging from a meat hook. Armando's big nose jabbed Clint's face, which was fading to white death. Clint backpedaled toward the living room, tripping on his own guns. Without warning, Armando fired a cannonade of words in a voice that plastered Clint against the wall.

The words were terrorizing and ugly, a barrage of waking-the-dead obscenities. Armando had humiliation down to a bitter science. Clint couldn't utter a word in response. His voice was less than a squeak.

Like a defiant bullfighter, Armando spun away from Clint, taunting him to raise a fist, or pick up a gun. Armando swung back again, pressing Clint with a voice beyond decibels.

CLINT *Pencil and Oil* 8" x 9" 1994

ARMANDO *Pencil and Oil* 8" x 9" 1994

"Hit me! Just hit me, cowgirl!!"

Finally sick-to-dying Clint gave way to tears.

It was pathetic, an utter humiliation. No one could party like Armando. In this giant's neighborhood, if you get out of line, he whacks you right on your front porch...or in your dining room.

Armando had his man. He lumbered out of the house without a backward glance. Clint wouldn't meet my eyes. He muttered to himself in a broken voice that was close to a sob, "He can't do that to me. He can't do that to me."

I tried to comfort Clint, fearing that he would pick up a gun and attempt to regain his manhood.

But it doesn't work that way against the likes of Armando.

* * *

I never heard from Clint again. The following week he had cleared out, saving me the cost of a lawyer.

I finally drew a picture for Armando; I wasn't going to write any scripts. I was an actor, busy in a series fighting giants. I was glad one of those giants wasn't Armando.

I saw Armando again a couple of times. To my amazement, I learned he was a serious hypochondriac. Armando took a complete physical exam once a month. He had a couple of real maladies and a hundred imagined ones. He feared no man or gun, but every invisible germ made him tremble.

In his last phone call to me, he mentioned that he wanted to come up to the ranch.

"Always wanted to raise chickens."

"Chickens?"

"Commercially."

I was in trouble.

"My doctor told me that people are gonna be eating more chicken...lot less fat. That's what I should've been eatin' instead of those damn steaks. Anyway, there's gonna be a lot of money made. You and me could be partners."

"You can't do anything like commercial chickens in that neck of the woods, Armando."

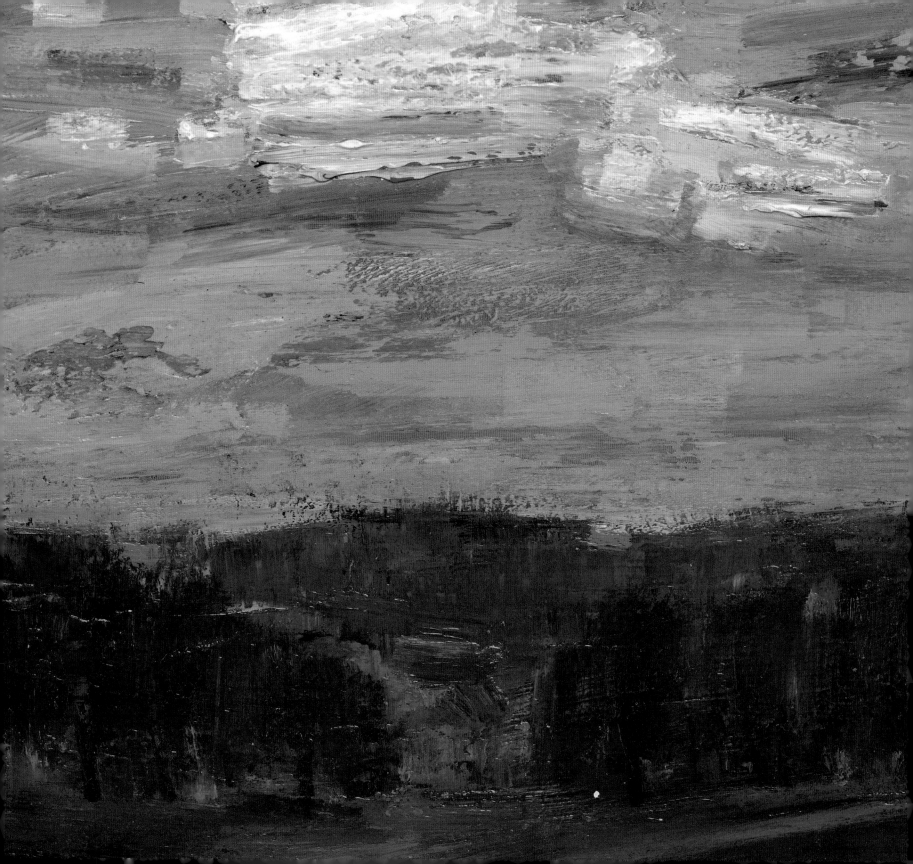

"What the hell? You got a big farm there. Plenty of space."

"You can't get an EIR approval farming chickens."

"EIR?"

"Yeah, a county red tape deal."

"That's right, your mother told me they wouldn't even let you put up a little school."

"They make you spend a fortune on a big report. And you know…a background check." That comment would worry him. "They make it real tough, then they turn you down."

Armando gave up the chicken ranch partnership. But I made a note. Armando's doctor was probably right about chicken futures. I should look into it…

At last word, Armando was looking for land in Paso Robles. I expected to run into him one day, maybe at Wilson's, dressed in cowboy boots, and a ten-gallon hat looking like a beanie on his twenty-gallon head. But it never happened.

Land of the Giants was a hit around the world, and every day was filled with TV star chores. My trips to the ranch were confined to mind roving, while I sat on a darkened stage at 20th Century Fox. In the world of make-believe, why not make believe I was plowing my precious umber dark earth before the winter rains swept in from the Santa Lucias?

And after such "real" work, I return to my easel, propped on the highest hill. I capture in oil the storm clouds thundering in from Big Sur and galloping over the foreland like a great herd of wild horses.

ELEVEN

LOVING HANDS

OF HOME

They could've been Ma and Pa Kettle, except they were from Taft, California, an oil town on Highway 33 about five hundred oil wells from Bakersfield, in a part of Kern County that has all the character of an off-season moonscape. It's hard to imagine someone wanting to call Taft "home," but it's probably unfair to judge a city as it whizzes past on a shortcut to L.A.

Elmore Windsor and his wife, Leona, had spent most of their lives in Taft. Elmore owned a small machine shop and manufactured drill bits for the wells.

Late one Sunday afternoon, the Windsors drove into the ranch to see if they could catch the owner. I was caught. At first I thought the pleasant, elderly couple was lost, and trying to find the route back into Paso Robles. But once they realized I was indeed the owner in the flesh, I learned all about the Windsors.

Elmore was retiring from his machine shop to devote his time to his real love…farming.

"I'm not retiring from work, no siree."

In fact, Elmore had just been negotiating on a D-7 Caterpillar. The asking price was $30,000, a serious plunge into the farming business, but the dozer was almost new. As Leona verified his commitment, Elmore scanned the open ranch pastures, assessing their slopes for tractor maneuverability. He liked what he saw.

It was that time of day when everything was bathed in shimmering light, and colors seemed their richest. We stopped talking for a few moments, entranced by the day's end aura in this Adelaida valley. Our eyes lifted to the panoramic sky. A magical curtain drew on the last act of the day—sunset over the Santa Lucias. The clouds were a delicate brushwork of faded pinks and silver gray, but the horizon burned bright in scarlet. It was a wonder, as usual.

VINEYARDS AND WOODS *Oil* 3" x 3½" 1992

Earthborn, Elmore and Leona were, no doubt about it, nature's noblesse. They wanted to live on the ranch, farm the land, and work hard to make a beautiful home. I knew it before they asked, as we beheld the last blaze of sunset in reverent silence.

Within a few days, the Windsors wrote to me back in Los Angeles, proposing an overall farming arrangement. In a businesslike yet friendly tone, they pledged to turn my place into a genuine working ranch right down to planting a new orchard and vegetable garden. Elmore would reinvest the equity that his machine shop had earned over the past twenty-five years into equipment and machinery needed to be an efficient farm operator. The Windsors longed to pull up their Taft roots and plant the seeds of a new life on my ranch.

It was a love letter; I could have framed it. I had finally discovered the missing ingredient. Finding the right, mature people. Good and decent folks know what hard work is and what it takes to make an honest living. It was simple and obvious. These Windsors were willing to do their share, in fact more than their share.

My newfound farm work ethic had all the depth of a sermonette. Was I rationalizing my taking advantage of these "good" people? On the other hand, they were realizing a life's dream. In the final analysis, while they were living at the ranch every day, I would be paying the mortgage, holed up in Los Angeles.

We agreed to meet at the ranch to work out the particulars. I was determined to go over things in detail with the Windsors. I didn't want any misunderstandings about who was to do what and when.

Eager to get the ball rolling, I made tracks to the ranch. The Windsors had already arrived and were making themselves at home. Elmore inspected the remains of the barn foundation. He could take advantage of the aged footings and construct a temporary tool shed. Leona wandered through the old orchard with a younger, chunky girl, introduced as her daughter, Linda.

Elmore proudly announced that he had sold his business and finalized the deal on the tractor. He wanted to bring welding equipment, electric pumps, engines, motors, and all kinds of machinery and tools from his shop out to the ranch. This honest-to-goodness old-timer mechanic had a load of tools and his own heavy-duty dozer. What a bonanza!

His wife expounded upon what fruit and nut trees to add to the orchard, and the need to prune the older, scraggly trees so that they could produce again. I was in heaven. Talk to me about fruit trees and berry bushes and herb gardens and grape arbors and welding equipment and dozer maintenance and safflower and barley. It was country music to my ears.

The Windsors had furniture—sleeper sofas, cedar chests, an upright freezer, big screen remote control color TV, a portable dishwasher, and everything else to stuff a house. Start stuffing!

Elmore grabbed a hammer out of his car and cleaned some of the crumbled barn footings, already, by God, working on the storage shed! Leona picked out the best spot for her garden. Linda was in the house, figuring where all her parent's furniture would fit.

On top of making me a fifty/fifty partner in the farming proceeds (a lot better than the customary one third/two thirds arrangement), the Windsors insisted on paying rent. I refused at first, but they wouldn't hear of it. I refused again, more tentatively. They remained firmly insistent. I caved in.

* * *

Marian listened patiently when I returned from my triumph at the ranch. She couldn't keep count of which wish-fulfillment fantasy I was on. Twenty? Thirty?

This time I had both my big feet planted on the ground. The Windsors were all over the land, fixing and trimming and planning my paradise…and their paradise too. In fact, the Windsors had accomplished more during our little chat than "Woodpile" and "Mr. NRA" had over their entire combined time "renting" the house.

Marian finally jumped aboard my milk and honey train, seduced by Leona's planned garden…organic at that. Maintaining a flourishing garden is an everyday chore (as we learned too quickly). Traveling hours to your ranch home and then spending more hours at a grocery, buying a supply of vegetables that should be abundant in your own gardens, is always a downer.

Marian also liked the sound of salt of the earth Elmore, strapping his tool belt to his hips and wasting no time building his toolshed. I assured Marian that Elmore's tools were not mere fixations, like those of our two previous tenants.

We had lucked into the best of all possible worlds—a sharecropping farmer, a caretaker, a Mister Fix-it, and a fruit and vegetable organic gardener—all rolled into one personable couple. I envisioned Mr. and Mrs. House and Garden greeting us on every trip with a fresh baked apple pie (apples from our trees, of course!). We would only sample the pie, saving room to feast on farm-grown vegetables and carrot juice until we turned yellow.

During the feed, Elmore would update me on the progress in all of his projects. Satisfied that everything was well, I would retire to my studio, paint my heart out and only reappear when Elmore had the steeds saddled up for a cool evening ride.

SUNSET *Oil* 11" x 17" 1992

170

171

Marian interrupted me. How many children and grandchildren did the Windsors have? I had met their daughter, Linda, who I'd gathered had a couple of kids. There may have been mention of other siblings.

"That'll be fun on the weekends."

"What do you mean?"

"Little grandkids sleeping all over the house—tripping on them when we have to go to the bathroom in the middle of the night." Marian was definitely smiling, "If you were renting, would you want the owner and his family sleeping next to you whenever they felt like it?"

"They're not going to think that way. They're the kind of couple that would run a bed and breakfast. We'll get along perfectly."

A few days after the Windsors moved in, I visited the ranch to ensure that everything started out on the right note. Sure enough, Elmore was out in the fields diligently plowing with his new dozer. Leona, staking out her garden, had purchased some pistachio and plum trees from a neighboring nursery. Before I had finished my greeting, I was digging holes for her trees. Well versed in soil science, she informed me that we were shoveling through a volcanic layer and into limestone, formed by ancient marine deposits. Her family was from Kentucky; it was limestone like this that made the great racehorses. An abundant limestone stratum was a rare gift.

I figured not to mention our limestone to my cousin John. He didn't need to hear that we could breed Kentucky racehorses.

A trio of youngsters ran down from the hill. Covered with dirt, they were introduced as Leona's grandchildren from a daughter that I had yet to meet. I awarded Marian one point for her prognosis.

Leona invited me inside and insisted I stay for dinner. (I assumed she understood I was staying the night.) She had baked a pie with the peaches from one of our trees. (Wrong fruit, but score one point for me!) She'd been able to salvage just enough peaches to make the single pie; birds got the rest. Next season, netting in the trees would birdproof the fruit.

Elmore finally appeared, covered with the Central Coast's richest dust, but rosy cheeked and vigorous. He greeted me and beelined for the shower. Farming's toilsome work apparently agreed with him.

A well-scrubbed Elmore and I moseyed into the living room. Elmore dropped into a La-Z-Boy. As he settled into the chair, Leona dutifully brought him his highball. This was the Windsor's evening ritual. A hard day's work, shower, climb into the La-Z-Boy, mellow

out with Jack Daniels and soda. Forsaking his nightly TV, Elmore played host to me, with the tube at a low, background drone.

We talked about the great buy he'd made on his tractor and about the advisability of planting safflower this year. Elmore was going to a production seminar sponsored by Agricom, the major seed company in the area. Agricom would cover all aspects of growing safflower, from the initial production contract to delivery. He asked if I wanted to join him.

I assured Elmore that I was very enthusiastic about safflower, but my producer would never rearrange a shooting schedule to fit in a seed seminar.

Talk of "producer" and "shooting schedules" sounded a bit too "Hollywood" for old Elmore. He did honor me, though, with a condensed review of *Land of the Giants*. It was "real clever how they could make you look so small."

He seemed interested in the secrets behind screen magic, but as I launched into my firsthand description of "blue screens" and "matte work," Elmore's little grandchildren darted into the living room and scrambled up and over their grandfather. I was impressed. A single La-Z-Boy could encompass one highball-balancing grandfather and three squirmy grandchildren with room to spare. Elmore surrendered to the attack of the little people, until eventually Leona came to his rescue.

By the time order was restored, Elmore had lost interest in the tricks of special effects. I had noticed a stubby little bookcase in the Windsor living room, crammed with *Reader's Digest* magazines and *Reader's Digest Condensed Books* and nothing else.

"You've read all those *Digests*?"

"The magazines, yep, sure enough. The wife likes to read the books."

Leona asked whether I liked *Reader's Digest*. Stuck for an answer, I responded noncommittally.

Leona and Elmore's daughter, Linda, pushed through the kitchen door. A youngish muscle-gone-to-fat man with her was introduced as Linda's husband, Bill. Four perpetual motion grandchildren shot out from behind him. Another Windsor daughter, Karen, had sent her children with Bill for a grandparent-and-cousin weekend. The grandchildren rushed each other like cavalry and Indians. Leona herded the seven kid melee up into the attic bedroom.

As the free-for-all subsided Bill joined the "men" in the living room. Linda left to help her mother in the kitchen.

Bill was the "partner" in his father-in-law's farming operation.

"I'm the business side." Bill's toothy grin was utterly charmless. "Dad, here, loves drivin' that tractor."

"Dad" stared at the television, smiling occasionally as he followed the on-screen sitcom without the sound. He'd let Bill do the talking.

Bill, who had recommended spending major bucks on the tractor, was looking for another ranch or two to farm. With more acres in the operation, Elmore's investment could turn into a profit-maker.

The picture unfolded. Bill had prodded Elmore into selling everything and sinking his equity and savings into a very expensive tractor, disc, seeder, and harvester. Everything should be "first class." Young Bill was very good at spending other people's money.

The Windsors went to sleep early. Bill and Linda took the second bedroom, and I bunked up in the attic with the kids.

I took a while to nod off, worrying about Elmore. He was in over his head. Farming my place only wouldn't pay off. To even make ends meet, Elmore had to count on my ground producing in a big way.

Son-in-law Bill had overextended Elmore's drill bit savings into financing a business for both of them. Whatever Bill had done before, he'd come up busted and scammed things so that the one-ranch farming operation had to support two households.

I tossed while the night wore on, deeply concerned for Elmore. He and Bill would never find more places to farm, not with Bill as front man. Most of the ranch owners farmed for themselves or had preexisting arrangements with big farm management companies.

My deal with Elmore did not provide for taking on his son-in-law in a battle for survival. I didn't trust Bill. For his own ends, he'd put his true-hearted father-in-law into hock.

I needed to go to the bathroom. Slipping out of my bed, I felt my way across the room in solid darkness. Arriving at what should have been the bathroom door, I stubbed my toes and stumbled on a mound on the floor. A grandkid shot up out of his sleeping bag.

Marian's prophecy was fulfilled, but when I got back to L.A., I decided not to let on. I didn't tell Marian that Sunnybrook Farm was not so sunny. My great expectations were fading again.

In any event, the Windsor rent check always arrived before it was due. Leona sent me a gift for Christmas, a subscription to *Reader's Digest*.

Every time I went to the ranch, there seemed to be more grandchildren. I trained my kidneys to hang in through the night.

Bill leveraged Elmore into one more purchase—a top-of-the-line brand new four-wheel drive truck. Bill needed it to project the right impression of a well financed farming operation. Bill had found no more places to farm, his façade had gaping holes in it. Shiny truck or no truck, it was too late in the season to nail down farm contracts. Elmore and Bill had to make it on my crop alone.

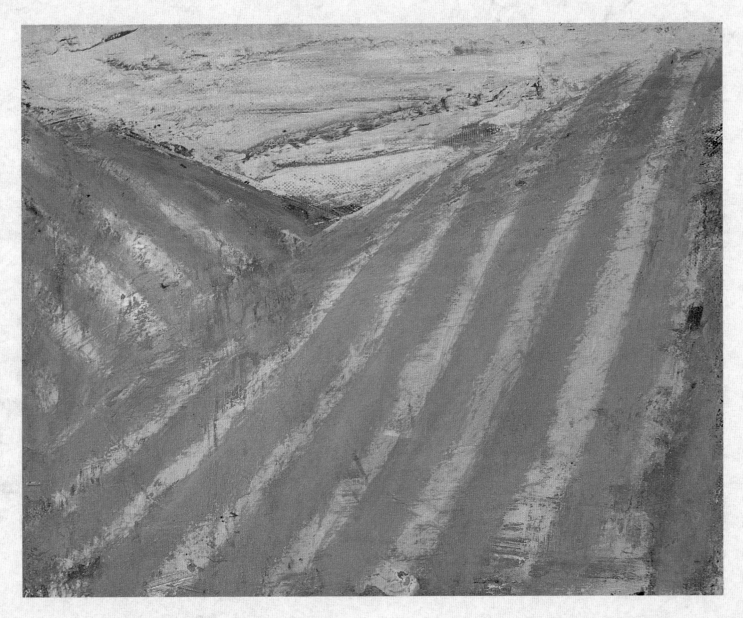

VINEYARD SYMMETRY *Oil* 11" x 14" 1992

175

The weather cooperated with generous winter rains, and we had a fair-to-middling yield. Also, fortunately, safflower prices held steady. Elmore paid my share promptly.

Elmore was hard pressed, but his simple, admirable stoicism wouldn't allow him to admit it. It was not in Elmore's character to whine.

His son-in-law was quite the opposite. Elmore, in his characteristic non-complaining way, muttered a single descriptive word for Bill: "bellyacher." That was the day Elmore presented my crop disbursement check. I told Elmore that I only wanted a third of the crop payment. He sounded as if I had insulted him.

"A deal's a deal!" he insisted, giving me my half share as he was obligated under our agreement.

Elmore's portion from the safflower sale barely covered planting the crop and running his extravagant equipment. He had little or no savings to fall back on—his nest egg was a barnful of superfluous machinery that this ranch would never need.

I had my own dashed hopes. *Land of the Giants* had run its course, and 20th Century Fox couldn't sustain the expense in props and special effects. I figured to spend more time at the ranch, and with film projects I had begun to develop.

Maybe I could find time to lose myself in painting the redeeming countryside, still waiting like a glorious spring. By now I had earned the right to interpret the land and its power and its pain...

* * *

A script caught my attention: *The Farmer.* Farmer? This title was for me. If I couldn't be a real one, I'd play a farmer in the movies.

The Farmer was about a young man returning to his Georgia farm after fighting in the Second World War. He finds that his fight for survival continues at home. The script, lacking only studio affiliation, needed financing. I pitched in with that terrible chore, and when the money was finalized, the director and I set the movie location in a farming community near Atlanta.

I played farmer to high hog heaven. I wore bib-overalls and sucked on a stogie. I drove an ancient tractor. I squinted under a farmer's hat and carried a shotgun in my truck. I had prepared a long time for this role. Since I couldn't seem to get up north and paint the farm, I painted myself as this celluloid farmer.

After the production wound up, I went directly to the ranch. Didn't even change wardrobe. Leona was tending a couple of grandkids and a new tyke, just a few months old. Elmore didn't seem to be around. Leona said that he'd gone back to Taft to "work for wages."

EARTHBORN #1 *Oil* 11" x 14" 1992

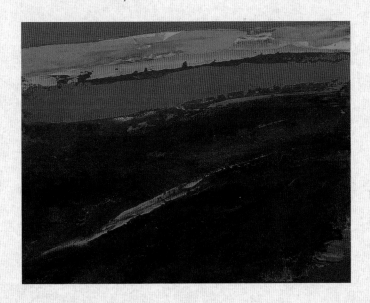

EARTHBORN #2 *Oil* 11" x 14" 1992

THE FARMER (Detail)
Oil 30" x 40" 1976

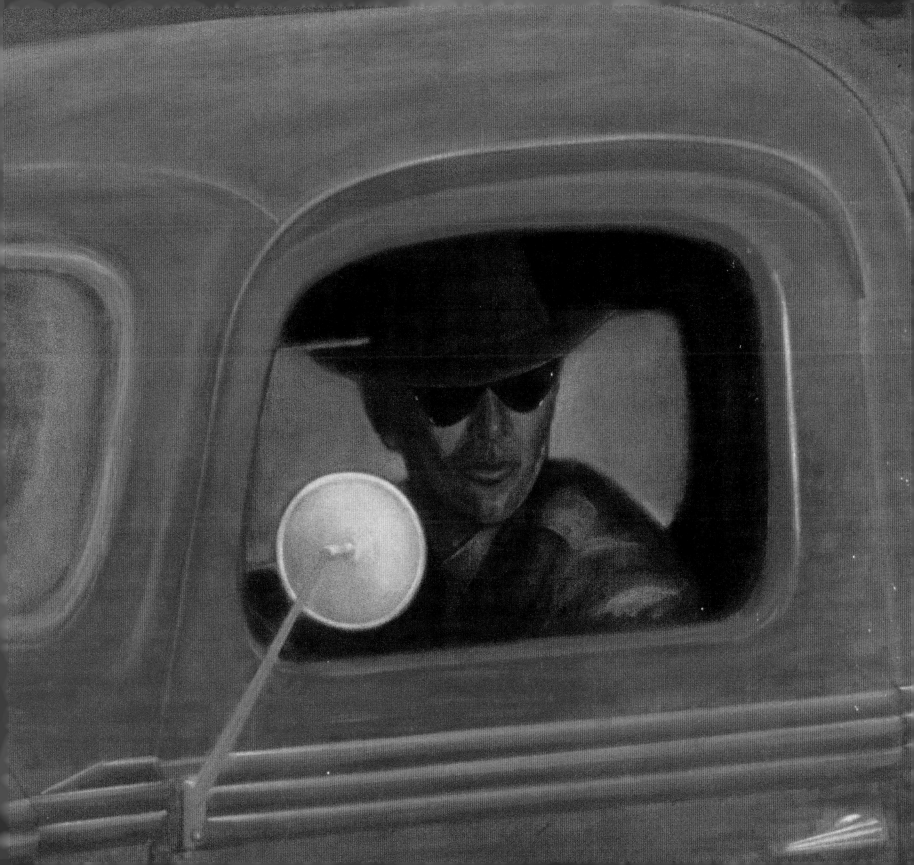

Leona swore that they were taking good care of my place. Elmore was already breaking ground for the new crop. Everything seemed well cared for, although the house was more cluttered than I remembered. Every wall had a curio cabinet. But it was clean.

Leona went on. Elmore was working weeks for a Taft drill bit shop, and attending to the ranch on weekends. I was afraid to ask about Bill. Leona anticipated me: Bill and Linda were having problems. They had separated, and Linda had gone to work full-time. I wasn't a bit surprised, but I kept it to myself.

Linda had moved to Paso Robles. During the day, Leona helped out with the two preschool kids and the new baby. Leona's recent operation made it difficult for her to keep up with the little ones, but now she was better able to handle it. Except when she had to go to Los Angeles for radiation treatments. I didn't like the sound of that, but she looked O.K. I assumed the best. Like her husband, grumbling was an unknown tone in Leona's voice. In fact, she sounded as if things couldn't be working out better.

Over a fresh peach pie, Leona filled me in on her other daughter, Karen. Her husband had an accident in the oil fields. They had no insurance. Leona would be taking care of those kids in short order. The oldest child, born out of wedlock, was the offspring of a high school flame killed in Vietnam.

As Leona unfolded the scenario of this ever-renewing soap opera, I glanced out the kitchen window. The fields blazed in the late afternoon sun. Rich sienna hues marked where Elmore had begun plowing the upper reaches of the ranch.

Leona pressed on, describing her widowed sister's sudden stroke. Over the hills, the light misted and diffused. Nature's beauty buoyed my spirits. The invulnerability of the land helped me, as Leona continued to turn the pages of her sorrow.

Leona's pie added comfort, the sweet peach overcoming the bitterness of our existence as described by Leona.

Over the months, I hinted that I wanted to help the Windsors financially. Any such suggestion went unheeded. They adamantly paid their share. His dignity at stake, Elmore would work three jobs if necessary to pull his weight and carry his family. Of course, I didn't have the heart to even vaguely suggest the possibility that they should leave. Their heartache became my heartache.

I tried to isolate Marian from the melodrama without end. It was hard to explain. I kept the Windsors on, but the imagined cheery-little-couple-waiting-at-the-door never became a reality.

In any event, Marian wouldn't stay at the ranch. Taking a bed from a couple of kids was worse than taking candy from a baby.

Marian would join me for a few wistful hours at the ranch, providing we were on the way to Big Sur or Carmel, or some other romantic destination along the coast. She acknowledged that with the Windsors, things looked well cared for and alive; the working ranch that we had always envisioned.

The Windsors put up some new corrals and a training ring, and began to raise quarterhorses. Elmore always insisted that Marian and I ride when we visited. It always ended up being great fun, but I limited Marian's time for fear she would learn about the Windsors serialized sob story.

For a new Central Coast experience, Marian and I stayed at the Paso Robles Inn for an evening. We had supper in the lost-in-the-40s dining room, and spotted an interesting item on what was described as the "wine list."

The Inn featured a "local" HMR Cabernet Sauvignon from the Hoffman Ranch, a neighbor, almost adjacent to the Paderewski vineyards. Dr. Hoffman had planted a vineyard a few years before. The Cabernet was one of his first releases. We were certainly curious.

Marian was the family wine connoisseur. The quality of the vintage reminded her of the wines of St.-Emilion, her favorite from France. The HMR was one of the most vivid wines I had ever tasted.

It seemed incongruous that this cattle and saddle country could produce upscale fine wines.

"That's what you should've done."

"What was that?"

"Planted a vineyard."

"Sure. What do I know about vineyards?"

"What did you know about anything else?"

"A vineyard takes years."

"I think you've had a few."

And undoubtedly, a few too many glasses of Cabernet. I was getting touchy. Marian's words hit below the belt…where she was aiming.

In any event, something connected in a sensitive area. All the years of dashed hopes had set me up for a big comedown. A decade flickered by in soft focus. One thing was painfully clear: I was right where I started. Maybe even further behind.

My conviction that the ranch would be my art retreat had been the supreme snow job on myself. The serene, spiritual landscape was supposed to provide unlimited inspiration, an artesian well of creative juices. But, in fact, I hadn't painted a lick at the ranch. I didn't even paint about the ranch, or about the woodlands, or the rich pastures, or the skies.

I was always too busy getting started as a rancher. The years rolled relentlessly by.

Naturally, at this painful moment of retrospection, I had something new up my sleeve, a sure-fire plan that would charge even Marian. But first I had to get all my ducks in order, calmly, deliberately.

TWELVE

THERE'S NO
BUSINESS LIKE

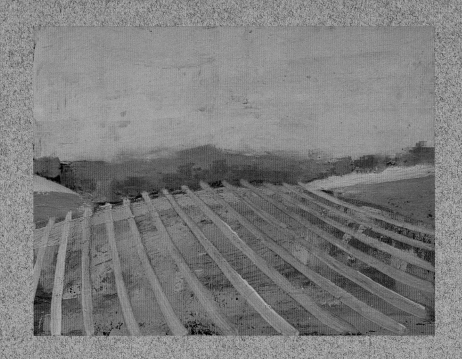

ADELAIDA SUMMER #1 *Oil* 8" x 11" 1992

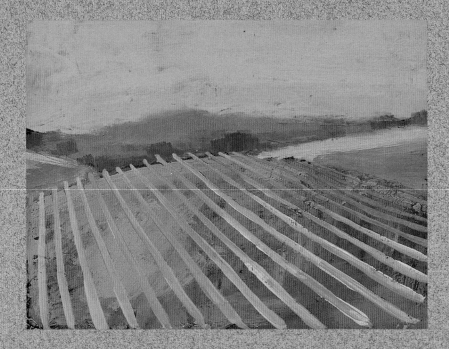

ADELAIDA SUMMER #2 *Oil* 8" x 11" 1992

Show business in Paso Robles was the business of showing blooded horses, prize livestock, sheep and poultry. Was theatre with a human face too great a cultural leap?

I knew the magic of summer theatre in the country, among the horses, the livestock, the sheep and the chickens; theatre in tents, old grain elevators, converted movie houses, and barns…waiting in the "wings" for my entrance cue…the crickets urging me on…the crystal night and a glittering canopy of heavenly stars for inspiration.

My thoughts about starting a theatre in Paso Robles germinated during an engagement at Birmingham, Alabama's Town and Gown Theatre, under the direction of James Hatcher. A marvel and a model of intelligent theatre operation, Hatcher's Town and Gown combined an unusually supportive university theatre department with professional performers and artists in an appreciative, dedicated community, establishing one of the country's most productive and long-lived theatres.

Hatcher invited me to star in a musical version of *Happy Birthday* by Anita Loos. The original Broadway production had starred Judy Holliday. Years later, Judy Holliday developed a musical based on the play with her husband, the renowned jazz musician Gerry Mulligan.

Judy unfortunately died, but her musical version finally came to life in Hatcher's theatre. Gerry Mulligan and his group came to Birmingham to provide the music, and Anita Loos was there for the words. Fannie Flagg, an Alabama native, played the Holliday role in song.

During the production, Marian and I spent many an hour enchanted with Anita Loos's stories of the glory days of San Simeon, our ranch neighbor to the west. She described William Randolph Hearst's grand scale entertaining, never duplicated again.

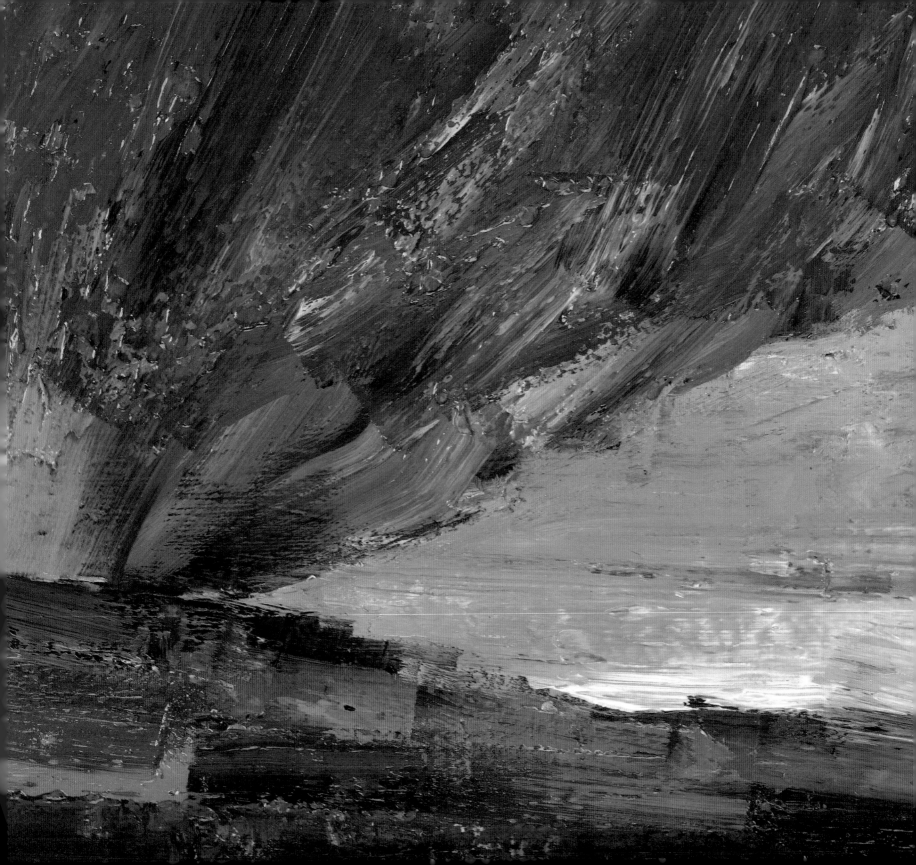

THE STORM (Detail) *Oil* 5 1/2" x 9" 1992

Anita was a living witness to the social extravagance of the "Castle." Her most enduring memory, superseding all the rich and famous legends that flocked to San Simeon, was that she could never get a decent warm bath in the cold, cold, marble tubs.

During the run of *Happy Birthday,* Hatcher and I found ourselves talking about California, especially the Central Coast, and my ranch, the success of which I tended to exaggerate.

Hatcher confessed to being smitten with the Central Coast. He had always wanted to start a theatre in the West, and the coast north of L.A., was the perfect area for an operation like his Town and Gown Theatre in Birmingham.

Hatcher kept in contact after the show. The idea of a Paso Robles theatre grew with each of his visits to Los Angeles. He concurred that Paso Robles was far enough from L.A. to be an ideal tryout town for plays headed for the city, very much like New Haven and Bucks County were tryout towns for New York.

Hatcher could accredit the theatre with the University of California, and thirty or forty students would train each year. The ranch would house these students, as well as the professionals contracted for each production. Although the theatre itself would be built in town, I pictured a satellite theatre at the ranch. Certainly the ranch provided the best setting to construct and store sets, to rehearse and to conduct playwriting seminars and acting workshops.

This ranch/theatre utopia consumed me. But I wanted to work out the details before I went public. With Marian, I discussed the general idea, keeping my passion secret. She would not tolerate another "incredible brainstorm."

Without warning, all passions came to an end. I learned that my father was seriously ill. The news was sudden and devastating. Nothing would ever be the same.

I stayed very close to my father over the next months. He ventured back and forth to the hospital for various chemotherapies. His calm, beautiful stoicism shored me up. His interest in his reading and poetry, and in the script, a father and son story that we were writing together, never flagged.

187

But the weight of time bore down on us. The poem that he had written upon his mother's death cut into me with new meaning:

It was like a stillness
After deep organ tones stop short—
The day you died.
You, who knew,
Had hid your withdrawing shadow;
And I, who knew,
Waited in the duping sun.
Then your face was torn out
Of the book of my life;
And in the time that went after
I stared at the emptiness
Where once you had been pictures and pages.
Only now, years after,
Do I recover fragments
From the poetry of your being.
They are enshrined in my young,
In the flesh of our flesh.

After that supreme day, I found it difficult to go back to the land for any reason. Too much of my father's presence remained there. So many of my dreams included my father. I had thought they were dreams without end.

This ranch in the Santa Lucias, the grand landscape with its overwhelming serenity, also expressed my profound sadness. The land's poignant beauty could turn in an instant to haunting melancholia. Yet, there were moments, in a playful, skipping breeze, where I would almost hear his voice...

* * *

One day, a real estate agent with a sixth sense called me about selling my ranch in Adelaida. I actually discussed the possibility with him. The agent, Bob Graham, eased into the conversation. He understood that I wasn't coming up to my ranch much anymore. He had been by the ranch and talked to the Windsors. They'd informed him of the growing intervals between my visits.

I mentioned Bob Graham's inquiry to Marian. She searched my eyes for my real feelings. I didn't know them myself.

Graham called again. He had a buyer for half of my property, 160 acres. I could make quite a profit. With the price Graham quoted the buyer, I would, in effect, end up with the remaining 160 acres free. Graham was smart about dealing with my ambivalence. I could sell, and it was almost like not selling. After all, 320 acres or 160 acres, what was the difference? Not much, except to a farmer. Graham knew I was no farmer.

But I was more interested in buying than selling. Another real estate agent named Bob, Bob Bergman, called about a commercially zoned parcel for sale on Highway 101. The rolling land would be the ideal spot for a theatre. Western-quaint Templeton, close by, would give the right small-town flavor to the theatre project.

I made an offer on the eleven-acre parcel. It was accepted without haggling. While the land was in escrow, I noodled every conceivable size and type of theatre design. It had to be theatre in-the-round; I was adamant for a while. I changed my mind. Only the classic proscenium arch would do. I toyed with a revolving stage concept, and then a stage that elevated from below. I kept coming back to a form of cabaret or dinner theatre, or perhaps two theatres.

Whatever structure I finally arrived at, the theatre shouldn't exist as an island. Even with the ranch as a supporting element, the site itself required a small country inn, artisan shops, a restaurant or two, perhaps galleries. I began to think big scale.

James Hatcher shared ideas with me, excited that I had taken the first step and

procured some land. Through friends, I met with James Doolittle, a vital force in Southern California theatre. He agreed there was real potential for a theatre in the area, and he pledged his full support.

Things began to move fast. I was constantly running up to San Luis Obispo and Paso Robles, never finding time to visit the ranch. Immersed in countless details, from water features to theatre seating, I hounded my old friends, the San Luis Obispo Planning and Building Department, expediting the various county processes. This time there were no neighbors named Wiebe. I had a clear shot at seeing the project to completion.

By sheer coincidence, another of my cousins, Ron Monello, had started a dinner theatre in Lake Havasu, Nevada. Ron was interested in relocating his theatre, and it made a lot of sense to move his operation, which consisted of Ron and his wife, to Paso Robles. His small dinner theatre would test grassroots community support and interest. The idea of starting up in Paso Robles excited Ron. We saw his operation eventually being incorporated into my theatre.

I tried to keep things in balance. Little by little, my ranch crept back into my dreams, but as part of a grander vision. The loneliness that had permeated the ranch after my father's death would be supplanted by the bustle of actors rehearsing, playwrights writing, scenic designers painting, musicians playing, and dancers dancing.

Crawling with artists, my place would be a hothouse of creativity. I saw myself managing the extensive ranching operations during the day, in between painting bouts in my north light hilltop studio. I would be painting themes of the theatre, somehow incorporating the mood and music of the land.

In the evening, as farmer-producer, I would oversee the current theatre production. After the performance, I would convene in the cabaret, sharing notes with the director, actors, singers, and dancers. Then, after singing the title song all the way home, I would delight in a country night's sleep, waking only to start another blissful day in paradise.

I even worked my film career into the ranch theatre equation. I would construct a small studio of barn-like sound stages. A mecca for independent filmmakers, the ranch would employ writers, actors, and artists from the theatre.

I kept most of these mind trips to myself; they were too intense for the casual observer. Unsuspecting Marian was pleased that the theatre had taken my mind off the ranch (and the passing of my father). She had no real idea. Don Quixote was running wild up and down the Central Coast.

One of reality's little annoyances sobered me a bit—money. I went through a pile of it in the initial planning stage. Building a theatre, even a barn-like theatre, is not cheap.

I had received the holy writ, a favorable Environmental Impact Report, and approval from the County Board of Supervisors. The Templeton Water District had issued a will-serve letter, guaranteeing a water supply and a sewer connection. I had complete plans and a fancy model of the project.

All of this had chewed up a couple of bank accounts, and I still had to make a final payment on the land. Any liens on the property needed to be cleared in order to build on it. Time to meet Mr. Banker. I bought businessman suits and purchased a briefcase and a portfolio to hold my renderings and plans.

Mr. Banker always started the conversation. His bank was "conservative"—they "do not take risks"—and they didn't understand show business. Yet, all the banks I approached were in Los Angeles, the show business capital of the world. Yes, the point was well taken: great artists are risk takers, great banks are not.

Mr. Banker always had a pile of forms, which after the second bank I dreaded filling out. Taking my plans and pro forma, he promised to get back to me as soon as possible with the bank's decision. After my zealous spiel, I always assumed the response would be positive.

It never was. Soon I had the bank rejection speech down pat. Whether in spoken English or letter form, my rejections always contained a key phrase: "Our bank cannot finance a theatre." This finding was discovered always after the meeting of the "Loan Committee."

I would have had better luck financing a massage parlor than a theatre, especially a theatre in Templeton, California, a place no banker had ever heard of.

Finally a youngish banker with a delicate face and a rugged moustache, who loved theatre and had season tickets to the Dorothy Chandler, cautioned me to never mention the "T" word in a bank. "Expand your inn, make it a motel, and call your theatre a convention room."

I must've been smiling. Somewhere under the moustache, the banker smiled back.

"You know, Gary, I was an actor once."

THIRTEEN

MEANWHILE BACK
AT THE RANCH

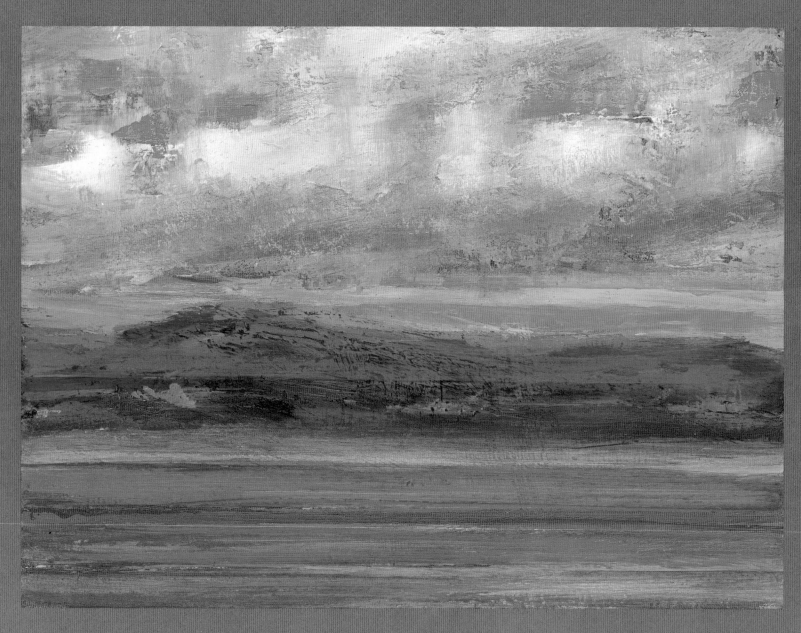

MOUNTAIN PASTURES *Oil* 7 ¼" x 9 ¾" 1994

194

The Windsors had had it. Weary-eyed, Leona sat in the kitchen in the late afternoon. We were all alone, not a grandkid in sight. Cutting a slice from a fresh-made apple pie, she told me that her husband couldn't handle the trip back and forth from Taft anymore. Even on the weekends.

"He had to sell the dozer."

Bill, her tycoon son-in-law, had taken a loan against the tractor.

"When they called the loan, Bill couldn't pay it. He couldn't pay any part of it."

Leona sensed that I wasn't surprised.

"Elmore has to even work Saturdays now at the shop."

I glanced out the window. Weeds were making their comeback.

"We tried for it, really tried. Farming is too hard nowadays."

"Try financing a theatre."

The poor woman had no idea what I was talking about. She gave me another generous slice of pie, my last piece of Leona's apple pie made with my farm-grown apples.

"When are you going to leave?"

"By month's end. I've already started to pack."

I noticed boxes in the living room. The *Reader's Digests* were all bundled away.

"I'm going to take a little walk. If you want, when I get back, I'll help you pack a bit."

"Oh, no. I pack a little every day. But I appreciate your offer."

Leona finished me off with a glass of cold milk. She knew my apple pie ritual.

Outside, Leona's garden was looking dejected. The ranch was saying good-bye.

I wandered up to my favorite spot on the hill, where I habitually erected my studio-to-be. A flat lichen-splattered rock was well placed for sitting and musing upon the divine view.

ELMORE *Oil* 14" x 11" 1994

Hawks weaved above me, catching the thermals. On second glance, they were buzzards circling some sad dead creature in the thicket under the oaks. They could have been circling me, the way I felt.

It was time to begin plowing for next season's crop, and I had to connect with a new farmer. Far too many seasons had gone by, and I still was a stranger in this patient land.

I would have packed up and left a long time ago, but I'd always felt this ranch had something special in store for me. I wondered why I was never compelled to explore its enchanted beauty with pencils and paint.

I sprouted so many plans for a western-styled nirvana, all plowed into the ground many times over. How often had I sworn to raise my two children on this ranch? When I discovered the place, Kathleen had not even started school yet, and Gareth hadn't been born. Now my flaxen-haired daughter was ready for college, and Gareth was a teenager.

I yearned to have my whole family living here, like the early settlers. Generations working the land together. Such a pipe dream…and yet I mourned that it hadn't happened.

I remembered walks with my father through fields and oak woods, discussing the great ideas that came naturally in this setting. My toddling son tagged along, finding the secret of the universe in each tiny wildflower and frog.

The pain of my father's loss stabbed me. We had not lived like farmers, close to the land, close to each other.

I picked myself up. I was starting to cry. I couldn't remember the last time I had wept, and I wasn't sure why my eyes dampened with tears.

I dared not look at the view anymore, out towards the lonesome immortal splendor of the Santa Lucias.

Night met me back at the house. Leona asked if I was staying.

"I would be glad to set a place for dinner. I have some nice fresh corn."

I would love to have some corn (that was one reason I'd bought the ranch), then I must be off. I couldn't stand the world's end quietness of the evening, alone with my thoughts. I was a city guy—I needed its sounds and tensions now.

* * *

Bob Graham caught me at the right moment. I was tearing up a letter from the most recent bank to reject my project pitch.

I had downplayed the theatre with the bank, taking my previous actor-banker's advice. Now I was presenting a hotel and shopping center with a secret dinner theatre. The bank doubted that a twenty room hotel would "pencil."

Graham had another buyer for half of my ranch. This was a serious buyer. He would pay "cash."

Cash was exactly what I needed.

"All cash, huh?"

"Full price, too."

"Who is this guy?"

"He's a banker. A banker from L.A."

THE VINEYARDIST
WITHIN US

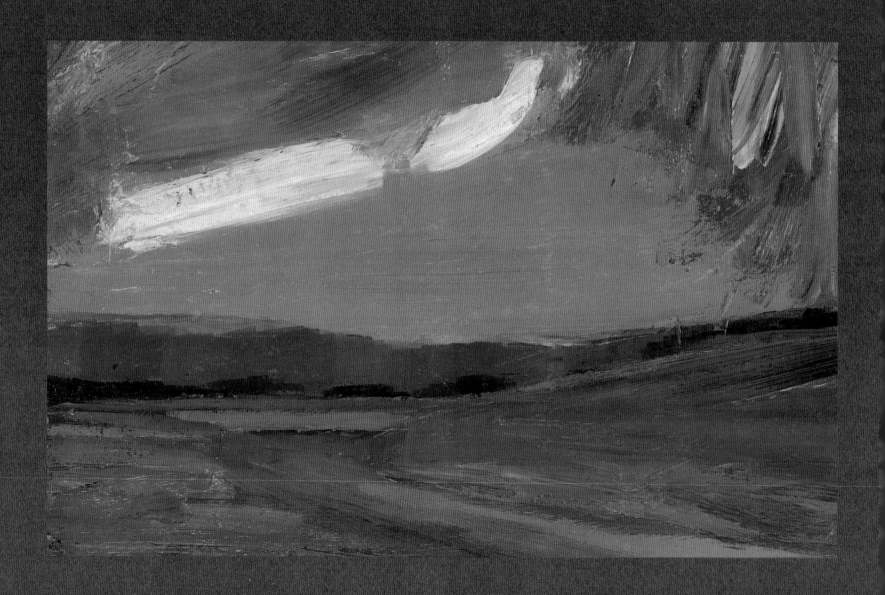

A *vineyard.* This is what the buyer, Justin Baldwin, wanted to plant on my property. Justin, indeed, was a banker who wanted to farm wine grapes and make wine.

A vineyard? How wonderful, and outlandish. But Justin was, after all, a banker. By definition he would be "conservative," not a "risk taker," and would know something "feasible" when he saw it.

The banker had spent years scouring up and down California searching for the perfect land to grow the wine grape varieties most identified with Bordeaux, France: Cabernet Sauvignon, Merlot, and Cabernet Franc. He also wanted to grow the grape of Burgundy: Chardonnay. Justin had a hunch that magic Adelaida was a uniquely suited place for all these varietals. He had ascertained every attribute for the ideal vineyard in my land.

Neighbor Paderewski had prophetically planted his Zinfandel grapes many years ago. Finally, wine culture was a growing phenomenon in the Central Coast.

If I agreed to sell, Justin would hire a vineyardist with a fine reputation, Jim Smoot, to conduct tests on the place, including soil samples and underground water supply. Jim Smoot had already told Justin that the "Conway Farm," an extraordinary place for vitis vinifera, had the potential of producing the finest wine grapes in the world.

I learned of Jim Smoot's unqualified enthusiasm later. A buyer won't share a glowing review of the land he is negotiating to purchase with the seller.

Justin proposed farming on a new and exotic level—farming for city folks! Sometimes when a person "follows visions and dreams dreams," the reality staring him in the face is the most difficult to see. I had considered almost every conceivable farming and non-farming endeavor for my ranch. I was even attempting to create and spiritually bond a theatre to the ranch.

Paderewski had fascinated me. Why? Because he was a great artist who farmed. And farmed in Adelaida. What did he farm? Wine grapes.

I had absorbed Paderewski's life but missed a main theme of his existence: planting grapes and making wine.

Even Leona had grasped the obvious. Mine was a land of limestone. Chimney Rock Road ended at Lime Mountain. Limestone was the soil of some of the greatest vineyards in France. Limestone was gold ore for grapes.

Selling part of my ranch became inevitable. My theatre needed help, meaning cash. My real estate broker reminded me again and again: if I sold half the ranch, I still had 160 of the most desirable acres left. "Especially for wine grapes," he added as a pregnant afterthought.

A Mr. Banker was willing to make a sizable investment and plant grapes for an exclusive wine. In effect, I would be joined to a model farm operation, a road test for a journey to new and exciting territory.

On the mat, beaten down from the endlessly defeated plans for a ranch that went nowhere, I, the farmer-artist, was being lifted up by a banker-trailblazer. The newly arrived oxymoron was passing a message to this old-timer weary oxymoron: "Plant grapes, fool…and if the grapes are good—make wine."

Besides, wine culture was in my genetic code. My grandfather's wine cellar in Boston ranks among my very first memories. Angelo Monello stored several barrels of lovingly made wine in that cellar. Each night before dinner he descended into this dark, scary place with his decanter and loaded up for the evening's meal.

The dank must of old oak barrels and older cellars commingled with whiffs of the blood red potion called "vino." An Italian family encourages drinking of the noble brew from an early age. No Harvard Medical School had to tell these Italians that wine was good for them. Taken with meals, and with common sense, wine keeps a man pretty damn robust.

Besides juggling real life career events, I had my hands full in Paso Robles. On one hand, my theatre project had slowly but surely turned into an embarrassingly bourgeois real estate development. On the other hand, I was unstrung about splitting up my ranch into a subdivided grape land.

Expanding on my actor-banker's counsel, I was now building a hotel rather than a motel. I couldn't settle for designing a side-of-the-highway motel. Also I had successfully hidden my theatre somewhere between the Kiwanis banquet room and the underground storage and delivery facility.

Back at the ranch, I was gently nudged into signing the final escrow documents, selling the western half of the place. Even Marian began to look at the ranch as a shrewd

investment after all. For me, I was not so much selling land as I was embarking upon a way of life that would redefine the Adelaida valley landscape and my inner landscape, for a long time to come.

The old Paso Robles farmers were grumbling about the vineyard creep. It imposed upon their notions of a bucolic setting. Vineyards meant rambling winery buildings and half-crocked visitors trampling the countryside. "Hollywood types" and stranger chaps—psychiatrists, comedy writers, computer scientists—who didn't know a tractor from a back-hoe and couldn't chop wood without spraining their backs, were ready to plunk down tax shelter bucks and strew grape stakes all over the countryside.

Despite the specters, I was avid to become involved in this new kind of farming, new at least to me and the area. I turned my attention to the business of wine grapes. On the sly, of course. I dared not tip my hand to Marian or anyone else. Everyone thought I was consumed by my invisible theatre in its glorified motel. I had exhausted all outside interest in my gentleman-farmer scenarios. They always fizzled before the second act.

A small, steady invasion of dream seekers were planting vineyards in the Central Coast. I learned words like "appellation," "rootstock," and "brix." Marian humored my newfound interest in tracing the various wines to the vineyards that created them. We visited the wine shop and traveled around the world: a Montrachet from Burgundy, Riesling from Mosel, Barolo from Piedmonte, and Bodegas from Rioja.

Even in my most wine-heady moments, I concealed from Marian that really I was selling half the ranch to begin a vineyard myself with a guinea pig next-door. I certainly couldn't tell her that my burgeoning interest in wines and my growing desire to plant a vineyard was from my true heart of hearts this time, and that planting a vineyard was the noblest work a man could do.

This was a serious business requiring serious financing, with little monetary return for many years. Ten years of hard work might reap only heartache, especially if you put all your heart into it from the start.

Dr. Hoffman, my wine pioneering neighbor, proved the tough point with his superb vineyard and winery. Marian and I compared his remarkable Cabernets to long-established elite wines from around the world. But Dr. Hoffman was being foreclosed by banks who saw nothing untoward in tripling his interest rate and forcing him into bankruptcy.

My grape growing neighbor-to-be, the banker, should know how to play the money game. That was something I needed to learn. I was having miserable results financing my clandestine theatre.

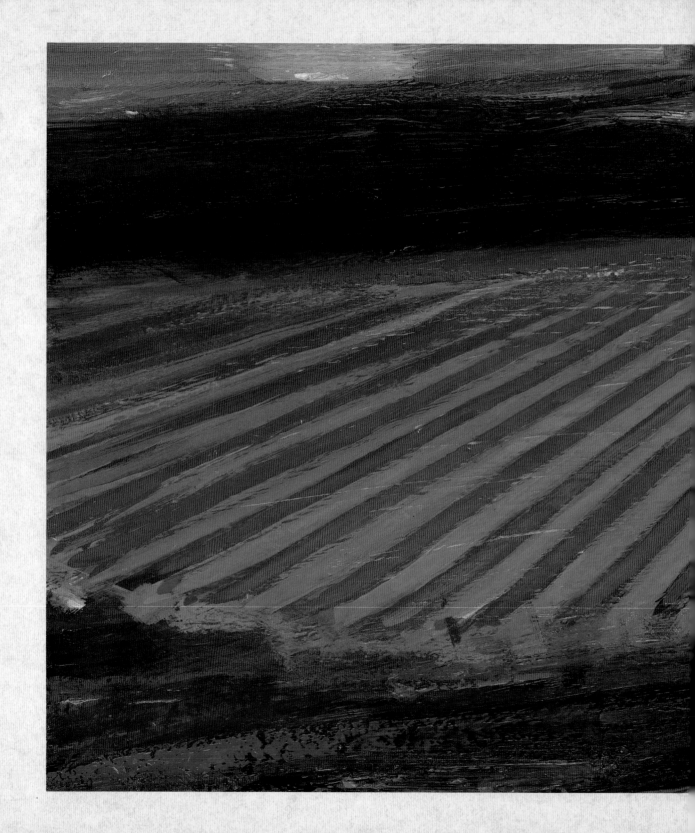

VINEYARD
Oil 10" x 21" 1994

204

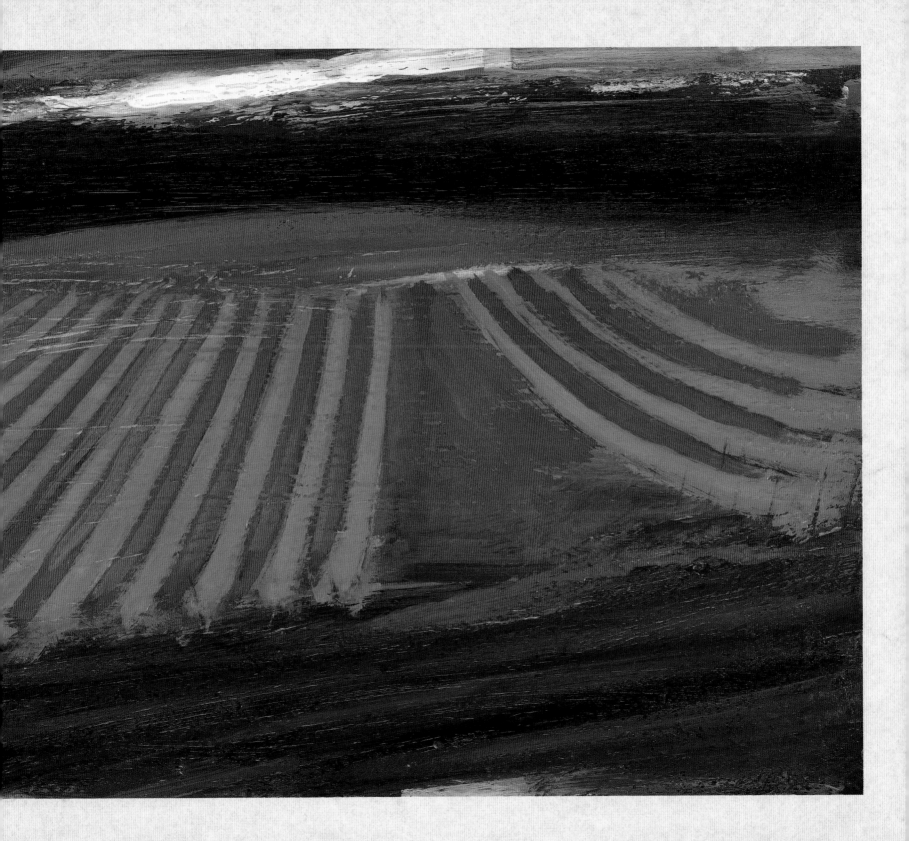

Our escrow agreement held one last contingency: water supply. Justin would drill a test well. It had to produce something close to commercial standards. Jim Smoot required a gallon per minute per acre planted.

Although Adelaida had significant rainfall—forty to sixty inches a year—high yield wells were hard to find. Wells with a steady output of over a hundred gallons a minute were rare, if they even existed, but this kind of well was needed for a vineyard.

Over the years, I had dry farmed, which utilizes natural rainfall only. Ample year around running springs on the property kept cattle troughs filled with water. The hand-dug well was as old as the house it supplied. I had drilled deeper on the same spot and cased a new well, supplying ten or fifteen gallons a minute, enough flow for the needs of a ranch house.

Now that I had made up my mind to sell, I didn't want the deal to fall apart because of a meager underground water source. If that were the case, I could kiss my vineyard aspirations good-bye.

I worried about something I had absolutely no control over and didn't know much about. There was either an aquifer below this beautiful land, sufficient to water a vineyard, or there wasn't. It was cut, and maybe dried.

Bob Graham called. Although he didn't sound worried, Graham informed me that a couple of neighbors were betting we couldn't come up with much of a well.

I didn't ask why it was the neighbor's business, why they would bother to make such a prediction, or who the neighbors were. I didn't even guess. It would be bad luck.

Water became central to my life. While I was fretting about availability at the ranch, I was being drowned in bureaucracy by the Templeton Water District. The will-serve letter guaranteeing me water for my hotel/covert theatre had been written with disappearing ink.

Everything came to a slippery halt. I no longer held a building permit. The county required water to serve the project. Water that I had secured by a document which, I was informed now, I no longer possessed.

My project, which by this time had cost a real wad, could not proceed unless I was willing to truck in a convoy of bottled water. But, there was another choice: get in line behind an army of other water seekers. Perhaps, some time in the unforeseeable future, I could hook up to Templeton's water supply. Such are the thrills of real estate development.

I broke the news to Marian. She was somewhat sanguine, if not philosophical.

"Why do you want to be a strip center magnate anyway?"

"Well, you know, I just wanted a little theatre."

"And what happened to it?"

"It's there somewhere."

"It's not on the plans, or in that model that cost you a small fortune."

"I can't show it, or no bank will loan me a dime."

"And no bank will loan you a dime on a hotel with a backhouse for a toilet."

"A theatre won't need much water. I could drill a well on the Templeton property..."

* * *

Marian sealed my lips with her finger and advised me to concentrate on one water problem at a time. She had a deeper meaning. She wanted to see Justin's well test resolved. A vineyard next door meant money—enough to bail us out of my hotel fiasco. Still, I hid my desires to plant my own vineyard.

I had endured yet another studio meeting on my script, *Over the Top*. Written with my father, the piece had originally been called *American Dreamer*, a title taken from my life.

In Hollywood, a script, even if it's been five years in the writing, is fair game for serious trifling by the purchasers and their hangers-on. A producer's duty is to change every third thing on every second script page. Of course, the producer would never rework the color in a painting simply to match the fabric on his couch. That would be creative graffiti. But a script is another story. The script writer is a second-class creative being.

As I was deep in angst over my inability to prosecute such artistic crimes, the phone startled me; my real estate agent, Graham. In typically measured cadence, he told me the test results were in. He sounded like a doctor about to inform me I had something worse than an iron deficiency.

"You mean Justin's well tests?"

Graham paused, as if repeating the question in his head.

"Yeah."

"And?"

"The first test was near that little horse pasture, at the far end of the property on the curve on the road...you know where that is?"

"Yeah, I know."

He dragged it out. I was straddling the San Andreas Fault, waiting for the Big One.

"That test didn't come up with much of anything."

"Really."

"Well, they drilled a second hole."

Graham paused again. If he were in the room with me, I would've throttled the words out of him.

"What happened?"

"At first, nothing much."

He took a break to address someone who apparently had come into his office. When he got back to me I was up on my feet, pacing.

"Sorry. They told me that I just had a colt."

"Congratulations." I had always suspected Graham could father a horse.

"Anyway, they drilled down to a hundred feet, and then two hundred…there was nothing. They almost decided to pull out. If there's any water to be found in the area, it's usually not very deep."

"I know."

"Well, at three hundred feet they hit a little gusher. Something like eighty gallons a minute."

"God! Eighty gallons?"

"Yep."

"That cinches everything then."

"Sure does. I know Justin was pretty happy."

Graham estimated escrow would close before the end of the week. A check would be in my hands by Friday.

"Live it up over the weekend!" Graham chuckled, already spending his sizable commission.

There was no going back. If grapes were to be planted in the Adelaida, for damned sure I would be planting some too. I'd find water on my side of the fence, or I'd slant drill over to what was now Justin's property. He wouldn't know the difference. Nothing would keep me from farming grapes.

Living it up on the weekend, Marian and I had dinner in Cambria and extravagantly sampled local wines. We bought a bottle of Fume Blanc from Creston Manor and Chardonnay from York Mountain. We tasted reds: Zinfandel from Mastantuono and Cabernet Sauvignon from Eberle.

As we appraised our wines, all I could talk about was planting grapes. Fortunately, Marian, intoxicated by the view of the wild sea, felt it inappropriate to call me crazy.

My theatre project was stuck, but it was just as well. The role of "developer" was uncomfortable, to say the least. I hadn't asked to play the part, and I couldn't learn the lines. Developers butchered the countryside, carving out endless shopping centers and malls, needed or not.

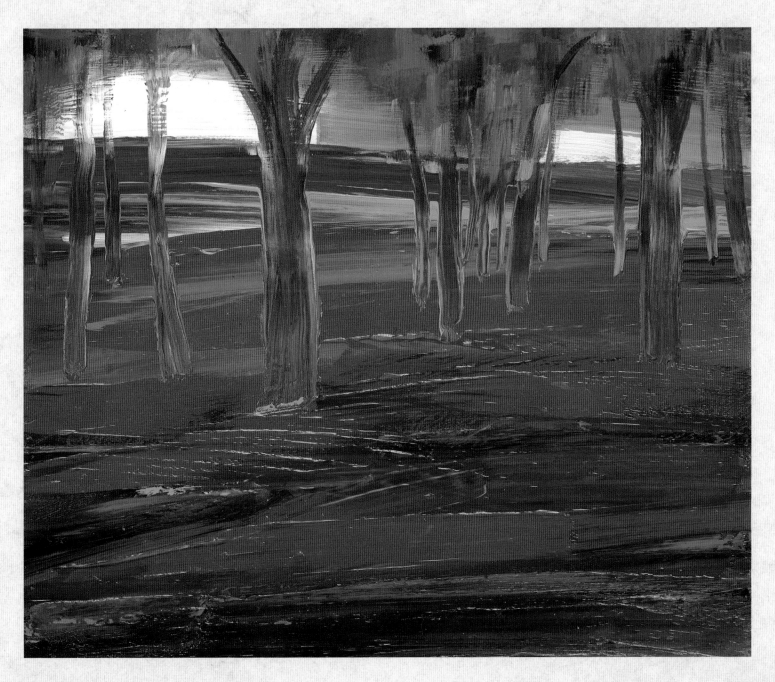

WATER'S EDGE *Oil* 9" x 10" 1995

Jim Smoot

One morning, a counter clerk at the San Luis Obispo Planning Department called me a "developer." I was cranky for the rest of the day. "Artist/grape farmer"—that I could emblazon across my bib.

I laid out careful plans to make my vineyard a part of the outside world, meeting covertly with Jim Smoot, Justin's vineyardist. I assured Jim that I wasn't one of those hustling fast-paced L.A. types who made a pile in the city and flaunted it on a country showplace. I had dirt under my fingernails for real, even though I was an actor.

I had been in Paso Robles for quite a few years now. I'd taken my licks in both farming and ranching. I decided not to stress that last aspect.

A sinewy, seasoned man with a sharp intelligence, Jim rattled off viticulture technicalities as if he were quoting from a textbook. I lapped up the tiniest minutiae, especially the heady, inspiring details mapping out my vineyard. My first crop, Jim cautioned me, would take years to come into fruition. I didn't care. I would love every minute of the adventure.

The wide-screened picture presented a glorious epic, a grand mural with a vivid rainbow arc…from vitis vinifera to the nectar of the gods.

A vineyard transcends ordinary farming. In planting barley or safflower, or even a row crop, harvest is the end of the story. In wine grapes, harvest is the beginning. Then the fun starts…creating wine, perhaps a great wine, adored by kings and cognoscenti…and the rest of us. If the grapes are not so loftily ordained, produce bulk wine, paint a pretty label, sell it to markets and liquor stores, and probably make a lot of money.

The former course, naturally, would be my way. During some divine moment of creation, this extraordinary piece of Adelaida earth had been destined to grow the grapes for the finest wines. This would be the wine cellar of the gods. I couldn't let the cosmic spirits down.

Most of my friends had lost track of what I was up to in my fantasy farm near Hearst Castle. My longest, deepest friendship was with my boyhood chum, George Atkinson. We'd met as hormone-hothouse teenagers at Mt. Vernon Junior High. George and I made the special journey through high school together, and came close to "growing up" at UCLA.

We were tight for so long that we began to look like each other, so George became my stand-in and double during the *Burke's Law* days. Later, with a chunk from my series earnings and some of my "valuable" time, George ventured out and virtually conceived the videocassette business.

Contrary to capitalist folklore, the entrepreneur with a new idea, especially one that will radically change the course of business as usual, finds a tough row to hoe. Being a farmer for so many years, I knew about hoeing tough rows, but we were in a long, long uphill struggle to prove the obvious: people would rent cassettes, stick them in a little machine and watch movies at home on TV.

Battling the Hollywood status quo took its toll on George. He found a crutch in alcohol. After some despairing years with alcoholism that nearly took his life, George was making a comeback with the help of a 12-step program. Strong and sober, he had developed the country's very first videocassette stores. He came to me again to ask for help, this time with motion picture acquisition. Movie rights would be the next important step for a business that was finally catching on with a vengeance.

George credited the 12-step program with saving his life. On many occasions, I accompanied him to meetings. He wanted to share the program's positive influence as it infused him with the inner strength to reconstruct his life without alcohol. George applied many of the program's principles to all aspects of our lives, even though I had no drinking problem.

Absorbed in the burgeoning cassette business, my oldest friend and I had become daily intimates again, but I dared not reveal to him my new lust for wine grapes. George wondered why I was constantly up at the ranch. I professed a love for the "voices of the land." I was "reconnecting myself with the earth." That statement, delivered with appropriate solemnity, carried the desired impact on him. The 12-step program had prepared George to accept a metaphysical approach to the world.

I was simply head over heels with the prospect of growing grapes and making lots of wonderful wine. I was experimenting with more and more wines, anticipating which varietals I would plant. I became obsessed with wine, just as George was becoming rational about the stuff.

I attended the program meeting acknowledging George's first anniversary of sobriety, hearing once again all the evils of demon wine and spirits. George, in a mood to celebrate after the meeting, insisted that I join the members for an alcohol-free dinner party.

I backed out on this important occasion. I was in a rush. I had signed up for an evening wine tasting seminar on California Chardonnays. I wouldn't miss it, not even for a wine-less anniversary celebration with my good friends.

I wanted so much to declare to George my passion for growing wine grapes and eventually making wine. Yes, George, wine—this heaven sent joy for the senses! I wanted to explain to my dear friend how wine is unlike anything else that we take into our being. Wine can live a century or more and reach wondrous levels of refinement, a feat man's spirit can only yearn for. Wine is an art form equal in sensual and intellectual fulfillment to any other mode of human expression.

I also wanted to point out that wine was healthy for the heart and many other vital body parts. So if medical studies weren't enough, my beautiful Sicilian grandmother proved the case. George adored Nana (and her pasta). Nana took red wine with her the only time she ever entered the hospital, at the age of eighty-nine (she gave birth to her five very healthy children at home). She survived the hospital experience convincingly, not with doctor's pills (if Nana couldn't cook it, she wouldn't eat it), but with the wine smuggled inside her knitting bag.

Nonetheless, my friend and I talked with fervor about other things.

At least Marian, equally fascinated by my vinous preoccupation, eagerly joined in wine tasting events. At a UCLA class on winemaking, Marian demonstrated a far surer grasp of the subject. After all, she'd been a chemistry major in college (and an overall straight-A student). I had avoided chemistry with gusto. Now I regretted my smug rejection of scientific disciplines. There was much science in the vintner's art. In all respects I was barely a beginner.

To George, I dismissed my attending UCLA, our alma mater, with some reference to a course in "sensitivity training." Such lofty pursuits seemed plausible to George's new-found philosophy.

* * *

Jim Smoot emphasized that growing wine grapes was complex and ever-challenging. Each season, from bud break in the spring to the last leaf falling in the dormancy of winter, presented its unique tests.

The viticulturalist lives with his plants, suffers with them, and sometimes extols

their glory. At harvest, a farmer is damned glad to sell what he's grown, unless he's making wine. Then a new process begins, one lasting many years—in fact, often many lifetimes.

The vintner arranges his existence (and wine cellar) to enjoy a bottled harvest for every following year of his life, and his children's lives, and their children's...

We visited our first real winery, Creston Manor. The winemaker, Vic Roberts, was well respected in the Paso Robles area. He took Marian and me through the winemaking process, sipping and sampling various wines aging in French oak barrels. Vic drew the wine from the barrel with a tastevin. As Marian and I swallowed the rich wines in their different cycles of maturation, Vic placed his nose deep in the glass, took a taste, swirled it in his mouth, and then spat it out.

In the process of tasting, smelling, and evaluating the wine, Vic did everything but swallow. It would be impossible, with the quantity of barrels and tanks that Vic had to sample, to drink all the wine that he tasted.

Most winemakers, and judges at wine competitions, trained themselves to appraise wine in this way. Vic actually had a winery owner friend who could not drink wine. (I wondered, was he in a 12-step program?) This friend savored the wine he made without swallowing a drop.

I couldn't wait to get back to L.A. and break the news to George. He could be with his program and still have a life. He need only master the art of tasting and spitting. Maybe Vic would give lessons.

I met George to spring the idea on him. I spewed out the first few words, and he actually stiffened at the idea of tasting wine. In a grave tone, he confessed: he had slipped "out of sobriety" a couple of weeks before. He brightened, though, several steadfast friends had come to his rescue.

George couldn't have faced me with alcohol on his breath (that could be a problem with wine spitting). His anniversary date would begin anew. He grumbled. That's the program's way.

Somehow tasting and spitting wine, I was afraid, would never be part of my pal George's lifestyle.

* * *

Jim prepared a cost breakdown. Planting a vineyard was damned expensive. My spirituality, soaring up from the yielding earth, nose dived. Not even counting the costs of building and equipping a winery, I'd be shelling out for years before I would see crop one.

A large portion of my money was tied up in the illusory theatre project, a subject

I sidestepped if it were brought up by Marian or anyone else. Marian, I knew, was psyched about planting a vineyard. Still, if she had any idea of the price tag, she would brain me with my own shovel. And I would deserve it.

I had no proof of my farm business acumen. And as far as vineyard economics was concerned, our closest vineyard and winery neighbor, Dr. Hoffman, went broke.

How would I breach the subject of planting a hundred acres of grapes with Marian? I would start with the obvious. A point had been made, dear Marian, when I had arrived at this land via helicopter, conclusively, on that fateful afternoon…many years ago. A point discovered now: I had been plunked down here to plant a vineyard, by God.

The message echoed in the whispering wind…in the seductive contours of the land.

Perhaps, just perhaps, with palette and brush in hand, I could be the messenger…

WISDOM OF
THE AGES

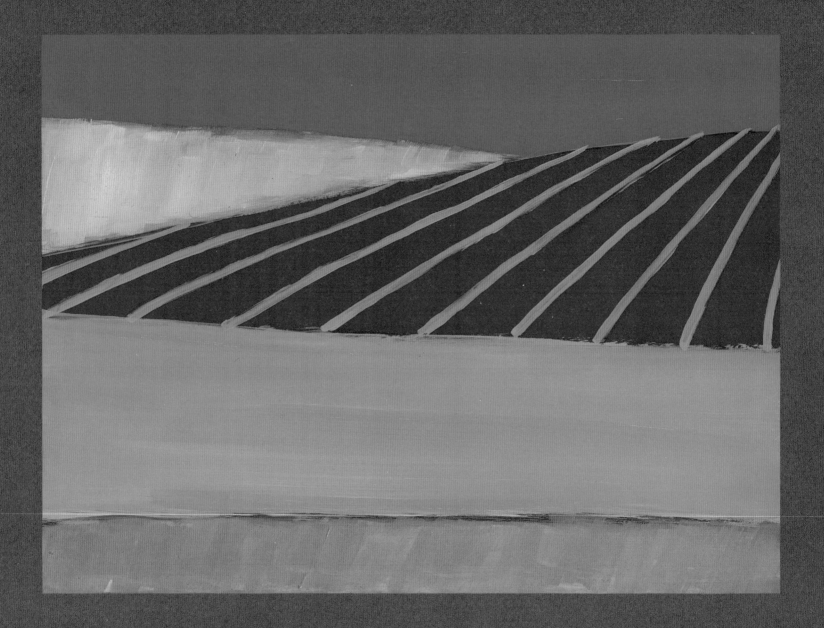

216

arian thought I had finally lost it. At least she didn't clobber me with my shovel.

I first tried logic, which lasted until I explained that "I could get a loan." After the laughter died down, I tried a new tack. I contrasted my out-of-control desires with George's. I could have been an alcoholic, after all. Or how about a druggie, or an insatiable sex addict? How would Marian like that? She became curious about the last option.

We were off the main subject, and I couldn't get back on course. Emotion-ridden and agog at the scope of this latest, greatest farm fantasy, I needed "hard numbers." (That term had stuck from my bank hopping exploits.) I had homework to do and bridges to cross (possibly over troubled waters) before I could present a coherent plan.

It was time to supplicate the water spirits. Lucky Justin hit an exceptionally good well. Could I possess the same fortune? Realistically, could two such wells exist on the same 320-acre ranch? The improbability agitated me. In the middle of the night, I fantasized how I could surreptitiously drill a horizontal pipe into Justin's well.

After weighing the merits of making a pact with the devil to get water, I consulted a water witch.

Roger Wentworth was a dowser. He looked like a life insurance salesman. In fact, he'd sold burial plots before discovering he could divine water. Wentworth's extensive dealings with death and the afterlife had put him, he assured me, in tune with the spiritual world which exists all about us.

I cut Wentworth off before I lost all faith in him.

"Just summon the spirits." Come up with water, or I'd as soon go to hell.

He gave me a "no problem" grin and took out a stick from the back of his car.

"Some folks call it a divining rod, but this here's just a forked branch from an ol' dogwood."

"And it does the trick?" I had the tone of a disbeliever who was dying to be born again.

LANDSCAPE *Oil* 10" x 13" 1994

"Hardly ever misses."

Jim Smoot drove up. Jim, the walking encyclopedia of vineyard technology, threw science to the wind when it came to water witching. It didn't seem to make sense, but it found water.

"Like my wife," Wentworth chirped. "Never seems to make sense, but she's always right." The water witch and budding feminist, firmly gripped the two forks of the dogwood branch and strode into the fields. Jim and I followed. My destiny as a fulfilled farmer, my future with grapes and wine, the precious heritage for generations to come, were all dependent on a chubby little man with a magical dogwood wand in his hand.

But in the last analysis, the course of any human being is a series of casual happenstances. If my father, on a whim, had not enrolled in an Italian class at Boston University, I wouldn't be here. If I hadn't been cast by the director of the UCLA drama department, Ralph Freud, in *Volpone*, my children wouldn't be here.

"And if this Wentworth character doesn't find water with his stick he won't be here."

"What did you say?" Jim glanced at me curiously.

"Sorry. Just thinking out loud."

Wentworth reached the top of the hill, plunging through the tall and tangled wild oats. He moved fast, darting about in different directions.

Jim and I were far away from Wentworth. I raised my voice above a whisper: "What the hell is he doing?"

"He's getting the lay of the land." Jim explained that a good water witch has a common sense idea of where water accumulates underground.

"You really think this hocus-pocus works?"

"If there's water, he'll find it," Jim proclaimed. He had used his share of geologists, and even an engineer with his own seismograph. "But I've had real luck with Wentworth."

Suddenly the water wizard came bounding back down the hill, his branch sticking straight out. It appeared to be mystically leading him.

"Where the hell's he going now?" I was all keyed up.

"I think he found something."

Those words wired me to a thousand volts of electricity.

"Really!!"

We caught up with Wentworth. He concentrated on the main stem of the dogwood branch, which was jerking downward. Sweating, he struggled to hold it fast.

"We got something here, fellas." Wentworth sounded as if he were holding a seance.

Jim looked around. We were in a saddleback between the highest hills of the property.

"As far as vineyard irrigation is concerned, this would be a good central spot."

Already planning irrigation!

The dowser hovered over a patch of earth, babbling about converging underground streams. He put away his divining rod.

"This could be a corker. I figure 'bout 275 feet." Scribbling out a bill, Wentworth took a moment to assess the land about him. "Pretty place you got here. Putting in a vineyard, huh?"

I nodded with an agreeable smile. He handed over his statement: fifty dollars. It seemed so little money for such an invaluable service...especially if the dowser were proven right.

I made out a check, and Wentworth climbed into his truck and left with a hearty wave good-bye. Jim returned to the business at hand. He wanted to use Filipponi & Thompson, the well drillers contracted by Justin.

I had no response. My fantasy vineyard world was inexorably moving toward contact with the real world. Still I resisted the last emotional leap.

Jim sensed my hesitation, and pressed me about calling and getting the well company started. He suggested drilling at Wentworth's spot for the first test. If that didn't pan out, a couple of other places on the ranch might have possibilities.

It was a punch in the gut to hear that it might not "pan out." That was the reality. Wentworth was usually right, but he could be dead wrong. Jim used him as a way of confirming his own hunches.

Anyway you witched it, I was committed to taking the next decisive step. And then what?

A jury of the gods had convened, with my water their sole agenda.

* * *

I told Jim that I wanted to be around when Filipponi & Thompson drilled. In truth, I wasn't so sure. If it turned out there wasn't water, could I control my sobbing? My heart and mind were on the line.

I ran into Bob Graham, the real estate agent. He pointed out again how uncommon a commercial well was in Adelaida. Justin's well was an anomaly. Thanks Bob.

Graham enthused about my vineyard plans. I was hazy, shielding my psyche in the event I came up dry. I would then live forever with the fact that I'd sold the portion of my ranch that had all the water. It would be better if Filipponi & Thompson lowered me into the test hole and covered me up for good.

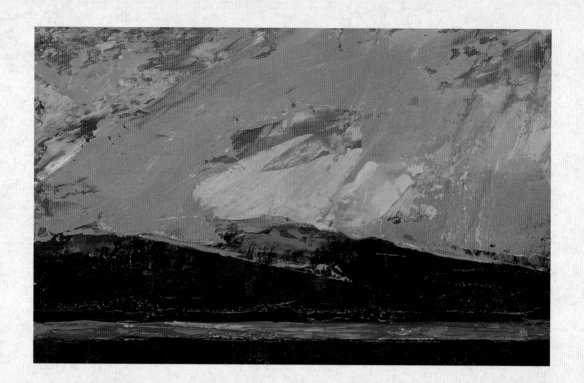

NEAR CAMBRIA #1
Oil 5" x 8" 1994

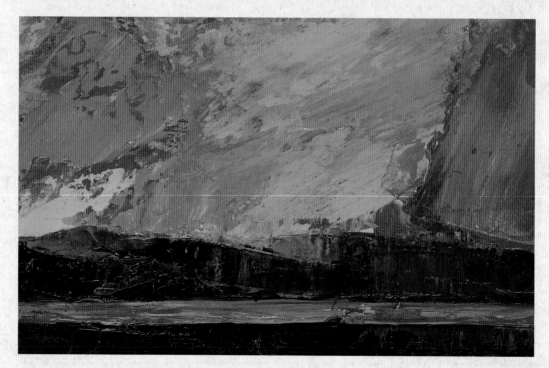

NEAR CAMBRIA #2
Oil 5" x 8" 1994

(Detail)

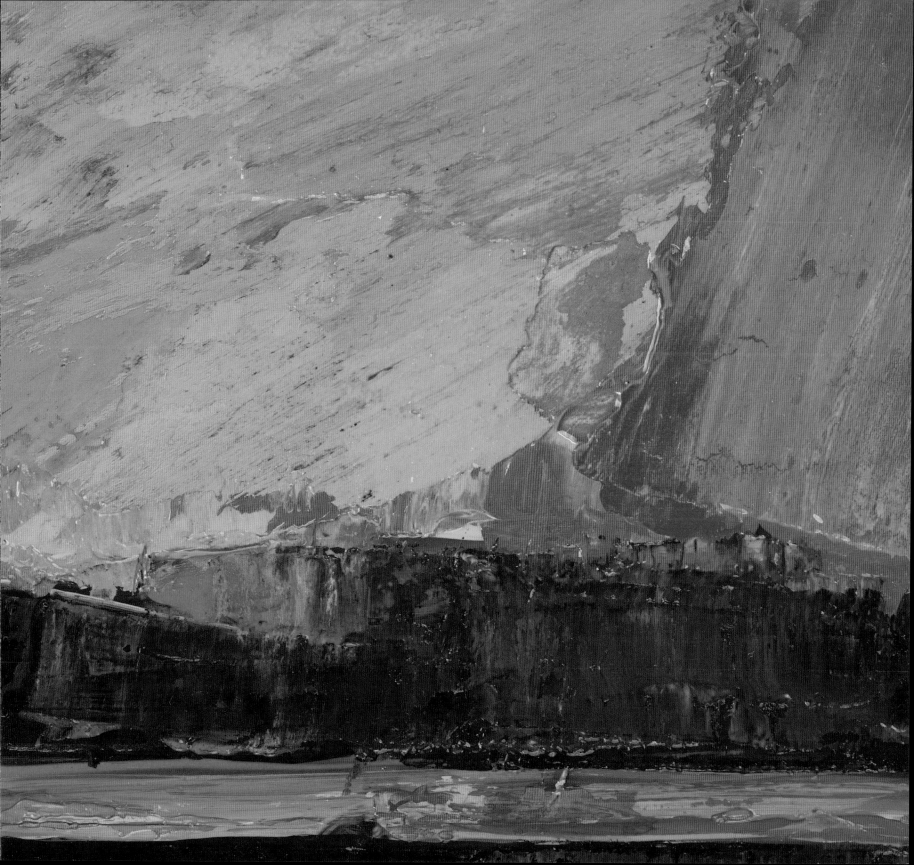

I was back in Los Angeles working on script projects when Jim Smoot called. Filipponi & Thompson had a sudden schedule slot. They were out at the ranch to drill. In a voice strange to me, I reminded Jim that I had meant to be there when the drilling began.

Jim told me that Filipponi & Thompson couldn't always predict when they could start on a site. It was best to take advantage of the opening. They might not come back to Adelaida again for weeks.

I was due at a script meeting on a sea adventure I was writing which was set in the Bahamas. The producer and I wanted to go to the Bahamas, but I urgently needed to get to Paso Robles, and fast. My "creative" meeting would wait. I would knock off a scene or two in my car, ensconced in a moving vehicle, with the seductive Pacific Coast appearing outside my windows, my creative juices oozing.

In actual fact, I was unable to concentrate on anything but water. I glanced out upon the boundless sea. I drove annoyed. If we had only harnessed our ocean waters in effective desalinization plants, I wouldn't be desperate for a well. Science had taken us to other planets, damn it. If they'd attended to earthly pursuits, I'd be able to pipe all the water I needed from the coast to my ranch, just a few miles away.

I imagined freshwater pipes leading from a Cambria desalinization plant up through Highway 46, forking off to my ranch. I merged onto Chimney Rock Road from Spring Street in Paso Robles, possessed with plans for a Cambria solar distillation plant...

I didn't know what it was.

I thought a water main had burst, but this wasn't L.A. or even Paso Robles. We were way the hell out in the country. There weren't any water mains.

But there she blew! I turned into my gate. Up on the rise, just at water witch Wentworth's chosen spot, a bold fountain of water, twenty or thirty feet, shot up into the air. Through the vapor, where the water plunged back to the earth, I made out vehicles, a truck or two, and a drilling rig.

Eureka! We'd hit water! And hit it big!

I screeched to a halt at the magic site, ready for a water dance, but Jim and the well drillers were an assortment of frowning masks.

"We've got a problem!" were the first words out of Jim's mouth.

I'd been ready to jump into the middle of this earthborne fountain and ride the water to the sky in ecstasy. My bubble burst.

"What do you mean? What kind of problem?"

"We hit an artesian. We can't cap it!"

Cap or no cap, I thought, could I irrigate a vineyard?

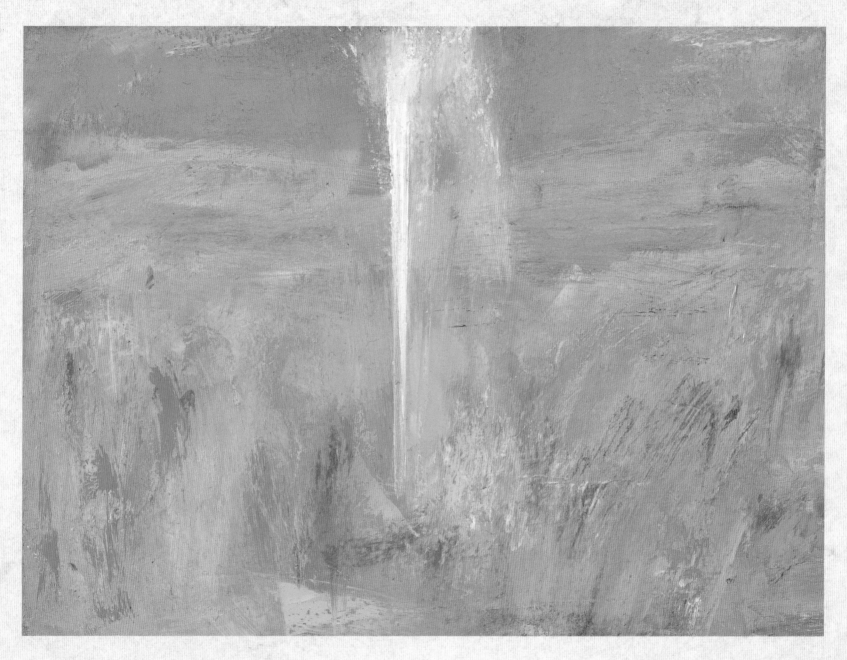

EUREKA! *Oil* 5" x 8" 1994

223

"How many gallons a minute?"

"God, at least a thousand!"

"Then I can irrigate?!"

"Irrigate, man! You can irrigate all of Paso Robles!"

Later, when Filipponi & Thompson filled out the required State of California Water Well Drillers Report, under the "Proposed Use" column, they checked "Municipal."

It took over a week to finally corral the artesian and cap it. Jim also had the drillers work on casing and sealing the well.

Sure enough, the water witch had accurately augured the depth of the well. Wentworth had figured " 'bout 275 feet." The well came in at 280!

This metaphysical water well proved, even to an agnostic, that this divine valley had been chosen as "the wine cellar for the gods," sanctified by holy water. Then the water analysis report came back. There was a greater array of minerals in these artesian waters than in the typical daily vitamin and mineral pack. Hell, forget the pills, just drink a glass of this miracle mineral water each day!

That's how I described it to Marian. As a final touch, I openly declared my supreme commitment, testifying that I was determined to make the vineyard a reality once and for all.

Marian had no chance to play devil's advocate. I was preaching from a pulpit on hallowed ground now. My previous "farming enterprises," righteous ideas one and all, were not miracles like this, by God!

Ordinarily it would be sacrilegious to pour the cold water of business logic onto a theological soliloquy. But one word more or less drowned me out: "money." Marian found that word and slipped it in while I was taking a breath. The demons were possessing her...

* * *

I got Jim's final cost estimate for planting over most of the property. Back to the banks I must go. Best to entreat a different set of banks than on my dried-up theatre project, or at least a different set of loan officers. I couldn't face the same lenders with a new story: "By the way, I don't have water to produce plays, but I have plenty of water to produce wine grapes."

I called a few banks to get a "feel" for their general attitude toward vineyards. The banks that weren't foreclosing on vineyards and other farming properties (California was in the middle of an agricultural depression), flatly declined to make agricultural loans.

Just for sport, I called one of the Japanese banks that were proliferating in the state, and told them I was planning a "theatre on a farm." The banker, an American from

a farming town in Iowa, deliberated on the concept for a few moments, then asked if there was much of an audience for that kind of theatre.

Before turning over the first dirt clods in a vineyard, dig up money, and plenty of it. I had a reasonable amount of capital for starters, and I owned my land, with a mortgage of course, but I had to nail down some long-term financing. Jim was my vineyard consultant. I needed a financial consultant.

Big Bob Tyler was that man. Big Bob knew his way around banks, specializing in ag loans. Born and raised on a farm in the Central Coast, Big Bob could rattle off soft twangy wisecracks at the drop of his Stetson.

As we left the first bank, where he pitched on my behalf to an elderly sphinx-like lending officer, Big Bob capsulized the meeting: "There's no fool like an old fool, 'cause he's had more time at it."

"Do we have a shot here?" I was a babe in these woods. "He sure didn't say much, just sat there."

"Yep, like a toad on a log."

Big Bob had worked at this bank at one time, which implied he had an inside track. Bob assembled a slick forty-page proposal on my vineyard, including all kinds of unrecognizable projections and a few studio head shots, but he seemed unable to get his big foot in the vault door. I had a sinking feeling. Bob wasn't any more effective than I had been on my solo bank encounters.

Bob tucked his tail in. His first time out of the chute, he hadn't impressed his client "up here from Hollyweird." He railed against the blank-faced banker as we traveled down 101 toward a second appointment in Santa Maria. "If you put his brains in a chicken, he'd forget how to peck."

Bob assured me we would get a better reception at the next stop. It was a small, more personal bank, and we would be seeing the president, Hoke Howard.

"Hoke started in the bank game when I did. He knows his beans from his buttons."

Laid-back Hoke, sure enough, seemed to know his beans. Actually he was laid-up. Broke his foot in a horse fall. We spent the entire appointment talking about the incident, and horses in general, which was Big Bob's biggest interest. We rambled on for a good forty-five minutes. Never once mentioned the vineyard.

Hoke hobbled out of his chair to shake our hands. His next loan-seeker had arrived. He took our presentation. He would give it a "good look-see and be back in touch."

Hoke said good-bye on a sad note. His old Spaniel, Clem, had "passed away" that morning. Big Bob knew Hoke's hunting dog.

NEW SEASON *Oil* 6" x 10" 1994

226

"How old was ol' Clem?"

"Twenty years old." Hoke's eyes glistened.

"Well, he had a long run."

Not one to leave a loan pitch on a downer, Bob popped off a riddle. "Say, Hoke, what does a gal do sitting down, and a man standin' up, and ol' Clem used to do on three legs?"

Hoke didn't have time for the answer. The image of ol' Clem peeing jarred him.

"Shake hands! Put it here, buddy."

Big Bob grabbed Hoke's hand and pumped heartily. I sensed the meeting had gone well. I learned a lesson. Never talk about what you come to the bank for. It gets plenty boring for the Hoke Howards of the world to discuss loans all day long.

* * *

After a few weeks on the bank trail, Big Bob put it bluntly: "I can't get this ox to plow." Hoke had turned us down after I'd sent up another hundred documents. We didn't even get to first base with Big Bob's other buddies.

"They're just not lendin'. It's all changed out there. I've beat my gums to death with your deal. Anythin' to do with farmin' and you're persona non gratified. It's tougher than puttin' socks on a wild turkey."

I'd heard that about theatres and hotels, but farms in farm country should be easier going. One thing for sure: Big Bob's good ol' boy network hadn't helped a goddang bit.

Jim didn't know that I was striking out with the financing. Assuming all systems were chugging, he wanted me to meet Juan Nevarez, a young Mexican who would make a "real dependable" vineyard manager.

Juan had stood out from the hordes of migrant workers who labor the California row crops, vineyards, and orchards. Right off, Jim saw that Juan was a born leader, with boundless good humor and intelligence.

When Jim had picked him out of the crowd, Juan figured he was about to get deported, or go to jail. Juan was worried because he'd been an organizer for Cesar Chavez (the first labor leader to effectively unionize the farmworkers), and had run into trouble with corporate farming operations.

Juan had changed his name because he'd been blackballed and couldn't get work. He quickly revealed his true identity to Jim Smoot, along with the details of his incendiary past.

Whatever agitating he had done for the welfare of his fellow braceros was further positive indication of Juan's character, as far as Jim was concerned. Young Juan was obviously eager to embrace greater challenges than stoop labor. Juan had the raw qualities to

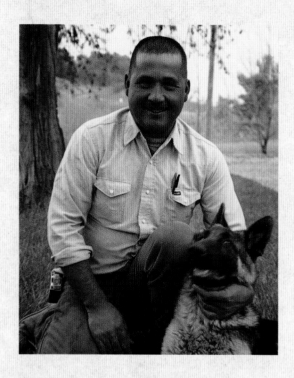

Juan

be a vineyard manager. In Jim's experience, this work wasn't meant for a "gringo."

I was immediately attracted by Juan's firm handshake, and the warm smile that never left his brown, symmetrical face. He expressed himself with an impressive exuberance and command of English.

Juan casually mentioned that he was from a family of twenty-two children in Durango, Mexico. The school in his primitive village stopped at the third grade, and after a few years of desultory education, Juan began helping his father full time. The Nevarez family lived on what they grew, and they had a lot of mouths to feed. Theirs was an all-labor existence. Juan's village had precious little electricity, let alone modern conveniences such as tractors, trucks, or TV sets.

Eventually, Juan took off for the United States to earn his five-dollar-an-hour fortune, riding for two days on horse-back to the bus station, which was not far from the border.

Juan had become proficient in all aspects of vineyard management. He could plot out vine spacing and row layout, employing laser technology, and had mastered the sophisticated engineering of the complex irrigation-drip systems.

Juan was able to do almost everything, and well. "What Juan doesn't know, he learns. He only has to see it done one time."

The young Mexican beamed as Jim described his strengths as a quick-study. Being studiously nonmechanical, I greatly admired this practical applied intelligence.

As Jim, Juan, and I walked the sunbright acres, my confidence took wing, soaring over rainbows of anticipation. The guidance of Jim, my vineyardist, and Juan, my new vineyard manager, ensured the sylvan vineyard of my loftiest fantasies.

I gazed across a golden sea of mustard, cascading over the greening hills. For an instant, I saw long ribbons of vines spreading to the violet mountains...

"Try the PCA."

Though I kept assuring him I was ready to fire up the tractor and rip up the ground, Jim sensed that my financing was out to pasture.

"You mean the Production Credit?"

"Yeah, they have an office in town."

I had always thought that only born-on-the-homestead farmers got anywhere with the PCA farm programs. Years ago I had sought their aid for one of my umpteen ventures, and didn't get much help. An agency of the Farm Credit Administration, the PCA was formed under Roosevelt at the height of the Great Depression. At the height of my own modest depression over lack of banking support, I took Jim's advice, and tried them again.

The Paso Robles PCA office had the easygoing atmosphere of a small-town bank of yesteryear, a neighborly and welcome contrast to the string of lending institutions that had been rejecting me lately. A member-owned cooperative, the PCA is willing to participate with the earnest farmer for the long haul. The usual bank is only interested in business ventures that will show immediate profit. But the PCA understands that a vineyard demands years of investment, and capital returns are far down the country road.

By pursuing a myriad of farming ventures through almost two decades, I had earned the qualifications to present a convincing case. The PCA would be talking to someone who had paid his dues, perhaps overpaid them.

Dave Chandler, the attentive PCA loan officer, deferred to my farming and ranching perseverance. I had, in fact, been in Paso Robles longer than he had. By now my body of gained experience made me credible. We began to talk deal.

I was talking at least three times faster than Dave was, galloping misspent energy. Mid-sentence, I cut my pace in half. I immediately sounded amazingly rural. Dave took me more seriously; seriously enough to indicate that the PCA would do something for me.

I kept wondering where the trapdoor was. So used to being turned down, I didn't know how to accept yes for an answer. But it suddenly all seemed so simple. I was in the right place at the right time with the right project...at long last.

Dave gave me the prerequisite forms and shook on it, delivering an unambiguous message: "Go start your vineyard, old-timer, what the heck have you been waiting for?"

Dave accompanied me to the door and as I walked out onto Spring Street, I waved back to him at least three times. I repeated to myself again and again: "Hey, you finally got it together, finally...'old-timer,' you're actually going to start a vineyard!"

The morning sparkled. The Paso Robles heat warmed me to the core, but there was the Paso Robles breeze that cooled my grateful body.

There was a Spring Street to inspire Thornton Wilder. I saw a crisp white church across the road. In the oak-studded hill beyond the church loomed the grandest Victorian house in Paso Robles. Surely, it belonged to Banker Cartwright.

A few doors down Spring Street was Mr. Morgan's drugstore. But it was Dr. Gibbs's house that stopped me in my tracks. I hurled an imaginary newspaper into his doorway.

"Morning, Doc Gibbs."

"Morning, Joe."

"Somebody been sick, Doc?"

"No. Just some twins born over in Polish Town."

"Do you want your paper now?"

"Yes, I'll take it. Anything serious goin' on in the world since Wednesday?"

"Yessir. My schoolteacher, Miss Foster, 's getting married to a fella over in Concord."

"I declare. How do you boys feel about that?"

"Well, of course, it's none of my business, but I think if a person starts out to be a teacher, she ought to stay one."

I'd been cast in *Our Town* in my first year at Los Angeles High School, as Joe Crowell, Jr. Joe's first lines opened the play. In junior high, I'd been Tom Sawyer and Wildcat Willie, but Thornton Wilder's *Our Town* was headier stuff, springing from Wilder's deep love of rural New England, and the universality that the American town represented.

I'd been a boy playing from the heart in *Our Town*. Grown up, I was still playing from the heart in this town.

I crossed Spring Street and its traffic of tidy pickup trucks representing every version of small-town commerce. Good for them! The working stiffs! Every day, in our town, making a real living...supporting a family in the best American small-town tradition. Joe Crowell was dancing down the street by now.

Just for fun, I waltzed into my favorite hardware store. I was going to splurge. I wanted tools, lots of tools, and I was going to buy them right away, as many as I needed. I had to get ready, Thornton Wilder! This is California, and I'm about to plant a vineyard!

* * *

The PCA was acting like they were making my vineyard loan, so I began acting like I was planting my vineyard. I had to get a jump on any pre-planting item that might hold me up. A delay in planting the rootstock could lose an entire season.

First on the agenda was an electric fence to encircle the property. I crammed in a study of the science of fencing. A fence had to be installed immediately.

Adelaida was practically a wildlife preserve. The abundance of wild boar and wild turkey, deer and vine-loving rabbits could graze and raze a vineyard, especially a newly-planted one. Justin's fence had failed in a section, on the far corner of his property. In one weekend his Chardonnay rootings were eaten to the ground.

Jim Smoot's recommended electric fence was at least ten feet high, consisting of ten wires tautly strung between plastic bars, which were spaced between rigid pine poles anchored in cement.

For me, equally important, were the aesthetics of the fence. The fence would be the first visible sign of the vineyard, and I didn't want a ten-foot-high, two-mile-long eyesore. These thorny artist-farmer issues often seem trivial, but anything that jars the eye ends up sticking in the throat.

One thing for sure, the required miles of fencing could not tolerate any point of vulnerability. The pesky local herbivores would be forever testing the perimeter. Innately, they sensed any weak spot between themselves and a feast.

I decided to beef up security and replace the tacky looking plastic spreaders with pine poles. After considering the added cost, I only really needed to replace the plastic in the portion of the fence fronting Chimney Rock Road. I would set the verdigris-toned pine poles every fifteen feet rather than the customary thirty feet.

The contractor, J.P. Miller, studied me with polite bemusement. The extra pine poles were essentially for looks, but I took the tact with J.P. that I wanted them for added structural support. I reminded him of Justin's fence. You shouldn't skimp.

J.P. bought the argument, which fattened his contract, and in fact was true. It does the heart good when art meets practicality in the vineyard.

* * *

I finally got the phone call I'd been waiting for all my life.

PCA Dave began matter-of-factly. It took me several moments to realize what he was saying. Dave got to the point. He would either mail me the loan documents, or I could come into the office and sign them. His message finally sank in.

I could've released my pent-up hysteria in wild whoops and hollers. The "Hallelujah Chorus" rose in my throat, but when Dave asked if I was ready to get started (planting season was fast upon us), I somberly drawled, "Yep, in two shakes of a lamb's tail."

I couldn't believe it was me talking. By God, I was a real farmer! After all this time—two decades' worth—I was an honest-to-goodness farmer.

I hung up the phone. I ran through the house to find Marian and reaffirm our marriage vows. I was her "husbandman."

She enjoyed the play on words, and took the rest of the news in stride, reminding me that a loan must be paid back. When loans aren't paid back, banks have a nasty habit of taking away the property.

I was very aware of the significant financial responsibility and the potential impact on my family. My tone was reassuring. I contended that my sordid record with farming economics only indicated that perhaps I had finally acquired practical wisdom.

"I've been studying vineyard management, you know."

"Really, I hadn't noticed."

"I can now tell you, planting a vineyard was the reason we bought the ranch in the first place, but of course I didn't know it then. And I can now tell you, I would rather have all the failures behind me and have learned from my mistakes. Wisdom is more profound and dependable if it's learned the hard, hard way."

I was sounding too sincere, with even an air of melodrama. Marian eyed me suspiciously. She didn't quite see Socrates of the soil standing in front of her. She combined wisdom and a hundred acres of grapes and confronted me with the word: "wiseacre."

The ringing phone saved me from defending my hard earned horse sense. Jim Smoot on the line. He told me to get back up to the ranch without delay. A couple of tractors were scheduled to start ripping the soil. I needed to make a decision about the old farmhouse.

I insisted to Marian that we drop everything and shoot up the coast. I wanted to celebrate, and I wanted to be there when the first clod was turned over. I didn't mention Jim's comment on the house. I wasn't sure what he had meant....

SAVING AN
OLD FRIEND

234

*W*e *arrived at* the ranch just as an eighteen-wheeler hauled in a big crawler on its back. Smoot met us with a strapping, ruddy fellow named Jack who looked like he never spent a minute indoors. Jack was working on the fence; he could also help construct our headquarters.

"I thought I might use the old farmhouse for our headquarters." Actually I hadn't thought about it, but I had to sound on top of things.

I was in the middle of a three-ring vineyard construction circus. The pine poles for the electric fence were being cemented into their holes. Gainsaying my decision, the ten-foot poles seemed to have all the height and charm of a prison perimeter.

The brutish D-7 was about to start plowing the fields. Jim and Jack needed a decision, pronto, on the headquarters.

We walked to the house. I asked Jim how he'd gotten everybody lined up and going at once. He'd run into PCA Dave a few days ago, and wondered how things were shaping up. Dave told him. The PCA was ready to fund. With that news, Jim jumped right on it. We wouldn't lose a day of valuable time.

That's how a small-town works. Your banker runs into your vineyardist, and everything is hunky-dory. No big deal.

But I was confronting a big deal. The house had never appeared so forlorn and needing of repair. Jim had already seen to it that everything around the place had been cleared and the ground was neatly plowed. Stark and uninviting against the leveled land, the house looked out of place. The only thing left standing on the entire ranch—it seemed sad and very, very tired.

Jack summed it up. "It's had its day." More money would be spent fixing this house than to start from scratch and build a solid functional headquarters in a better location.

FARM LANDS AND FOOTHILLS *Oil* 11" x 13" 1993

This was my test. Could I make a pure business decision? Had I really learned over the years? Indulging myself for all this time had earned me the status of farmer-clown. Now I must assert my acquired acumen. In practical terms, I must frugally manage the vineyard, employing up-to-date agricultural science, and be steadfast in my economic responsibility.

We walked around the old house. It leaned in several directions. The fascia boards under the eaves were hopelessly warped. The roof was gone for any intent or purpose. What was left of the porch wouldn't be fit for firewood. For the first time, I noticed that the big front windows were glaringly asymmetrical.

Jack, bless his heart, brought up the missing foundation. Jack chuckled, and Jim joined in, shaking his head in wonderment. Jack continued, "The wiring should be completely redone, as well as the plumbing."

Jack piled it on. "With the money spent to just bring the house up to code, you could build something brand new." Jack reiterated that none of the walls were insulated. Every wall needed studding to stem the waste of money on extra heating bills and air conditioning.

Jack was brutal. Jim nodded in agreement. The tractor fired up. It was ready. The house could be demolished in five minutes. Out of its misery. The tractor would then dig a big hole and bury anything not worth saving.

Marian was buying these practical, sensible, money-saving arguments. She thought we should build the headquarters up on the hill, where I wanted my studio, anyway.

"You'd have a hell of a view," Jim added.

"You're gonna be money ahead," seconded Jack.

The monster D-7 tractor worked toward the house like an invading tank.

Something felt wrong...

A face distinctly emerged from the paint-scumbled clapboards of this old, old house...a simple, pleading visage. The eyes were directed toward me.

This house had been here when there were still Indians. Built by the first settler who had ridden out by horseback, it had grown from a one-room farmhouse and had protected all who came to this serene valley. A century later, I showed up one day, out of the sky, from some distant city. The old house took me in too, and stuck by me through my years and my glorious failures. Now I was about to plant a shining vineyard on this rich land and the homestead would be no more. It had seen the past but not the future.

That's what the face in the house was telling me.

Jim suggested we all jump in his truck, drive up the hill and find the spot for the new headquarters. It was a good idea. It would give me a better perspective, and I would get away from the face.

My heart lifted as we rumbled to the crest. The jade green hills plunged into thick groves of oak and pine. The brooding Santa Lucias threw off a fog drift from Big Sur, holding my gaze with their grandeur. So many years after that first fateful moment when I discovered this valley, lifetimes later it seemed, I was about to enhance nature's work with the verdant warp and woof of a vineyard.

The stakes and burgeoning vines on Justin's land to the west—once a part of my ranch—were assembled like a vast army at attention. The vine rows interwove with bursts of oak and soft-breasted hills and abrupt ridges. Here, man and nature collaborated on a resplendent landscape.

Jim was addressing me, pointing to the east, to the great rolling pasture where I'd first seen the deer bounding through the waving barley.

"Perfect for the Chardonnay. It's the highest point on the ranch, with north/south exposure."

Jim drew our attention to an adjoining pasture, sweeping below into the shrub-tangled headlands.

"Ideal for the Cabernet Sauvignon. The soils get very complex here, volcanic, and it's still high enough to be protected from spring frost."

Marian asked where we would plant the Merlot and the Cabernet Franc. Jim pointed to the west, toward Justin's. "Next to the Cabernet," he told us, "and wrapping back on the other side of this hill."

Marian was caught up in the excitement of plotting the vineyard. She and Jim hiked up a little higher, to better assess where the Merlot would be planted. I returned to the mural of my past.

The old house below the fields appeared strangely alienated. Everything was stripped away around it, except the mighty oak trees, standing sentinel at the front. It seemed as if some little boy had dropped his play house as he ran across the vast field.

My mind drifted through the years. I smiled, remembering the cold night when Marian and I found that a bat was sharing quarters with us. Then cousin John had disturbed a colony in the attic. I'd turned "chicken" as John engaged those mini-dive bombers engaged in the attic battle. I laughed out loud.

Eastward, the hillside orchards loomed above my neighbor Wiebe. What a ride that day! Tony, my faithful horse! Me a joy riding Western hero in the gilded morning roundup!

I glanced back toward the house again, and pictured my dad and me sitting on the porch. We watched the color burst of the setting sun as everything faded into soft twilight.

We talked into the night about the spectacle of life and about little things. He was always teaching me. I wanted to talk to him now. I wanted to go down to the house and sit on the porch with him once again. I wanted to tell him about the vineyard.

I remembered the characters who shared the house and the years. The gun-toters and wood-choppers. Leona and Elmore. Decent people. How were they doing? Did they still have dreams...?

"Do you remember Gareth running down this hill...?"

Marian startled me. I looked up. She was alone. Jim was with Jack, back at the truck, studying a fence diagram.

"He thought he could catch that frisky calf." Marian sat down and put her arm around me. "Remember how muddy Gareth got? And how his hair turned red from your mineral water when we bathed him that night?"

"Both kids will have a lot of wonderful memories from this place," I responded. "I'm glad of that."

Marian's eyes were directed toward the house. "The place seems pathetic down there, doesn't it?"

"Like an orphan."

We fell silent, as if observing the passing of an old friend. Marian found the appropriate words.

"We can't let it go."

Marian had made up our minds. "I really love that house...it's part of our life now," she added decisively.

I quickly voiced my total agreement. "I know...it's been around too long to tear down..." But I didn't get to finish the thought. The tractor, positioned at the front of the house, seemed ready to pile drive it into oblivion.

I yelled for Jim and raced down the hill. I could probably make it to the house faster than to double back to the truck and then drive.

All the way down the hill, I kept shouting at the top of my lungs. The tractor motor must've drowned out my voice. The driver wasn't responding. As I got closer, I saw that he was ripping the porch off the front of the house and pulverizing it into the soil. I was running to save a life!

The driver was positioned to ram into the center of the house. He saw me waving my arms wildly, out of breath and panting hard. Within a foot of the front door, revving up for the death blow, he read my frantic body language and jammed on his brakes.

Jim's truck arrived with Marian, Jim, and Jack. There had been a mistake. Signals were crossed. When we went up the hill, the operator had assumed that he had to get the house leveled in short order.

The driver apologized for mowing down the porch. The porch was a hopeless wreck anyway.

Minus one front porch, the house had picked up in appearance. With this lucky accident, the house had acquired a New England Colonial design, which seemed now its essential architecture. I laughed to even think the word architecture in regard to our old friend.

Yes, our old friend...who would be staying with us as we created a vineyard.

A vineyard of Chardonnay and Cabernet Sauvignon, of Merlot and Cabernet Franc. A vineyard that would spring from the passions of the land, and take root in the love and wonder of our time here together.

THE ART OF
THE VINEYARD

242

*I*t was late into the city night. I was yet to find sleep. My mind was loaded with the filmstrip of the previous few days.

I thought reading would be better than counting sheep or vine rows. I turned on the light by the bed, above the stack of photos on the night stand, photos that were developed that afternoon.

I had at least ten shots of our first Chardonnay rootstock being placed in its birth bed. It was the first of six hundred plants for that acre, with ninty-nine acres to go.

I'd come pretty close to taking a photo of each plant. Marian said I hadn't shot nearly as many pictures of the children when they were first born. I think she was right.

Instead of reading, I went into my studio to assess the painting I'd been working on the day before. If I couldn't sleep, I would indulge my curse. Whenever I was about to finish a work, usually in a burst of glory, I left it for a cooling down period. Invariably, when I came back to the painting, I found it far less compelling than I had assumed. I then wondered why I was painting at all.

That's what kept me going, I guess. I was always trying to achieve, in the end, that brief possibility of perfection I had glimpsed at some point during the process.

Lately, in my usual figurative stuff, my suggestively human figures were shrinking, and a vague, shrouded landscape was emerging. Man straining against the power of the land.

I succumbed to my usual mistake, never willing to leave well enough alone. And why not?

I opened my turpentine and linseed oil, mixed them with varnish, and poured the medium into a small jar. I picked up my brush.

I stepped back from the easel. Dammit, the yellow ochre which dominated the painting was all wrong, at least at this time of night.

THE HOUSE *Oil* 10 ¼" x 13" 1994

I moved aggressively, splashing on a bolder hue of chrome green. My sweeping strokes ran into the almost human figure, poised beyond the vanishing point. The little fellow had to go.

Now I was one with the land and only the land. The work seemed better. But something was missing, and it puzzled me.

The first ray of dawn peered down from my studio skylight. I was starting this new day painting furiously, almost out of control. But I was painting something very different to my eye. This was a landscape, all right, but curiously barren even though I was on top of my game with organic color and earth shapes.

I was painting as if I had drifted from my body in some creative transmigration. Ah, the night plays its alchemy. I was the observer, and what I began to see...startled me.

Rows of vibrating color appeared, reaching miraculously across the canvas. I felt a catharsis as I traced my life in new horizons.

I was painting a vineyard! There could be no doubt. This composition was born from this moment...and all the other moments before.

I was on a new journey.

A journey, out of the past and the future...

EPILOGUE

I remembered the future.

It was ablaze in a sun slipping into the horizon.

The vineyard massed on the hill, the symmetry lost in radiant foliage, reaching beyond the rows. Our past reached into the deep roots.

"Well, who opens it?"

Marian handed me the bottle of Chardonnay as if I had made the decision.

It was cool in my grasp. Outside light patterned the glass, streaking it gold.

Marian had purchased a silver foil-cutter and corkscrew for the occasion.

"How many years in this bottle?"

"I don't want to remember now." I drew closer to the window, to the divine afterglow settling on the Cambrian hills. It was a new painting.

I fumbled with the corkscrew, terrified that the cork would crumble and I would wake up from a dream.

"Are you going to make it?" Marian was concerned. It had never taken longer to open a wine bottle.

I freed the bottle of the constricting cork. Marian handed me a long-stemmed wine glass and took one for herself.

She pressed close to me, following my gaze beyond Thoreau's cabin, up into the Chardonnay fields, haloed in mystic light.

"You better pour."

Instead, I raised my glass, capturing beams in its bowl. I studied the little universe... then gave Marian the bottle.

"Why don't you do the honor? You've always had the steady hand."

Marian poured our first vintage...steadily. The Chardonnay shimmered, like the fields before it.

We made a toast with silent words...and took our first sip of the wine.

"God, it's good!"

I heard myself distinctly, although there was an eternity in that moment.

Then we laughed. And we cried...and then we laughed again.

The Farm Today

Silver Canyon Vineyards